Masterworks from Munich

Masterworks from Munich

Sixteenth- to Eighteenth-Century Paintings from the Alte Pinakothek

BEVERLY LOUISE BROWN

ARTHUR K. WHEELOCK, JR.

National Gallery of Art
Washington

The exhibition is supported by the foreign office of the Federal
Republic of Germany and by the German-American Cultural Fund.

The official carrier of the exhibition is Lufthansa German Airlines.

The exhibition is supported by an indemnity from the U.S. Federal Council on the
Arts and the Humanities.

Exhibition dates:
National Gallery of Art, Washington, 29 May–5 September 1988
Cincinnati Art Museum, 25 October 1988–8 January 1989

Edited by Jane Sweeney and Barbara Anderman
Designed by Susan Lehmann, Washington, D.C.
Typeset in Meridien by VIP Systems, Inc., Alexandria, Va.
Printed by Schneidereith & Sons, Baltimore, Md.

Library of Congress Cataloging-in-Publication Data

Brown, Beverly Louise, 1948–
Masterworks from Munich.

Includes index.
1. Painting, Renaissance—Exhibitions. 2. Painting, Baroque—Exhibitions. 3. Painting,
Rococo—Exhibitions. 4. Alte Pinakothek (Munich, Germany)—Exhibitions. I.
Wheelock, Arthur K. II. Alte Pinakothek (Munich, Germany) III. National Gallery of
Art (U.S.) IV. Title.
ND160.B78 1988 759.04′074′0153 88-12426
ISBN 0-89468-118-4

Cover illustration: Detail, cat. 23

Frontispiece: Detail, cat. 30

Contents

Preface

For the first time in the history of the Bayerische Staatsgemäldesammlungen, a large number of the most important masterpieces of art from the world-famous Alte Pinakothek in Munich will be shown in the United States of America.

This extraordinary exhibition gives a completely new dimension to the cultural exchange between Bavaria and the United States.

The loan from the Alte Pinakothek affords the American public direct access to works of art by the forty-eight most important European painters of the sixteenth, seventeenth, and eighteenth centuries.

As Minister-President of Bavaria, I am particularly pleased that these valuable works of art can be shown in Washington and Cincinnati. This proves that Bavaria not only carefully keeps and preserves its manifold treasures, some of which have been in its possession for centuries, but also spares no effort in making them accessible, even over the greatest distances, to an interested international public.

May I recommend to every visitor who likes the exhibition and enjoys the paintings in it that he or she consider it as a stimulus to visit Bavaria. I cordially invite you to see the other outstanding works of art of the Alte and Neue Pinakothek in Munich as well as the great number of additional treasures that Bavaria is happy to show to its visitors.

I wish the exhibition of the Alte Pinakothek in Washington and Cincinnati the best of success.

FRANZ JOSEF STRAUSS
Minister-President of Bavaria

Foreword

The year 1988 is the bicentennial of the city of Cincinnati, a city that has long enjoyed cultural ties with Munich. With this in mind, the two undersigned directors met in Washington in January 1985 to discuss an ambitious proposal initiated in 1984 by the Cincinnati Art Museum to organize jointly an exhibition drawn from Munich's principal museums. The idea suggested an opportunity to celebrate the remarkable history of collecting throughout the centuries that was begun by the Bavarian rulers in Munich.

The importance of Munich collections has long been recognized by Americans. Since the nineteenth century, many of our most gifted artists went there to study, including some from Cincinnati, notably Frank Duveneck, William M. Harnett, William Merritt Chase, and John Twachtman. Later, Elie Nadelman and Hans Hoffmann spent time there, as did Louise Nevelson, who went to study with Hoffmann in 1931.

The original concept, following the pattern of the Gallery's Dresden exhibition of 1978, which explored the collecting history of the kings of Saxony, had been to cast our net very wide. It was soon apparent, however, that the breadth and complexity of Munich's collections are staggering. They are so rich and varied that our fundamental challenge was to find a way to bring sufficient focus to a mere excerpt of the collection. We needed to devise an exhibition that would leave our visitors with a sense of quality and joy, rather than too much diversity. A first visit was made to Munich in the spring of 1985 by Cincinnati's director and his colleague Elisabeth Batchelor, head conservator, to explore the proposal with the staff of the Alte Pinakothek and Bavarian government officials. Subsequently, the two American directors met in Munich in May 1986 with a group of our German colleagues, under the chairmanship of the then-Generaldirektor of the state painting collections, Dr. Erich Steingräber, together with Cincinnati's Elisabeth Batchelor and Washington's chief and deputy chief of installation and design, Gill Ravenel and Mark Leithauser. At that meeting were many supportive colleagues, including Dr. Peter Eikemeier of the Alte Pinakothek, Johann Georg Prinz von Hohenzollern, formerly of the Alte Pinakothek and now director of the Bayerisches Nationalmuseum, and Dr. Hubertus Falkner von Sonnenburg,

then director of the Doerner-Institute for Conservation, and since March 1987 Dr. Steingräber's successor as Generaldirektor of the Bayerische Staatsgemäldesammlungen.

The Alte Pinakothek presented a list of pictures that they were prepared to lend. The quality was so splendid, and the coherence of that kind of Old Master collection so telling, that the concept of the exhibition soon evolved to concentrate on Munich's spectacular richness in European baroque painting, from both north and south, set in the wider context of its sixteenth-century antecedents and its eighteenth-century evolution into the rococo.

Over a period of many months, the Gallery's chief curator, Professor Sydney J. Freedberg; its curator of southern baroque painting, Dr. Beverly Louise Brown; of northern baroque painting, Dr. Arthur K. Wheelock, Jr.; Cincinnati's Elisabeth Batchelor; and the undersigned, working closely with Dr. von Sonnenburg and with Dr. Eikemeier, refined the list to the present selection.

We feel enormously privileged to be able to show our visitors paintings of such extraordinary quality. It is a rare treat, and we can think of no better way of introducing an American audience to the glories of collecting in Munich than by this group of pictures. Flemish, Dutch and German, Italian, Spanish and French, they symbolize the kind of exalting experience that can be provided by a visit to a major Old Master collection that has grown continuously since the sixteenth century.

We wish to thank all those in Munich who have facilitated this project, particularly Franz Josef Strauss, minister-president of Bavaria; Prof. Wolfgang Wild, minister of art and science; Ministerialdirigent Franz Kerschensteiner; Dr. Erich Steingräber, former Generaldirektor of the Bayerische Staatsgemäldesammlungen; Dr. Peter Eikemeier, Landeskonservator of the Alte Pinakothek, who has contributed an introductory essay; and, above all, Generaldirektor of the Bayerische Staatsgemäldesammlungen, Dr. Hubertus Falkner von Sonnenburg, who must rank as one of the most forward-looking and collegial museum directors with whom we have ever been privileged to collaborate.

The interest in this project of the embassy of the Federal Republic of Germany has been keen from its inception, beginning under the ambassadorship of H. E. Guenther van Well and with the close interest of Dr. Götz von Boehmer, then consul general of the Federal Republic of Germany in Detroit. We want particularly to thank the present ambassador of the Federal Republic, Dr. Jürgen Ruhfus, and the cultural

counselor, Mrs. Eleanore Linsmayer. We are proud that the foreign office of the Federal Republic of Germany has supported this undertaking financially. Our gratitude goes to the official airline carrier of the exhibition, Lufthansa German Airlines, and to its chairman, Heinz Ruhnau, for their help. We thank, too, the German-American Cultural Fund, Inc., for its part in supporting the exhibition, and John Rehak for his assistance throughout this project. We are very grateful to the U.S. Federal Council on the Arts and the Humanities for granting the exhibition an indemnity, and want to thank in particular our ambassador in Bonn and his wife, the Hon. and Mrs. Richard Burt.

In Washington, in addition to those members of the Gallery staff already mentioned, and especially the two curators who wrote the catalogue, Drs. Brown and Wheelock, we are grateful to D. Dodge Thompson, chief of exhibitions programs, Deborah F. Shepherd, exhibitions officer, and Jane Sweeney and Barbara Anderman, who saw this catalogue through the press. In Cincinnati, we would also like to thank the staff members who participated in planning and implementing the exhibition, particularly Elisabeth Batchelor, head conservator; George E. Snyder, assistant director for operations; Robert W. Helmholz, assistant director for development; Ellie Vuilleumier, registrar; Mary Ellen Goeke, associate registrar; and Gretchen A. Mehring, assistant director for public affairs. To these, and so many others on the staffs of all three cooperating museums, we offer our heartfelt thanks.

"Masterworks" is a word we treat with care. We trust that, in characterizing the pictures in *this* exhibition, we may, for once, be indulged.

J. CARTER BROWN
Director
National Gallery of Art

MILLARD F. ROGERS, JR.
Director
Cincinnati Art Museum

Acknowledgments

The Alte Pinakothek in Munich houses one of the finest collections of Old Master paintings in the world. The sixty-two works presented here range in date from the mid-sixteenth century to the end of the eighteenth century, but the majority were created during the seventeenth century. Thus in a very real way *Masterworks from Munich* is about baroque painting. While the pictures were not chosen to illustrate the history of the period, their vitality and diversity do constitute, at the very highest level of achievement, a sampling of the major schools of baroque painting from the style's origin in Italy through its spread to the Low Countries, Germany, Spain, and France. For those who know the Alte Pinakothek well, it will be instantly clear that they represent the very heart of the collection in Munich. From the grand salons of the museum's second floor, the physical core of the building, come the monumental Venetian, Flemish, and southern Italian masterpieces that line their walls. Small-scale works, including the many Dutch "cabinet pictures," are intimately displayed in adjacent galleries. To be able to borrow such a magnificent selection from the Alte Pinakothek is an extraordinary privilege.

The challenge of writing a catalogue on such famous pictures was at once irresistible and formidable. Fortunately, we were abetted by the fine series of catalogues prepared in recent years by the Alte Pinakothek's curatorial staff. We have made some new suggestions in dating, attribution, and iconography, and have brought the literature on each artist up-to-date. Our primary goal, however, was to elucidate Munich's paintings for our American audience, many of whom will be seeing the works for the first time in Washington and Cincinnati.

We have incurred many debts while preparing this exhibition. The first and foremost is to our colleagues and friends in Munich, Hubertus von Sonnenburg, Peter Eikemeier, and the entire curatorial staff of the Alte Pinakothek. They not only provided Bavarian hospitality, but once we returned to Washington, answered our every query whether large or small. We are extremely grateful for their careful reading of our text and for their helpful suggestions. Other colleagues have kindly offered their expertise on a number of the questions that invariably arose during the course of such an involved project. We would like to thank in particular Margaret Carroll, Keith Christiansen, Colin Eisler,

Jane ten Brink Goldsmith, Thomas DaCosta Kaufmann, Susan Kuretsky, Thea Otto Naumann, Roger Rearick, Scott Schaefer, Cynthia Schneider, Thea Wilberg Vignau-Schuurman, and Seymour Slive. In Washington, we were ably assisted by Sally Ann Metzler, research assistant, and Janice Collins, who helped with the preparation of the manuscript. Not only did we benefit from their cheerfulness and patience, but also from many of their valuable suggestions that were incorporated into the text. Alison Luchs prepared the translation of Dr. Eikemeier's introductory essay. We would also like to thank our chief curator, Sydney J. Freedberg, for his support and advice during this project. Finally, we are grateful to Jane Sweeney and Barbara Anderman for shepherding the catalogue through production. Their suggestions have made the text eminently more readable.

BEVERLY LOUISE BROWN ARTHUR K. WHEELOCK, JR.

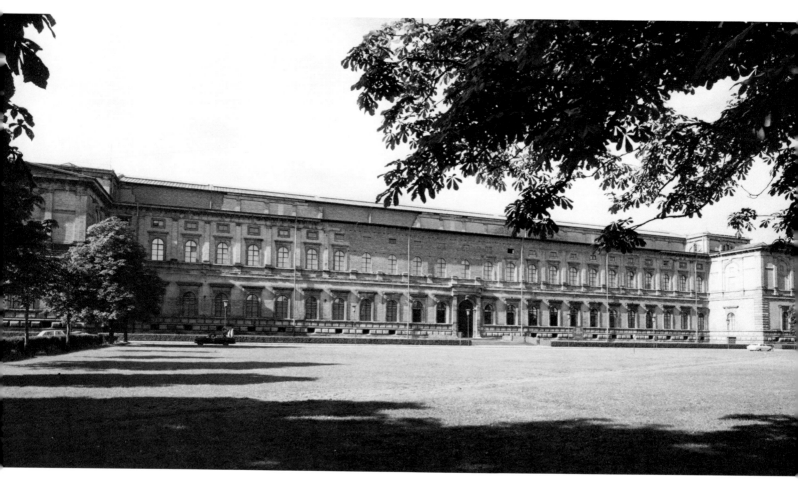

Fig. 1. Alte Pinakothek, view from the north
Photo Bayerische Staatsgemäldesammlungen

On the History of the Collection

PETER EIKEMEIER

In 1826, six months after his accession to the throne, Ludwig I of the house of Wittelsbach, king of Bavaria, had the cornerstone laid for a gallery building. The date chosen for this event, 7 April, was Raphael's supposed birthday. The gallery was to house and to offer public access to the rich collection of paintings assembled by the king's forebears for the past three centuries. The name given to the building (fig. 1) was the ancient Greek word "Pinakothek" (picture collection), the place in a temple where paintings given as votive offerings to the gods were kept. For the king, imbued with the spirit of romanticism, art was a manifestation of the divine, the museum a temple of devotion from which instructive and ennobling effects would come.

Despite this orientation toward high ideals, the practical necessities were not neglected (fig. 2). Leo von Klenze, the court architect, designed a building that was recognized by contemporaries as exemplary in functional as well as aesthetic respects, and widely imitated. But it is not only in the history of museum architecture that the Alte Pinakothek holds a special rank. The modern visitor senses the harmony of its proportions, the unobtrusive dignity of its sequence of spaces, the optimal introduction of daylight.

The building was severely damaged in World War II, but fortunately the paintings in it had been moved to safe storage. After the war, thanks to the energetic demands of art lovers and the people of Munich, the ruins of the structure were restored, rather than demolished and replaced by a new building. In 1957 the project, with an essentially faithful reconstruction of the main gallery on the upper floor, was completed. However, historians would perhaps regret that the decision was made not to attempt to replicate the lavish stucco and fresco decoration (fig. 3).

In the Alte Pinakothek today there are some eight hundred paintings from the principal schools of European painting from the fourteenth through the eighteenth centuries. The art of the nineteenth and twentieth centuries is exhibited in the Neue Pinakothek and Staatsgalerie moderner Kunst (State Gallery of Modern Art). These collections form the core of the Bayerische Staatsgemäldesammlungen (Bavarian State Painting Collection), which at present consists of about twenty thousand works.

An art collection that has developed over centuries is fundamentally different from a collection planned and created in modern times according to a more-or-less uniform historical point of view. In its strengths as well as its gaps it reflects a broad span of the history of the country in which it originated, with that history's high and low points, its intellectual currents, and the personalities who played decisive roles in its course. Fashions, special preferences, and aversions are reflected in it, and times of economic prosperity and periods of austerity leave their mark. Not infrequently, pure chance plays a part.

There are two fields that give the Alte Pinakothek unique world importance. The voluminous holdings of early German panel paintings have resulted from a logical and consistent, almost historically necessary development. And the remarkable collection of Flemish baroque paintings, in which Rubens and his workshop are represented by some

Fig. 2. J. Maass, *Alte Pinakothek, Rubens Gallery in 1891,* oil on canvas, 101 x 125 (39⅜ x 48¾), inv. no. 13420

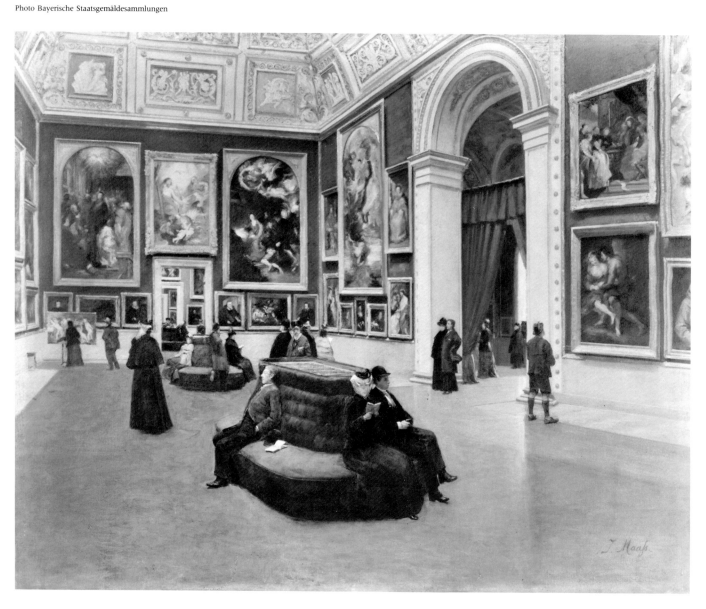

eighty paintings, Van Dyck with about forty, Jan Brueghel the Elder with about fifty, and Adriaen Brouwer with at least nineteen works was a fortuitous result of the dynastic policy of the family that had ruled Bavaria and that had amassed the collections, the Wittelsbachs.

The need for self-representation, an essential driving force of art collecting in general, marks what we recognize today as the beginning of the Munich collection. Duke Wilhelm IV of Bavaria (reigned 1508–1550) and his wife Jacobaea of Baden commissioned several well-known artists from Augsburg, Regensburg, Ingolstadt, and Munich to produce a series of paintings for the Munich Residenz, the principal palace of the Wittelsbachs. The depictions of exemplary deeds of famous women and men of biblical and classical antiquity (Judith, Susanna, Esther, Hannibal, and Julius Caesar, for example) were meant to testify to the virtues professed by the ducal couple. Of this

Fig. 3. Alte Pinakothek, exhibition hall with works by Dürer, Baldung, Cranach, Grünewald

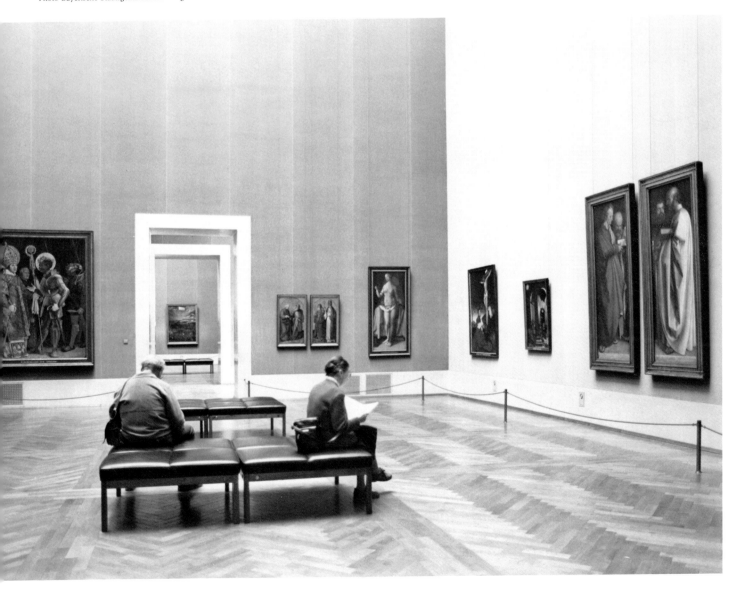

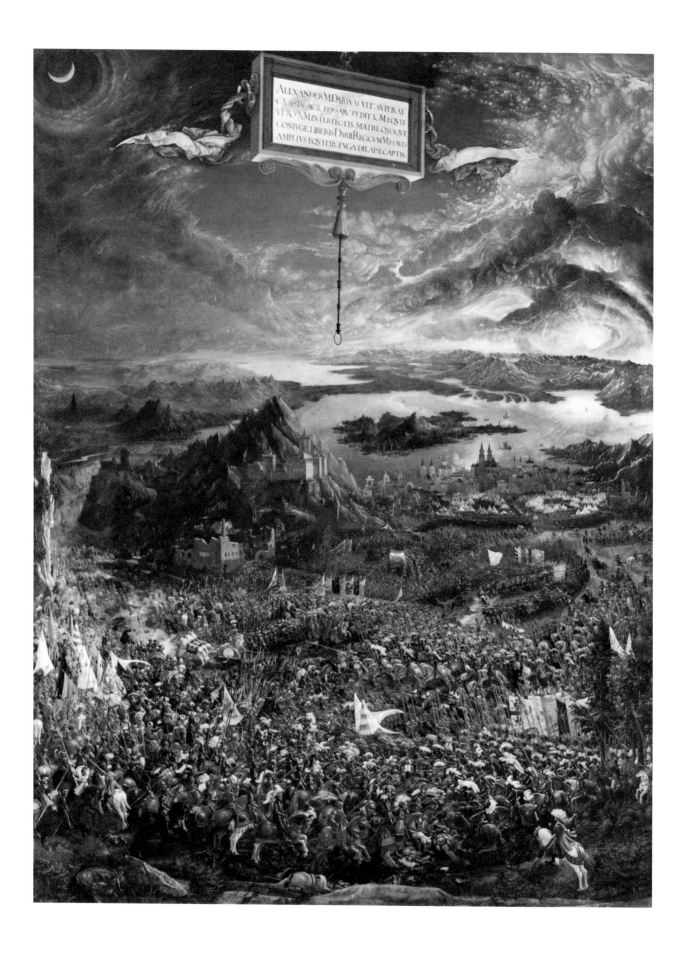

group, the Regensburg painter Albrecht Altdorfer achieved the highest artistic level with his *Battle of Alexander* (fig. 4), a visionary portrayal of the decisive battle in 333 B.C. in which the Greeks under Alexander the Great defeated the Persian army led by King Darius III. This series, of which eleven still belong to the Alte Pinakothek, did not long retain its original decorative function. The next duke of Bavaria, Albrecht V (reigned 1550–1579), had them installed in his *Kunstkammer* (chamber of art), a suite of rooms whose furnishings conformed to a widespread fashion in princely courts of his time. The determining factor for inclusion in a *Kunstkammer* was not artistic quality, but rather documentary character. Portraits, paintings of events, depictions of exotic human types and animals, rarities, curiosities, natural specimens, and precious objects testified to the variety of creation in the sense of a humanistic encyclopedia. In Duke Albrecht's *Kunstkammer*, as the first surviving inventory of 1598 testifies, Duke Wilhelm's pictures joined more than seven hundred other paintings, a most imposing number for the time, which had been brought together from various castles. Because of insufficient description in the inventory, only a few paintings from the *Kunstkammer*, aside from the cycle just mentioned, can be identified in the present collection.

The first real painting enthusiast and passionate collector among the Wittelsbachs was Maximilian I, who ruled for more than half a century, from 1597 to 1651. He was in many respects a remarkable man. As one of the heads and leading general of the Catholic League, he received in 1623 the title of elector for his energetic support of imperial policy during the Thirty Years' War. His artistic taste inclined toward the work of Albrecht Dürer. He sent agents in pursuit of pictures by the Nuremberg master, and spared no effort to acquire them. He had a no less passionate and determined rival in Rudolf II, the emperor, residing in Prague, whom he nevertheless repeatedly was able to best. He had particular success in obtaining paintings that were still in Nuremberg. For this purpose he did not hesitate to use political pressure, so that in 1613 the magistrate made him a "present" of the *Paumgartner Altar*, and in 1627 even gave up the *Four Apostles* (fig. 5), which Dürer himself had donated to the council of his native city a hundred years earlier "in eternal memory." German, and especially Netherlandish contemporaries of Dürer, from Quentin Massys, Lucas van Leyden, and Swart van Groningen to Jan Sanders van Hemessen and Marinus van Reymerswaele, found admission to the *Kammergalerie*, which Maximilian set up to house works of art in the Munich Residenz. It is noteworthy that many of these paintings, doubtless at the collector's wish, were "corrected" by court painters of the time, sometimes even changed in size with new elements introduced in Dürer's style, which these court painters learned to imitate perfectly. But Maximilian's artistic interests were not exclusively retrospective. He also acquired paintings by contemporary artists, which were in most cases not placed in the gallery, but rather used as decorative

Fig. 4. Albrecht Altdorfer, *The Battle of Alexander*, oil on panel, 158 x 120 (61⅛ x 46¼), inv. no. 688
Photo Bayerische Staatsgemäldesammlungen

17

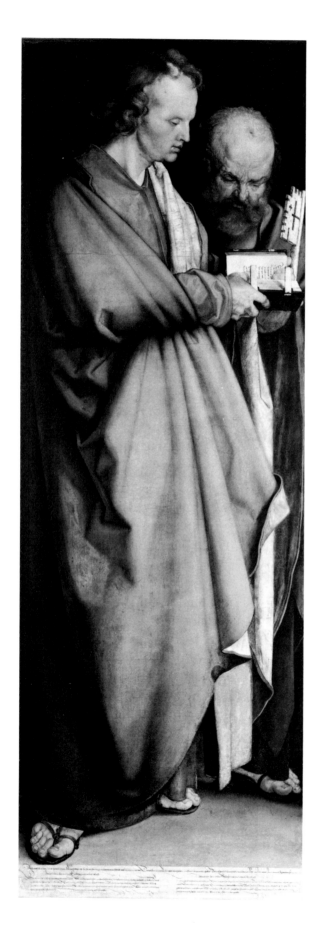
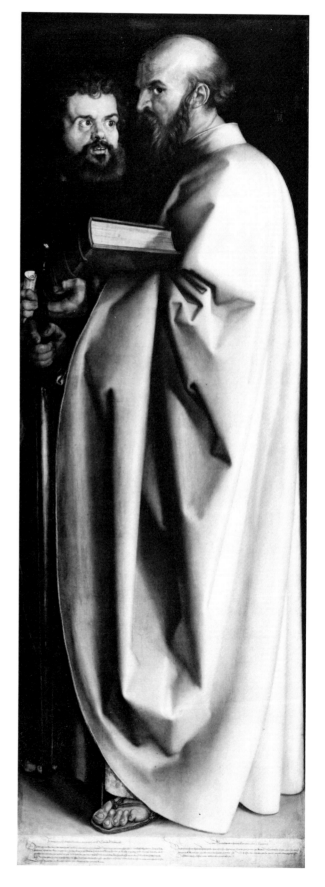

furnishings. Thus four hunting scenes in large format, commissioned in 1616 from Rubens and executed largely by his own hand, hung in state rooms of the ducal summer residence, the old Schleissheim Castle.

Doubtless Maximilian profited as an art collector from the political importance that he managed to give his small country in the military conflicts between the great European powers. On the other hand, the disadvantages that resulted from his support of the imperial side were of no little consequence. In 1632 Munich was occupied by Swedish troups. The city escaped sacking by paying a high forced tribute, but the conquerors did not protect the property of the electoral family, who had fled. In particular, the contents of the court library, the *Kunstkammer* and the gallery (whose most important pieces had been moved to a secure place) fell victim. King Gustavus Adolphus of Sweden obtained a number of paintings and other art objects for the royal collections at Stockholm, where they have remained ever since.

Maximilian inaugurated the effort to increase the importance of the Bavarian elector in the balance of European power by means of a court whose splendor went beyond purely regional norms. This policy, in which the promotion of the arts took greater pride of place than in other German princely courts, was continued by his successors. Under his son, Elector Ferdinand Maria (reigned 1651–1679), who married an energetic and high-spirited princess from the House of Savoy, the paintings collection at first took a minor place because the country and the city needed to heal themselves from the wounds of the Thirty Years' War. Only after a period of recovery could the resplendent scenario of the baroque in architecture and decorative arts, music, and theater develop, with the help of Italian and French artists and craftsmen. The cultural foundation was systematically laid for the realization of ambitious dynastic goals that were to lead the Wittelsbachs, by means of tactical alliance and marriage policy, into the highest ranks of European power relations, culminating in the person of Elector Maximilian II Emanuel, known as Max Emanuel (reigned 1679–1726, fig. 6). In the conflict between the Hapsburgs and the Bourbons for dominance in Europe, he first chose the Austrian side. He was an imperial general and won fame in the war against the Turks. In 1685 he married a daughter of the emperor, who had hereditary claims to the Spanish throne for herself and her descendants. But this and others of Max Emanuel's highflown plans, such as the project for a new palace in front of the gates of Munich that would rival the courts of Vienna and Paris, were less successfully realized than he hoped. The structure was built in a fragmentary and comparatively modest form as the new Schleissheim Palace (Schloss Schleissheim).

Max Emanuel was nevertheless successful as a collector of paintings. It remains uncertain whether this activity—pursued, like all his undertakings, with great energy—was only a fashionable foil for his political ambitions or an expression of a genuine passion. Due to inadequate

Fig. 5. Albrecht Dürer, *The Four Apostles*, oil on panel, each 215 x 76 (83⅞ x 29⅝), inv. nos. 540, 545
Photo Bayerische Staatsgemäldesammlungen

19

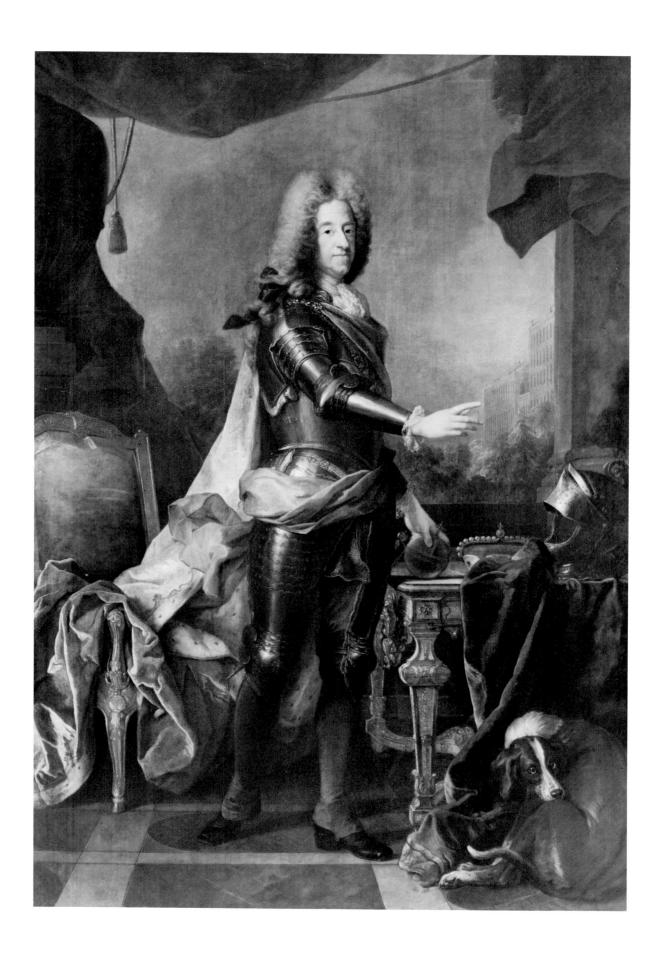

documentation we must guess about his acquisitions. Yet it can be reasonably established that during his time the paintings collection quadrupled in size, to some 3,000 works. The great majority of these pictures were probably acquired between 1692 and 1701, when Max Emanuel assumed the office of *Statthalter* (governor) of the Spanish Netherlands and lived in Brussels. Decisively he seized the opportunities presented by the rich art market, with an ambition doubtless stirred by the sensational collecting activities of his predecessor in the office, the Hapsburg Archduke Leopold Wilhelm (see cat. 30). Without concern he frequently overstepped his financial limits. A contemporary report that he spent 200,000 francs on paintings in Brussels in half an hour may be exaggerated. Yet as late as 1763 a debt of 30,000 Brabantine guilders remained outstanding from a 1698 painting transaction, and was pursued by the heirs of the seller against Max Emanuel's grandson. This fact sheds significant light on the elector's acquisition practices and financial ethics. We are well informed about this spectacular deal by the demand note and an appended list of pictures: it concerned a batch of 101 paintings that Max Emanuel had acquired from the Antwerp merchant Gisbert van Ceulen for 90,000 guilders. The majority were of high quality, and 20 of them are on permanent exhibition today in the Alte Pinakothek, including four portraits of Hélèna Fourment, Peter Paul Rubens' second wife, which presumably came from the Fourment family, to whom Van Ceulen was distantly related. Along with other paintings by Rubens and his workshop, this acquisition included eight autograph portraits by Anthony Van Dyck and as many small panels by Adriaen Brouwer (cats. 14, 15), as well as the *Boys Playing Dice* by Bartolomé Murillo (cat. 51).

Since Max Emanuel's immediate successor could spend no comparable sums to acquire pictures on account of the ruinous state of his finances, we may assume that the great majority of the paintings listed in the inventories drawn up in the mid-eighteenth century were acquired by Max Emanuel, except for the ones from the older collection. Outstanding among these are the *Crowning with Thorns* and the *Portrait of Emperor Charles V* by Titian, the Gonzaga cycle by Jacopo Tintoretto, the *Boys Eating a Melon and Grapes* by Murillo (cat. 50), three paintings by Nicolas Poussin, including *The Lamentation over the Dead Christ* (cat. 59), Rubens' sketches for the Medici cycle (cats. 25, 26), his *Meleager and Atalanta* (cat. 27), and his *Massacre of the Innocents*, which hung along with Van Dyck's *Rest on the Flight into Egypt* in Max Emanuel's bedroom at Schleissheim. This palace, along with the Munich Residenz, contained the most important part of the paintings collection. Schleissheim's central Grande Galerie, on the upper floor between the apartments of the elector and electress, is one of the first formal gallery spaces in Germany designed exclusively for paintings (fig. 7). The large-scale masterpieces were installed there, while smaller pictures, primarily by Netherlandish artists, were hung densely side by side and one above the other, covering the walls of a small room located

Fig. 6. Joseph Vivien, *Portrait of Elector Max Emanuel of Bavaria*, oil on canvas, 236 x 176 (92 x 68⅝), inv. no. 54
Photo Bayerische Staatsgemäldesammlungen

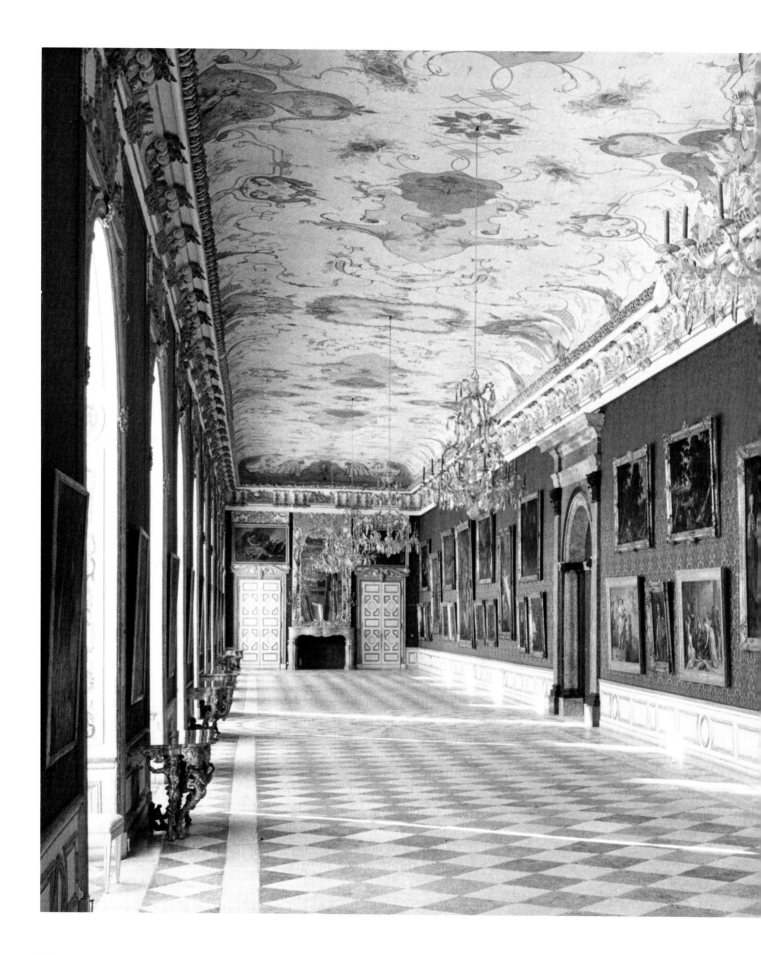

Fig. 7. Schleissheim Palace, Grande Galerie
Photo Bayerische Staatsgemäldesammlungen

nearby. Max Emanuel's clear preference for Flemish painting may have been encouraged by his stay in Brussels, but it is primarily an expression of the dominant taste of the time, as it also appears in the Düsseldorfer Galerie, which became part of the Munich collections long after the death of Max Emanuel.

The Bavarian line of the Wittelsbachs ended with Max Emanuel's grandson, Elector Maximilian III Joseph, who died without an heir in 1777. The Palatine branch of the house took over the succession, so that the electorates of the Palatinate and Bavaria were united, with Munich as the court city. The results of this forward-looking family policy had far-reaching consequences for the art holdings, for it laid the foundation for the integration, around the turn of the century, of the Palatine galleries of Mannheim, Zweibrücken, and Düsseldorf into the Munich collection. Only a few years after his ascent to the throne, Elector Karl Theodor (ruled 1777–1799), guided by educational ideals of his time that called for the spread of knowledge and art, had an exhibition building erected in the palace garden to allow public access to the painting collection. This freed the collection from its exclusivity in the castles. But with the addition of the Palatine collection, the Hofgartengalerie proved, soon after its creation, to be a cramped, temporary solution.

The most important enrichment of the Munich collection from these Palatine galleries was the collection in Düsseldorf, the gallery of Elector Johann Wilhelm of the Palatinate (reigned 1690–1716). The choice quality of its roughly 350 paintings placed it at the highest level. In the eighteenth century it was a favorite attraction for the numerous travelers on educational journeys who visited the Rhineland, and in contemporary literature it was ranked beside the collections in Dresden and Vienna. Goethe, who visited the Düsseldorfer Galerie in 1774 and 1792, recalled that there he had received "the profit of a lifetime" (*Dichtung und Wahrheit*, book III). Elector Johann Wilhelm appears to have been a more circumspect and purposeful collector than his Bavarian cousin Max Emanuel, who in this undertaking had behaved with a certain irrationality and extravagance. In addition, Johann Wilhelm evidently had an excellent adviser in his Dutch court painter, Jan Frans van Douven. The first painting he acquired was reportedly the *Battle of the Amazons* by Rubens. The cunning Van Douven had the painting secretly installed in the study of his prince, who at first had been quite uninterested. The story is told that in time the picture stirred him to such enthusiasm that he charged his court painter to be on the lookout for more works by this master. Whether true or invented, the anecdote does offer an appealing explanation for the particular richness of the Rubenses owned by the Düsseldorfer Galerie. Indeed, the collector's preference for the great Flemish master is fully comparable to Elector Maximilian's passion for Dürer. No fewer than 23 of the Rubenses acquired by Johann Wilhelm now belong to the permanently exhibited collection of the Alte Pinakothek, including

Fig. 8. Adriaen van der Werff, *Portrait of Elector Johann Wilhelm of the Palatinate*, oil on canvas, 76 x 54 (29⅝ x 21), inv. no. 210
Photo Bayerische Staatsgemäldesammlungen

25

masterpieces like the *Self-Portrait with His Wife Isabella Brant under the Honeysuckle Arbor* (fig. 9), the *Drunken Silenus*, *The Rape of the Daughters of Leucippus* (cat. 23), *The Fall of the Damned*, and the small and large *Last Judgments*. The other Flemish masters of the seventeenth century were also represented by important works, including in particular the Van Dyck self-portrait (cat. 20) and *The Lamentation of Christ* (cat. 19), as well as Jacob Jordaens' *The Satyr and the Peasant* (cat. 21).

At the time when the Düsseldorfer Galerie originated, the interest of European collectors in Dutch bourgeois painting, which arose later in the eighteenth century, had not yet awakened. Nevertheless certain important works were acquired, including the five-part passion cycle by Rembrandt, the intimate genre painting of *A Boy and His Dog* by Gerard Terborch (cat. 42), and the theatrical *Lovesick Woman* by Jan Steen (cat. 41), to say nothing of the artists who worked in fine detail, such as Gerard Dou and Frans van Mieris the Elder, whose followers Eglon van der Neer, Van der Werff, and Ruysch enjoyed high respect as court painters in Düsseldorf. Johann Wilhelm's second marriage was to the daughter of Grand Duke Cosimo III Of Tuscany. This close connection with the Florentine court favored the acquisition of Italian paintings, which frequently came to the gallery in exchanges or as gifts from Johann Wilhelm's father-in-law, who was himself a zealous collector. The most significant work, Raphael's *Canigiani Holy Family*, was evidently a wedding present.

The collection, which was installed in a specially constructed building on the grounds of the Düsseldorf castle, was not expanded after the death of Elector Johann Wilhelm in 1716 because his successor transfered the court to Mannheim. The publication of the first printed catalogue in 1719 indicates that it was accessible to a broad public at that time. While the Düsseldorfer Galerie remained largely untouched in the subsequent period (although its contents often had to be moved to security against Prussian and French troops until it came to Munich in 1806), the collection of small-format pictures, which had been installed in several small rooms in the Düsseldorf castle, was moved to Mannheim in 1731. There it formed the foundation of a new collection that finally overtook the Düsseldorfer Galerie in numbers, but was far inferior to it in artistic value. According to the new taste of the time, the main emphasis in the Mannheimer Galerie was on Dutch masters of the seventeenth century, who appear in their full scope, with landscapes, genre scenes, still lifes, and portraits. Amid this profusion Rembrandt's *Holy Family* (cat. 38) and his *Sacrifice of Isaac* stand out.

The Mannheim collection presumably came to Munich in 1795; the approximately two thousand pictures of the Zweibrücker Galerie followed in 1799. These had been amassed in barely fifteen years by a frenzied collector, Duke Karl II Augustus of Zweibrücken. He too had been able to rely on a distinguished adviser, the court painter Johann Christian von Mannlich, who cared for the collection, saved it from

Fig. 9. Peter Paul Rubens, *Self-portrait with His Wife Isabella Brant under the Honeysuckle Arbor*, oil on canvas on panel, 178 x 136 (69⅜ x 53), inv. no. 334
Photo Bayerische Staatsgemäldesammlungen

the clutches of the plundering French revolutionary army, and successfully used delaying tactics to thwart its planned sale in 1796. Finally entrusted with direction of the Kurpfalz-Bayerische Zentral-Gemälde-Galerie (Central Picture Gallery of the Electorates of the Palatine and Bavaria) in Munich, von Mannlich planned the security and organization of the mighty treasury of paintings, the effects of which continue today. The contents of the Zweibrücker Galerie too were dominated by the Dutch masters, but there was also, on account of geographic proximity to France and the pronounced orientation of the court toward Paris, an impressive number of French paintings, including two pendant landscapes by Claude Lorrain and François Boucher's *The Blonde Odalisque* (cat. 55).

Maximilian IV Joseph (1756–1825), the younger brother of Karl Augustus, was the fortunate heir, first in 1795 of the duchy of Zweibrücken, and four years later of the electorates of the Palatinate and Bavaria. At that time Napoleon was causing unrest among the powers of Europe. His shadow as well as his light fell on Bavaria and left pronounced marks, even in the field of art. When Munich was occupied by French troops in 1800, an agent of the Paris government requisitioned seventy-two paintings for the "Musée Napoleon" and other French museums. Of these, twenty-seven were returned in 1815 after the fall of Napoleon. Among them were the Altdorfer *Battle of Alexander*, Titian's *Crowning with Thorns*, and Rubens' *Meleager and Atalanta*. Enmity with Napoleon did not last, however. The Palatine-Bavarian elector was soon his most loyal ally, and in consequence received a king's crown in 1806. The Secularization of 1803 also was a direct result of French policy. Ecclesiastical principalities were removed, free imperial cities were placed under the control of the elector, and convents and church possessions were nationalized to provide indemnities for the territories on the left bank of the Rhine that had been annexed by France. This action meant a great increase for the art collections: some fifteen hundred paintings entered state possession from convents, monasteries, and castles in Bavaria, Franconia, Swabia, and the Tirol. These included numerous early German panel paintings, often in the form of complete polyptychs that had decorated churches. These provide a unique, sumptuous, and detailed panorama of German painting of the fifteenth and sixteenth centuries and form a prologue to the art of the time of Dürer, richly represented in the collection since Elector Maximilian I but little noted up to this time. Outstanding among these are the *Church Fathers* by Michael Pacher, as well as the panel with Saints Erasmus and Mauritius and the *Mocking of Christ* by Matthias Grünewald.

Only a few years after it received this extraordinary enrichment, the collection enjoyed a few more shining hours through the work of King Ludwig I (fig. 10, reigned 1825–1848), the builder and virtual creator of the Alte Pinakothek. As a young prince he had received profound impressions in Italy, not least his experience of the antique, that left

Fig. 10. Joseph Stieler, *Portrait of King Ludwig I of Bavaria*, detail, oil on canvas, 72 x 60 (28 x 23⅜)

him with a lifelong receptiveness to art. These united with the ideals proclaimed by romantic poets and philosophers of a renewal of religious, artistic, and nationalistic values based on the spirit of the Christian Middle Ages, which, in opposition to the pro-French policies of Max Joseph, also contained a marked anti-Napoleonic aspect. His numerous acquisitions of paintings, for the most part financed from his private means, reflect clearly these fundamental components of his artistic and world views, in that they consist almost without exception of Italian and German/Netherlandish schools of the fourteenth through sixteenth centuries. A marked didactic motivation appears in the king's collecting practices. He sought to demonstrate the development of art through selected examples, especially in the Italian field, to show the way from Giotto to Raphael as the absolute pinnacle of painting. Thus he opened up a new aspect of the collection, with masterpieces by Fra Angelico, Fra Filippo Lippi, Domenico Ghirlandaio, Botticelli, and others; even Pietro Perugino, the teacher of the "divine" Raphael, could not be omitted, and the latter himself was represented by the *Madonna della Tenda* and the *Tempi Madonna* (fig. 11), with whose austere beauty Ludwig had fallen in love as a crown prince in Florence. He finally brought the *Tempi Madonna* to Munich in 1829 after twenty years of pursuit. We encounter his classical taste also in the severely composed *Christ in the House of Mary and Martha* by Eustache Le Sueur (cat. 58). A highly significant completion of the already rich holdings in south German late medieval painting came in 1827 with the purchase of about 220 pictures, primarily by early masters from Cologne and the Netherlands, from the collection of the Boisserée brothers. Many of these came from the secularization of Cologne churches and had been assembled by the collectors with the express purpose of preserving a valuable national heritage—initially in opposition to the taste of the time. King Ludwig also realized that he could not count on general assent when he paid the high sum of 240,000 guilders (from his privy purse!) for these old paintings. When the contract for purchase was signed, he expressed the wish that the price not be mentioned in the newspapers, since "if you lose money at gambling or spend it on horses, people think that's all right, that's the way it goes; but if you spend it for art, they talk of waste!"

Along with masterpieces of the Cologne school, there are above all the *Columba Altarpiece* by Rogier van der Weyden (fig. 12) as well as panels by Dieric Bouts, Hans Memling, Gerard David, but also Dürer, Lucas Cranach, and Altdorfer that gave the Boisserée Collection its unique stature. The three last-named artists were also represented by important works in another equally large private collection of early German paintings that Ludwig acquired a year later, in 1828, from the holdings of the prince of Oettingen-Wallerstein. Here also the collector had recognized the duty and the opportunity to save national treasures from dispersion or even destruction.

With Ludwig I, who also patronized the art of his own time, the

Fig. 11. Raphael, *Tempi Madonna*, oil on panel, 75 x 51 (29¼ x 19⅞), inv. no. WAF 796
Photo Bayerische Staatsgemäldesammlungen

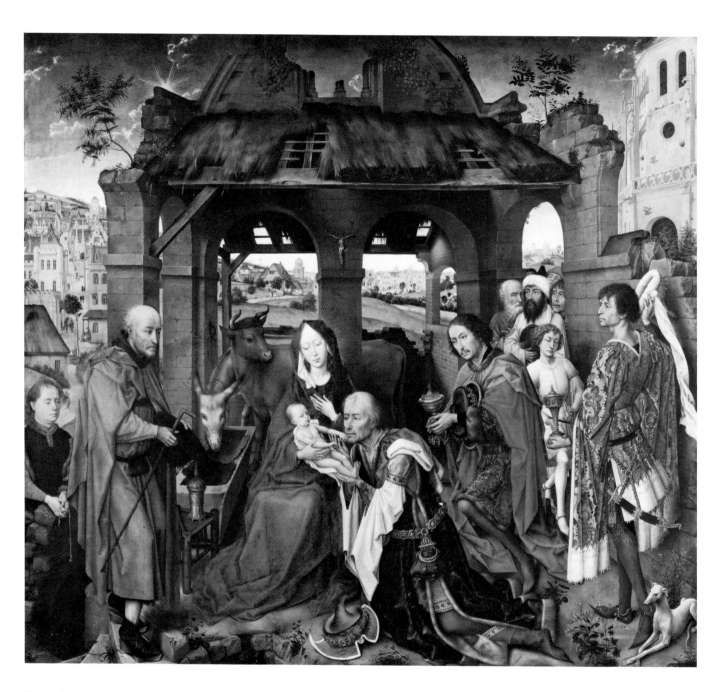

Fig. 12. Rogier van der Weyden, *Columba Altarpiece*, central panel, oil on panel, 138 x 153 (53⅞ x 59⅝), inv. no. WAF 1189

formative phases of the Munich collection of early painting come to an end. The collection had taken its unmistakable shape, to which subsequent generations could only give occasional new accents and corrections. Important works by artists like El Greco (acquired 1909, cat. 49), Frans Hals (1906, 1969), Francisco Goya (1909, 1925), and Francesco Guardi (1909, cat. 8), whose stature was only recognized in modern times, could be included. Other significant additions—Madonnas by Leonardo (1889) and Antonello da Messina (1897), the *Land of Cockaigne* by Pieter Bruegel the Elder (1917), Tintoretto's *Mars and Venus Surprised by Vulcan* (1925, cat. 11)—came through fortunate opportunities. Finally, in recent years, long-term loans from the Bayerische Hypotheken- und Wechsel-Bank have enriched the collection with masterpieces of the eighteenth century, including choice paintings by Boucher and Fragonard (cat. 57) as well as a major series of views of Venice by Guardi (cat. 9). By a conscious decision there will be no systematic attempt to round off the collection, to blur its edges and soften its contours. Having grown over four hundred years, the collection of the Alte Pinakothek represents a historic monument of the first rank that must be handled with the greatest care.

TRANSLATED BY ALISON LUCHS

A Brief Chronology

1528–1540 Duke Wilhelm IV of Bavaria (1493–1550) and his wife Jacobaea of Baden (1507–1580) have a series of history paintings executed for the Munich Residenz.

1563–1567 Duke Albrecht V (1528–1579) establishes a *Kunstkammer* (chamber of art) built by Wilhelm Egkl (presently used as the mint). The collection includes not only various art objects, but also curios and a "theatrum mundi" based on principles of "Inscriptiones vel tituli theatri amplissimi . . . ," written by the doctor and historiographer Samuel Quickelberg.

1569–1571 The "Antiquarium," designed by Jacopo Strada and Wilhelm Egkl, is erected and will house the ducal collection of antiquities in the Munich Residenz.

1597–1651 Under the regency of Elector Maximilian I (1573–1651), numerous acquisitions of the finest quality are made.

1598 Johannes Fickler, lawyer and collector, councillor to the Bavarian court, compiles the earliest known inventory of the ducal *Kunstkammer*, comprising 3,407 items including 778 paintings.

1611–1617 A court gallery, the *Kammergalerie*, is established in the Munich Residenz.

1679–1726 Rule of Elector Maximilian II Emanuel, known as Max Emanuel (1662–1726). The collection achieves a rank among the finest in Europe.

1698 Max Emanuel purchases 101 paintings, including Rubenses, Van Dycks, and Brouwers from Gisbert van Ceulen in Antwerp for 90,000 Brabantine guilders.

1701–1726 The residential palace at Schleissheim is built by Enrico Zuccalli and Josef Effner. The "Grande Galerie" and other rooms house major parts of the electoral collection.

1729 Fire in the Munich Residenz destroys Dürer's *Coronation of the Virgin Mary* and a Madonna by Raphael.

1733 Under Elector Karl Albrecht (1697–1745), the "Grüne Galerie" in the Munich Residenz is constructed by François Cuvilliés.

1777–1799 On the extinction of the Bavarian line of the House of Wittelsbach, Elector Karl Theodor of the Palatinate (1724–1799) inherits the Bavarian and Palatine estates, creating the legal basis for the merger of the Mannheimer Galerie and Düsseldorfer Galerie.

1780–1781 Architect Carl Albert von Lespilliez builds the Munich Hofgartengalerie, which is open to the public and will house a major part of the future Alte

Pinakothek collection. Johann Edler von Weizenfeld and painter Johann Jacob Dorner will be the first two directors.

1799–1825 Elector Maximilian IV Joseph (1756–1825) of the Palatinate-Zweibrücken line (in 1806 becomes King Maximilian I) accedes to power in Bavaria after the extinction of the Palatinate line of the House of Wittelsbach.

1799 The Zweibrücker collection, consisting largely of Dutch and French paintings acquired primarily by Duke Karl II August (ruled 1775–1795), is assimilated into the Munich collection. Prior to this, the Mannheimer Galerie, creation of Elector Karl Philipp of the Palatinate-Neuburg (ruled 1716–1742), was transferred to Munich. This collection contained predominately Dutch paintings. A central administration is formed under the direction of Johann Christian von Mannlich who, as gallery director, arranged the Hofgartengalerie paintings not according to school or epoch, but by quality.

1800 Numerous important paintings are requisitioned by the Napoleonic General Lecourbe and the French government commissioner Neveu and removed to Paris. In 1815, twenty-seven of these pictures were returned to the Bavarian collection and forty-five remained in France.

1803 During the period of secularization, there was confiscation of church property in Bavaria and Tirol, as well as the property of the Free Imperial Cities, the Franconian margravates, and ecclesiastical foundations (c. 1,500 paintings). Extensive purchases, with an enormous increase in the number of panel paintings by early German masters in particular. Associated galleries built in Augsburg, Ansbach, Bamberg, Würzburg, Nuremberg, and Aschaffenburg.

1805–1810 Publication of the 3-volume *Beschreibung der Churpfalzbaierischen Gemäldesammlungen zu München und Schleissheim* (Description of the Electoral Collection of Paintings of the Palatinate and Bavaria in Munich and Schleissheim) by von Mannlich.

1806 The collection of the Düsseldorfer Galerie, inherited by Karl Theodor in 1777, is brought to Munich, although reduced in size by the vicissitudes of war. The acquisitions of Elector Johann Wilhelm of the Palatinate (ruled 1690–1716), including some 350 paintings, formed one of the finest and most important collections in Europe.

1825–1848 Reign of King Ludwig I. As crown prince he was already a passionate collector. Johann Georg Dillis (1759–1841) will be the king's trusted advisor and gallery director.

1826 Laying of the foundation stone of the Pinakothek building designed by neoclassical architect Leo von Klenze (1784–1864), who also designed the Munich Glyptothek.

1827 King Ludwig I acquires, for 240,000 guilders from his private purse, the Bois-
 serée Collection, concentrated in Netherlandish and early German panel
 paintings. The collection's importance was due to the efforts of Sulpiz and
 Melchoir Boisserée of Cologne and colleague Johann Baptist Bertram, who
 capitalized on the low popularity of religious art during the period of seculari-
 zation.

1828 Gallery director Dillis recommends purchase of Prince Oettingen-Wallerstein's
 collection. The king acquires the 219 works for 80,000 guilders from his pri-
 vate funds.

1836 Opening of the Pinakothek, one of the earliest monumental structures built
 solely to exhibit art.

1838 First catalogue of the collection written by Dillis: *Verzeichnis der Gemälde in der
 kgl. Pinakothek zu München* (List of Paintings in the Royal Pinakothek in
 Munich).

1853 Opening of the Neue Pinakothek across the street; Pinakothek now desig-
 nated Alte Pinakothek.

1939 Outbreak of war; galleries are closed and collection is removed for safe stor-
 age.

1943–1945 Air raids cause significant damage to the Alte Pinakothek building. Nine of
 the twenty-five exhibition areas are destroyed, including the frescoes designed
 by Peter von Cornelius in the first-floor loggia.

1946–1957 Temporary exhibition of important paintings from the Alte Pinakothek in the
 Haus der Kunst.

1957 Alte Pinakothek reopens after major reconstruction supervised by Hans Döll-
 gast.

1966 Beginning of a cooperation between the Bayerische Staatsgemäldesammlun-
 gen and the Bayerische Hypotheken- und Wechsel-Bank including their gen-
 erous loan of important eighteenth-century paintings exhibited in the Alte Pi-
 nakothek (Guardi, Fragonard).

1986 Festschrift *Ihm, Welcher der Andacht Tempel Baut, Ludwig I. und die Alte Pinako-
 thek* celebrates the 150th anniversary of the Alte Pinakothek.

A Note to the Reader

Dimensions are given in centimeters followed by inches in parentheses.

The short citations within the text refer to the literature section at the end of each entry. We have not tried to compile an exhaustive bibliography, but rather to provide the most recent scholarship on each painting and artist. For a more comprehensive list of the earlier literature, the reader should consult the relevant Alte Pinakothek catalogues, which are cited in the text with the following abbreviations.

Kat.AP. *Alte Pinakothek Munich: Explanatory Notes on the Works Exhibited*, Munich, 1986. German ed., *Alte Pinakothek München; Erläuterung zu den ausgestellten Gemälden*, Munich, 1983

Kat.AP.I Kurt Löcher and Ernst Brochhagen, *Alte Pinakothek München; Katalog I, Deutsche und Niederländische Malerei zwischen Renaissance und Barock*, 3d ed., Munich, 1973

Kat.AP.II Christian A. zu Salm and Gisela Goldberg, *Alte Pinakothek München; Katalog II, Altdeutsche Malerei*, Munich, 1963

Kat.AP.III Ernst Brochhagen and Brigitte Knüttel, *Alte Pinakothek München; Katalog III, Holländische Malerei des 17. Jahrhunderts*, Munich, 1967

Kat.AP.IV Johann Georg Hohenzollern and Halldor Soehner, *Alte Pinakothek München; Katalog IV, Französische und Spanische Malerei*, Munich, 1972

Kat.AP.V Rolf Kultzen, *Alte Pinakothek München; Katalog V, Italienische Malerei*, Munich, 1975

GK.I Halldor Soehner, *Bayerische Staatsgemäldesammlungen, Alte Pinakothek München; Gemäldekataloge, Spanische Meister*, vol. 1, Munich, 1963

GK.IX Rolf Kultzen and Peter Eikemeier, *Bayerische Staatsgemäldesammlungen, Alte Pinakothek München; Gemäldekatalog, Venezianische Gemälde des 15. und 16. Jahrhunderts*, vol. 9, Munich, 1971

GK.XIV Gisela Goldberg and Gisela Scheffler, *Bayerische Staatsgemäldesammlungen, Alte Pinakothek München; Gemäldekatalog, Altdeutsche Gemälde, Köln und Nordwestdeutschland*, vol. 14, Munich, 1972

The provenance section at the end of each entry gives the date on which a painting entered or is first recorded in one of the collections of the Bayerische Staatsgemäldesammlungen (Bavarian State Picture Collection). The earlier history of each picture may be found in the Alte Pinakothek catalogues listed above.

Italian Paintings

Jacopo dal Ponte, called Bassano

Bassano c. 1515–1592 Bassano

1 *Madonna and Child with Saint Martin of Tours and Saint Antony Abbot*

early 1540s
oil on canvas
190.5 x 120.5 (75 x 47⅜)
inv. no. 917

This monumental and impressive altarpiece by Jacopo Bassano came to the Bavarian state collections after a piece of skulduggery. In 1674 Giovanni Battista Volpato, a little-known artist and critic, removed Bassano's painting from the high altar of San Martino, a church in the small provincial town of Rasai near Feltre. Volpato was supposed to restore the painting, but instead he replaced it with his own copy. Then, in 1682, he used the original altarpiece plus another painting by Bassano (*Madonna and Child with Saint James and Saint John the Baptist*, c. 1545, Alte Pinakothek, Munich) from the parish church of Tomo as collateral for a loan from a bank called Monte di Pietà in the city of Bassano. On 6 February 1686 Canon Alvise Zeno, a member of the bishop's curia in Feltre, accused Volpato of substituting copies for the two altarpieces. Volpato was duly condemned and, in April 1687, banned from Feltre, Belluno, and all their territories for a period of ten years. The two paintings left with the Monte di Pietà were acquired in 1695 by a certain Salviani, from whom they were later stolen. By 1719 they both appear in the inventory of the Düsseldorfer Galerie (GK.IX, 26; Pallucchini 1982, no. 12).

At the time that Volpato made his copy of the *Madonna and Child with Saint Martin of Tours and Saint Antony Abbot*, he was writing a treatise called *La verità pittoresca*. This manuscript contains what is perhaps the earliest critical appreciation of Jacopo Bassano's so-called "mannerist" phase—that period of his career during the early 1540s when he painted the Rasai altarpiece. The treatise takes the form of a dialogue in which one of the protagonists recommends the copying of Bassano's work in order to understand better its artifice. Volpato may have written this as a justification of his underhanded dealings. Alternatively, once his copy was made, Volpato may simply have reasoned that the local populace would never notice a substitution and subsequently switched the paintings for his own financial gain.

No matter what reason Volpato had for promoting Bassano's work, the critical acclaim he brought it was short-lived. By the beginning of the eighteenth century, Bassano was no longer ranked beside Titian, Tintoretto, and Veronese as one of the greatest masters of the Venetian school. He was viewed as an interesting but provincial painter. Ironically, Jacopo's seemingly isolated career in his hometown of Bassano was in reality a self-imposed exile. After a brief period in Venice around 1535, he chose to return home and set up shop. From this vantage point he

Cat. 1

evolved an eclectic, but nevertheless discriminating response to developments in Venice, Emilia, central Italy, and even northern Europe. For his main source of inspiration he relied on his well-stocked portfolio of prints. In the relative tranquility of his studio, he could dissect, analyze, and incorporate into his own pictorial language a variety of motifs and stylistic traits culled from the work of other artists. Furthermore, his patronage was primarily provincial, if not indeed rural. Jacopo seems to have been most at ease when catering to the conservative tastes of local parishioners.

Bassano's tendency to repeat traditional formulas is evident in *Madonna and Child with Saint Martin of Tours and Saint Antony Abbot*. On what has been described as the pinnacle of a human pyramid (Longhi 1948, 46), the Virgin and Child are perched on a lofty and unreachable throne. This type of elevated Madonna ultimately derives from the work of earlier Ferrarese artists such as Francia or Costa and, closer to home, from the work of Pordenone. Bassano, however, has injected into this decidedly old-fashioned composition a new sense of vitality through the elongated proportions, rhythmic movement, and refined elegance associated with Parmigianino's mannerist aesthetic. Bassano's altarpiece contains a synthesis of stylization and reality that allows capricious elements to coexist in total harmony with perfectly observed naturalistic details.

Behind the Virgin the sides of an elaborate throne rise up like a pair of marble wings. Their delicately swirling volutes and exaggerated verticality belong to the realm of pure fantasy, but the oriental carpet that covers the base of the throne must have actually belonged to Jacopo, for it appears in several of his other paintings (London 1983, cat. 2). Like the rug, Saint Antony's bell and Saint Martin's miter and crosier are depicted with remarkable fidelity, but they remain isolated passages of realism in an otherwise unnaturalistic environment. The space is compressed and flattened, and the color very limited and concentrated. The rich red of Saint Martin's robe is repeated in the carpet and in the Virgin's gown, where it has been broken with white and flows like a myriad of small streams from under her deep-blue mantle.

The composition of this painting repeats that found in a fresco attributed to Jacopo in the cloister of San Francesco in Bassano (Arslan 1931, 88, fig. 13). This fresco, which only exists in a fragmentary state, probably predates the painting. Bassano may well have utilized the same cartoon for both works, changing the identity of the saints to suit his respective clients. The unidentified bishop to the left of the throne in the fresco has been transformed in the painting into Saint Martin of Tours, the patron saint of the church in Rasai, for which the picture was painted, and the Saint Francis has become Saint Antony Abbot. The similarity between the works has led some authors to doubt the attribution of the Munich canvas to Jacopo and, instead, to assign it to one of his sons (GK.IX, 27–28). There can be little doubt, however, that the painting is entirely by Jacopo's hand, for the incorporation of stylistic devices borrowed from Parmigianino's art is totally in keeping with Jacopo's experimental work of the early 1540s and has little to do with the later style adopted by the members of his vast family workshop.

B.L.B.

PROVENANCE
entered the Düsseldorfer Galerie by 1719

LITERATURE
Giovanni Battista Volpato, "La verità pittoresca," ms, Biblioteca Civica di Bassano del Grappa, 1670–1679; Wart Arslan, *I Bassano*, Bologna, 1931; Sergio Bettini, *L'arte di Jacopo Bassano*, Bologna, 1933; Roberto Longhi, "Calepino Veneziano. XIII: Ancora il Maestro dei Santi Ermagora e Fortunato," *Arte Veneta* 2 (1948), 41–55; Rodolfo Pallucchini, *Bassano*, Bologna, 1982; *The Genius of Venice 1500–1600*, exh. cat., Royal Academy of Arts, London, 1983; W. R. Rearick, "Jacopo Bassano and Mannerism," in *Cultura e società nel Rinascimento tra riforme e manierismi*, edited by Vittore Branca and Carlo Ossola, Florence, 1984, 289–311.

Girolamo Mazzola Bedoli
Viadana c. 1500–c. 1569 Parma

2 *Virgin and Child with Saint Bruno*

c. 1536/1537
oil on panel
27.3 x 21.6 (10¾ x 8½)
inv. no. 5289

Girolamo Mazzola Bedoli was a follower and cousin by marriage of Girolamo Francesco Maria Mazzola, better known as Parmigianino. It is not only the names, but also the works of the two artists that over the centuries have continued to confuse scholars. The *Virgin and Child with Saint Bruno* attests to Bedoli's extraordinary ability to imitate, paraphrase, and adapt Parmigianino's style. Like many of Bedoli's best works, it was once thought to be by Parmigianino. Although the attribution to Bedoli has now been universally accepted, there has been no general agreement on the painting's date. Opinions have ranged between 1533 and 1539 and depend to a large degree on how one defines the relationship between this work and Parmigianino's oeuvre. (For a summary of the various opinions, see Kat.AP.V, 25–26; Milstein 1977, 146–149.)

The combination of a half-length Madonna, recumbent infant, and rose derives from Parmigianino's *Madonna della Rosa* (Gemäldegalerie, Dresden) of about 1530. Although Bedoli has tempered the overt sensuality of Parmigianino's image, he has consciously reproduced the model's physical beauty as well as borrowed the decorative vocabulary of her hairstyle and costume. Creamy folds of semitransparent drapery swirl around the Virgin's erect nipple and, as in Parmigianino's work,

the entire surface is brought to an exquisite degree of finish. Every detail is scrupulously painted. There is also an unquestionable similarity between this painting and Parmigianino's *Holy Family with the Infant Saint John the Baptist* in Naples (fig. 1). Bedoli repeats the general arrangement of the figures, the Madonna's pose, and particular motifs such as the carpet of white roses in the foreground and the stone slab and tasseled pillows that the Christ Child rests on. He has, however, compressed the entire composition, thereby losing the monumental effect of Parmigianino's painting, but increasing the visual and psychological importance of the saint in the doorway. The dating of the Naples picture is controversial, but if we accept Freedberg's cogent argument for a date after 1535 (Freedberg 1950, 197–199; 1987, 43–44), we may also assume a date after 1535 for *Virgin and Child with Saint Bruno*. The painting still belongs to the period in Bedoli's development when he most aggressively sought to imitate Parmigianino, but anticipates the formation of his own personal style exemplified by the *Immaculate Conception* (Galleria Nazionale, Parma), which was commissioned in 1533 but not completed until 1537. Therefore, a date of about 1536/1537 seems the most reasonable for the Munich picture.

A further correspondence exists be-

Fig. 1. Parmigianino, *Holy Family with the Infant Saint John the Baptist*, Museo e Gallerie Nazionali di Capodimonte, Naples

Italy during the early sixteenth century. Parmigianino repeated variations of the figure in paintings, drawings, and engravings. Bedoli used it not only for this painting, but also in his *Putti Disarming the Sleeping Cupid* (Musée Condé, Chantilly). This later work was the basis for a drawing by Orazio Samacchini (De Grazia 1984, 335–337), who seems to have known either an ancient or a contemporary sculpture of this type directly. Tintoretto, too, knew this type of sleeping cupid, since it appears in the background of his *Venus and Mars Surprised by Vulcan* (see cat. 11).

The white-robed monk who appears in the doorway has traditionally been identified as Saint Bruno. Bruno was the founder of the Carthusian Order, and in 1514 he had been beatified. His attribute is an olive branch. The figure here carries a red rosebud, and it is possible that the figure instead represents Saint Bernard of Clairvaux, who as a Cistercian also wore a white habit and is particularly remembered for his frequent references to flowers in his collection of sermons *On the Song of Songs*. The Virgin and Child miraculously appeared before both saints, and Bedoli's elegant apparition could just as plausibly represent one as the other. Interestingly, in the numerous copies of the painting, the saint has been replaced by a landscape (Milstein 1977, 148–149).

B.L.B.

PROVENANCE
from the Kammergalerie of Elector Maximilian I

LITERATURE
S. J. Freedberg, *Parmigianino: His Works in Painting*, Cambridge, Mass., 1950; A. E. Popham, "The Drawings of Girolamo Bedoli," *Master Drawings* 2 (1964), 243–267; A. E. Popham, *Catalogue of the Drawings of Parmigianino*, 3 vols., New Haven, 1971; Ann Rebecca Milstein, "The Paintings of Girolamo Mazzola Bedoli," Ph.D. dissertation, Harvard University, 1977; Diane De Grazia, *Correggio and His Legacy: Sixteenth-Century Emilian Drawings*, exh. cat., National Gallery of Art, Washington, 1984; Giovanni Agosti and Vincenzo Farinella, *Michelangelo e l'arte classica*, exh. cat., Casa Buonarroti, Florence, 1987; S. J. Freedberg, "Parmigianino Problems in the Exhibition (and Related Matters)," in *Emilian Painting of the 16th and 17th Centuries*, Bologna, 1987, 37–47.

tween the Munich picture and Parmigianino's *Madonna of the Long Neck* (Galleria degli Uffizi, Florence) of about 1535. There is a relationship between the pose of Bedoli's lively Christ Child and the sleeping infant in the Florentine painting (Milstein 1977, 35). Bedoli quite literally repeated the pose of the child from an etching that reproduced in reverse a study for the Florentine painting (Popham 1971, 1: 248, no. 17, and 3: pl. 354, O.R. 17). What has gone unnoticed is that the pose is derived from an antique prototype of a sleeping cupid. Several sculptures of

sleeping cupids were known during the Renaissance. Isabella d'Este had in her collection in Mantua no fewer than three, perhaps the most famous being Michelangelo's counterfeit antique. Much debate has arisen over the exact physical appearance of Michelangelo's lost *Sleeping Cupid* (Agosti and Farinella 1987, 43–47) and it is impossible to say whether Parmigianino and Bedoli were actually copying it. Clearly, however, a sculpture of a sleeping cupid similar to one now in the Methuen Collection at Corsham Court (see cat. 11, fig. 1) was well known in northern

Cat. 2

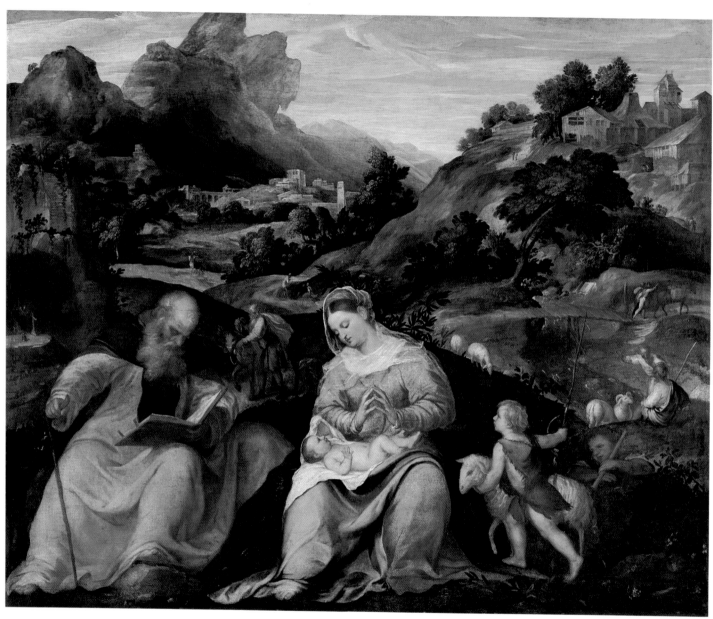

Cat. 3

Giovanni de' Busi, called Cariani

San Giovanni Bianco c. 1485–after 1547 Venice

3 *Virgin and Child with Saint Antony Abbot and the Young Saint John the Baptist*

c. 1540
oil on canvas
164 x 199.5 (64⅝ x 78½)
inv. no. 9210

In 1810 an engraving after this large and impressive canvas was published by the legendary Parisian art dealer Jean-Baptiste Pierre Lebrun (Bailey 1984, 45, fig. 12). Lebrun, who claimed to have discovered the work in Rome, ascribed it to Titian. This attribution stuck until the early 1920s, when the picture was sold to the Alte Pinakothek as a Cariani. Subsequently, authors universally attributed the work to Cariani, emphasizing its Titianesque character and using it as a reference point for the reconstruction of the final years of Cariani's career (GK.IX, 82–84; Kat. AP.V, 32–33). Recently, however, Pallucchini has made a very strong case for a reattribution to Lambert Sustris and a dating of c. 1550 (Pallucchini 1982, 192–196; Pallucchini and Rossi 1983, 312–313).

Both Cariani and Sustris are enigmatic figures who remained outside the mainstream of sixteenth-century Venetian painting, but were nonetheless profoundly influenced by it. Newly discovered documents now make it clear that Cariani was born in a small hamlet near Fuipiano in the region of Bergamo (Pallucchini and Rossi 1983, 18). His earliest training, however, was in Venice, where in 1509 he is recorded in the workshop of Giovanni Bellini and later in the circle of Giorgione.

Cariani kept in close contact with his native place, working in Bergamo between 1507 and 1524 and again from 1528 to 1530. There the Lombard school with its painstakingly persistent treatment of details and hard-edged reality would leave a lasting and somewhat provincial mark on Cariani's style. The last years of his career are obscure. He lived in Venice, but painted very little. While Cariani easily assimilated the compositional mode of the young Titian and Sebastiano del Piombo, he had more difficulty in mastering their technique. His forms remained heavy, angular, and disjointed, and his touch coarse. Even in his later work, when he had come to a more complete understanding of the Venetian style, Cariani never moved beyond an idiosyncratic and often prosaic rendition of its form and color (Freedberg 1983, 338–349; London 1983, 160–166).

Lambert Sustris (Amsterdam, c. 1515–after 1568, Venice) was even less of a Venetian than Cariani. He was born in the Netherlands and trained in Scorel's workshop in Utrecht. By the late 1530s he was probably working in Titian's studio, where, according to the seventeenth-century critic Carlo Ridolfi, he apparently specialized in landscape painting (Ridolfi 1914, 1:225). Sustris

accompanied Titian on his trip to Augsburg in 1548 and is recorded there again in 1552. It was probably at this time that he added the landscape view to Titian's *Portrait of the Emperor Charles V* (Alte Pinakothek, Munich). When he returned to Venice his style became more elegant and mannered, and needless to say, more Italianate, but even in this guise Sustris never lost certain Netherlandish predilections, which are most apparent in his expansive landscape compositions. Practically nothing is known about the latter part of his life. Attempts to identify him with a certain "Alberto de Ollanda," who painted official state portraits in the Procuratoria de Supra in Venice from 1572 to 1584, now seem unwarranted. In 1568 the artist and biographer Giorgio Vasari briefly mentioned that Sustris was still alive (Vasari 1878–1885, 7:588), and after that we have no certain record of his existence (Venice 1981, 138–143; London 1983, 211).

Both Cariani and Sustris were closely allied with Titian, and this painting is undeniably Titianesque in character. The picture shows the Virgin and Child seated in a vast panoramic landscape. The setting is reminiscent of the Dolomite valleys north of Venice, where the majestic peaks of craggy mountains pierce the sky and small rustic villages cling to the hillsides below. To the left of the Virgin, Saint Antony Abbot, identifiable by his bell and domesticated pig, sits reading a book. Young Saint John the Baptist enters from the right coaxing a lamb forward. In the middle distance young shepherds tend their flocks, peasants toil in the fields, men lead horses toward town, and a hermit monk offers his prayers at a makeshift altar in a cave. The artist has combined elements of a Rest on the Flight into Egypt with a *sacra conversazione*, creating a religious idyll that celebrates the presence of God in remote places and the virtue of meditation, austerity, and manual work. Perhaps this helps explain the presence of Saint Antony Abbot, the Egyptian hermit who was the founder of monasti-

Fig. 1. Giovanni Cariani, *La Madonna Cucitrice*, Galleria Nazionale d'Arte Antica, Palazzo Barberini, Rome

cism. In any case, this express type of religious idyll with saints other than Antony enjoyed a special popularity in Venice during the first half of the sixteenth century (Christiansen 1987). Titian, and his studio in particular, treated the theme a number of times, most notably in *Madonna and Child with a Female Saint and the Infant Saint John the Baptist* (National Gallery, London), in *Madonna and Child with Saint Catherine and a Rabbit* (Musée du Louvre, Paris) and in *Madonna and Child with (?) Saint Catherine of Alexandria and the Infant Saint John the Baptist* (Kimbell Art Museum, Fort Worth). While the composition of the Munich painting with its monumental triad of figures pushed close to the picture plane is ob-

viously derived from Titian, the landscape is more expansive and more romantic than any of the foregoing examples. Indeed, the landscape passages dominate the canvas and ultimately provide the key to the picture's authorship.

The painting has often been associated with Cariani's *La Madonna Cucitrice* (fig. 1), the so-called "sewing Madonna." The forms and coloration of *La Madonna Cucitrice* are powerfully assertive, yet awkward. The drapery, which is painted in a rather patchy manner, appears brittle and angular; its flatness is at odds with the more precisely rendered details of the fruit trees, rose bushes, sewing basket, and rabbits. *La Madonna Cucitrice*'s graceless fusion

Fig. 2. Lambert Sustris, *Saint Jerome*, Ashmolean Museum, Oxford

andering vista, the rhythmic movement of their bodies echoed by the curving contours of the fluid landscapes. The soft greens, blues, and browns of the settings are perfectly harmonized into a poetic vision of pastoral tranquility. Pallucchini is absolutely correct in maintaining that *Virgin and Child with Saint Antony Abbot and the Young Saint John the Baptist* is by Lambert Sustris and not Cariani. The work should be dated c. 1550, in the period when Sustris was most closely associated with Titian and his shop.

B.L.B.

PROVENANCE
acquired in 1923

LITERATURE
Giorgio Vasari, *Le vite de' più eccellenti pittori, scultori ed architetti* (Florence, 1568), edited by G. Milanesi, 9 vols., Florence, 1878–1885; Carlo Ridolfi, *Maraviglie dell'arte* (Venice, 1648), edited by D. von Hadeln, 2 vols., Berlin, 1914–1924; *Da Tiziano a El Greco per la storia del Manierismo a Venezia 1540–1590*, exh. cat., Palazzo Ducale, Venice, 1981; Rodolfo Pallucchini, "Note Carianesche," *Arte Veneta* 36 (1982), 192–196; S. J. Freedberg, *Painting in Italy 1500–1600*, 2d ed., Harmondsworth and New York, 1983; *The Genius of Venice 1500–1600*, exh. cat., Royal Academy of Arts, London, 1983; Rodolfo Pallucchini and Francesco Rossi, *Giovanni Cariani*, Bergamo, 1983; Colin B. Bailey, "Lebrun et le commerce d'art pendant le Blocus continental," *Revue de l'art* 63 (1984), 35–46; Keith Christiansen, "Titianus (Per)fecit," *Apollo* 125 (1987), 190–196.

between a Venetian subject and a Lombard mode of realistic description is typical of Cariani's work, but has little in common with the soft and fluid presentation of the Munich picture. This latter work is characterized by a loosely painted, atmospheric background that melds seamlessly with the figures in the foreground. The sweeping beauty of the hills, lakes, valleys, and rivers are filtered through a dense bucolic light. Our eye moves gently back through a progression of ever higher plateaus. In *La Madonna Cucitrice* a tightly woven thicket of leaves abruptly separates the principal figures from the background. Behind this impenetrable hedge the mountains rise like a brown curtain.

The stagelike composition of the Munich picture strongly suggests that the artist had assimilated certain Netherlandish models. While this could be said of several sixteenth-century Venetian artists, it should be remembered that Lambert Sustris was Dutch by birth and never totally abandoned his Northern style. We have already noted that he was primarily known in Venice as a landscape painter, and it is to his loosely executed, sensuously flowing pastoral works this painting is most clearly related. It bears a close resemblance to Sustris' *Saint Jerome* (fig. 2) and to his *Rape of Europa* (Principe Castelbarco Albani, Milan). In all of these compositions monumental figures are placed before an open and me-

Bernardo Cavallino
Naples 1616–1656 Naples

4 *Erminia and the Shepherds*

1650s
oil on canvas transferred from panel
diameter 50.2 (19¾)
inv. no. 960

5 *Erminia and the Wounded Tancred*

1650s
oil on canvas transferred from panel
diameter 52 (20½)
inv. no. 964

Torquato Tasso's epic poem *La Gerusalemme Liberata* was one of the most popular sources for the visual arts in seventeenth-century Italy (see cat. 60). The lyrical quality of its narrative readily suggested the close affinity between painting and poetry to an audience that was eager to prove the Horatian dictum *ut pictura poesis*: which, simply stated, means that poets and painters were attempting to achieve the same artistic goals only in different media. Perhaps with this in mind, the Neapolitan painter Massimo Stanzione recommended that his pupil Bernardo Cavallino read Tasso's poem (De Dominici 1742, 3:34). Indeed, years later, near the end of his career, Cavallino did turn to *La Gerusalemme Liberata* for the subject of this pair of tondi.

The poem tells the romantic tale of the First Crusade, in which Christian soldiers ultimately triumphed over the infidels. Erminia, who was the daughter of a Saracen king, loved the Christian knight Tancred. Believing him to be wounded in the Crusade, Erminia set off to search for him, disguised in the armor of a female warrior. Cavallino's first tondo shows a chance encounter between Erminia and an old shepherd who is weaving a basket (*La Gerusalemme Liberata*, canto 7, v. 6). His three sons, frightened by her armor and the threat of war, cling anxiously to their father's side as he extols the virtues of the pastoral life. The second tondo depicts an episode near the end of the poem when the crusaders have made an assault on Jerusalem (canto 19, v. 112). The severely wounded Tancred is cradled in the arms of his armor-bearer, Vafrino. Erminia, crazed with grief, cuts off her hair in order to bind Tancred's wounds, while the slain body of Argantes, an Egyptian ambassador to the city of Jerusalem, lies unattended in the background.

The first illustrated edition of *La Gerusalemme Liberata*, which was published in Genoa in 1590, contained twenty-one engravings by Giacomo Franco and Agostino Carracci after drawings by Bernardo Castello (De Grazia Bohlin 1979, 272–279; Newcome 1979). The striking resemblance between many seventeenth-century depictions of Erminia and the shepherds

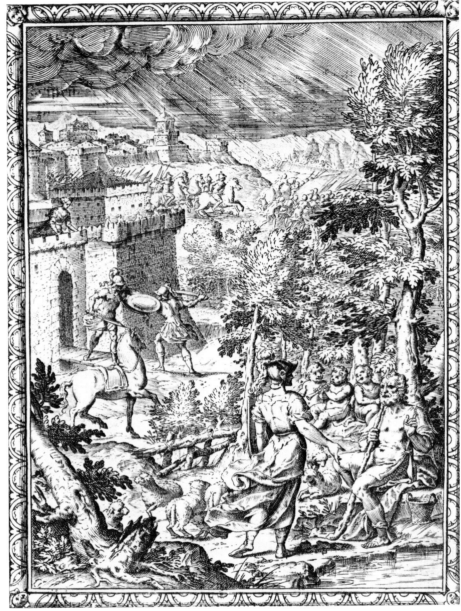

Fig. 1. Giacomo Franco and Agostino Carracci, engraving after Bernardo Castello, *Erminia and the Shepherds*, Library of Congress, Washington, Rosenwald Collection

gesture. The nudity of the puttoesque child is also clearly derived from the engraving, as is the abbreviated version of the sylvan landscape.

What is uniquely Cavallino's is the poetic sensibility with which he has translated the story into print. In each tondo there is a quiet sentiment that owes more to contemporary literature and theater than to the overblown sensationalism of much Neapolitan art. The two scenes are unobtrusively yet convincingly conceived as theatrical vignettes. The protagonists are arranged across a small stagelike setting and rhythmically connected through a series of balletically poised gestures. Even when they are caught at a moment of violent emotional confrontation, such as in the *Erminia and the Wounded Tancred*, they are frozen in a tableau. The light, too, seems more contrived than natural, as if partially emanating from footlights. Although we lack a concrete connection between Cavallino's paintings and a specific performance, the overall effect of his works suggests a close relationship with the flourishing theatrical and literary life of Naples.

By the 1640s Cavallino's small-scale paintings executed for cultivated private patrons had become the most important part of his artistic production. Their tempered classicism reflects the influence of the French painters working in Rome during the 1630s, including Nicolas Poussin, Charles Mellin, Sébastien Bourdon, and Jean Tassel. In the Munich tondi this influence is particularly evident in the luminous, transparent, yet muted colors. Silvered greens, dull oranges, and pale blues dominate the palette. The *Erminia and the Wounded Tancred* specifically recalls Poussin's versions of the same episode (State Hermitage Museum, Leningrad; The Barber Institute of Fine Arts, Birmingham). Unlike the first illustrated edition of Tasso, in which an engraving shows Erminia nursing Tancred's wounds, Poussin and Cavallino both depicted Erminia in the process of cutting her hair. As is typical of Cavallino, however, his rendering of the moment is more intimate and less heroic than

suggests that Italian artists frequently consulted this particular edition of Tasso (fig. 1). Cavallino was certainly familiar with it, as the composition of his *Erminia among the Shepherds* (Museo e Gallerie Nazionali di Capodimonte, Naples) proves; but in order to accommodate the round shape and small scale of the Munich tondo he

compressed and edited the scene so that it does not resemble the engraving as closely as the Naples picture does. Nevertheless, there are numerous similarities between the engraving and cat. 4 in pose, costume, and landscape. Erminia, who in both is clad in a breastplate and flowing skirt, confronts the shepherd family with an open-armed

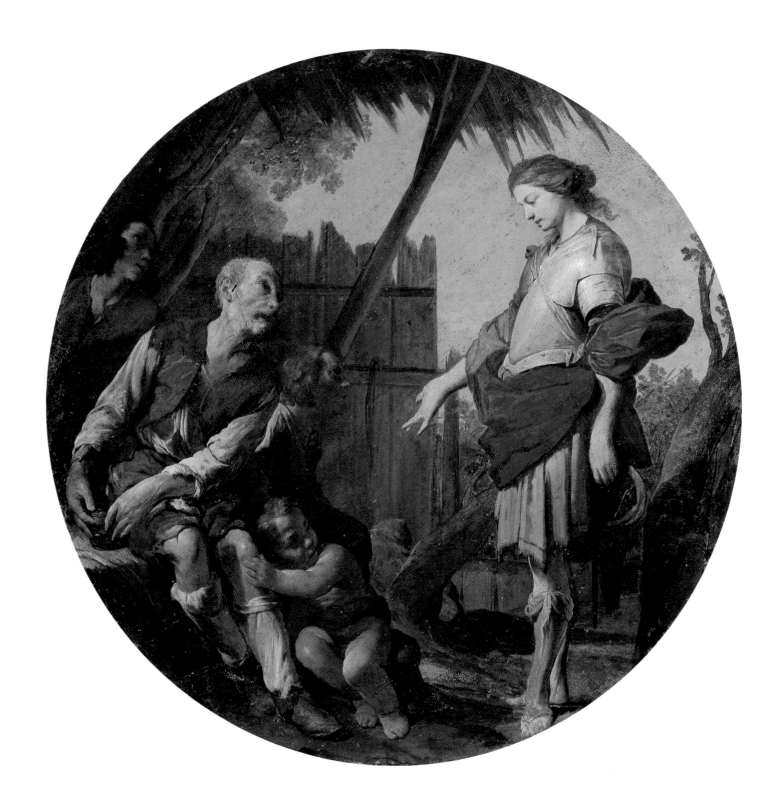

Cat. 4

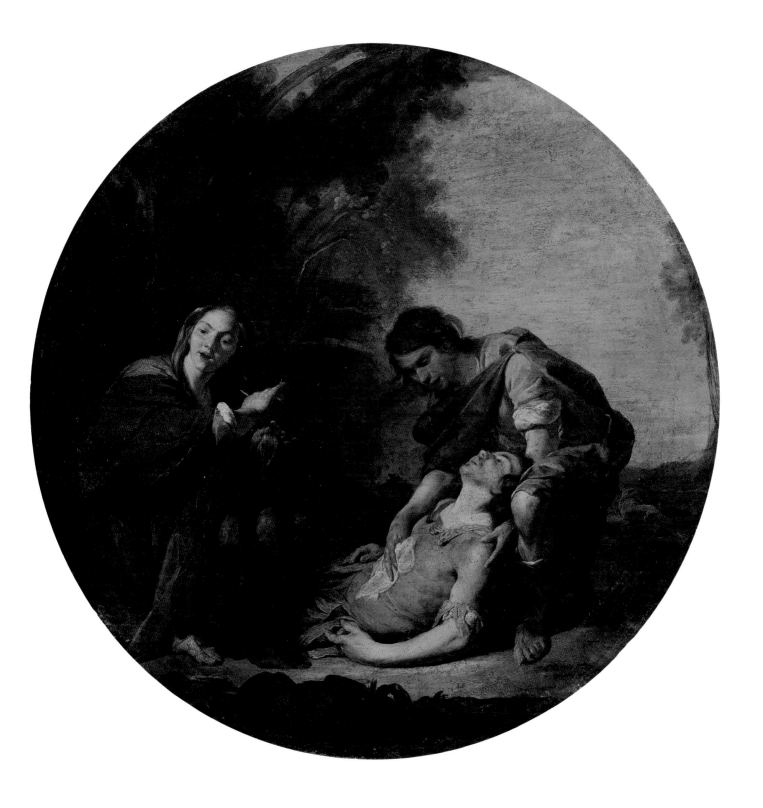

Cat. 5

Poussin's. For all their theatricality and classical restraint, Cavallino's tondi possess a tender lyricism and delicate grace that are uniquely the artist's own.

When and how Cavallino came into contact with the French painters is unknown. We have virtually no documents concerning his life and only one dated painting, the *Saint Cecilia in Ecstasy* (Palazzo Vecchio, Florence), from 1645. It is extremely difficult to date the works of such an elusive artistic personality, but there is general agreement among scholars that the Munich tondi are among the last paintings of Cavallino's career. They may have belonged to a larger cycle of scenes from *La Gerusalemme Liberata*. There are precedents for such cycles in Naples, but none connected with Cavallino's name (Cleveland 1984, 205–207).

B.L.B.

PROVENANCE
both entered the Mannheimer Galerie by 1756

LITERATURE
Bernardo De Dominici, *Vite de' pittori, scultori, ed architetti napoletani*, 3 vols., Naples, 1742; Frederico Hermanin, "Über einige unedierte Bilder des neapolitaner Malers Bernardo Cavallino," *Monatshefte für Kunstwissenschaft* 4 (1911), 183–188; Otto Benesch, "Seicentostudien. I. Zu Bernardo Cavallinos Werdegang," *Jahrbuch der Kunsthistorischen Sammlungen in Wien*, n.s. 1 (1926), 245–254; Michael J. Liebmann, "A Signed Picture by Bernardo Cavallino in the Pushkin Museum, Moscow," *The Burlington Magazine* 110 (1968), 456–459; Clovis Whitfield, "A Programme for 'Erminia and the Shepherds' by G. B. Agucchi," *Storia dell'arte* 19 (1973), 217–229; Diane De Grazia Bohlin, *Prints and Related Drawings by the Carracci Family*, exh. cat., National Gallery of Art, Washington, 1979; Mary Newcome, "Drawings by Bernardo Castello in German Collections," *Jahrbuch der Berliner Museen* 21 (1979), 137–151; *Bernardo Cavallino of Naples 1616–1656*, exh. cat., The Cleveland Museum of Art, Cleveland, 1984.

Carlo Dolci
Florence 1616–1686 Florence

6 *Madonna of the Lilies*

1649
oil on canvas
88 x 74 (34⅝ x 29⅛)
inscribed on the reverse, *1649. Il primo venerdi di marzo a detto anno 33 di mia età per la divina grazia vetimo giorno de mie ritoccature. Io Carlo Dolce*
inv. no. 466

No painter has suffered more from the fickle fortunes of taste than Carlo Dolci. In his own day he was the leading painter in Florence, extensively patronized by Church and state and lavishly praised for his astonishing technique and deep piety. Ironically, it is these very qualities, plus a host of feeble copies of his work, that turned later generations of collectors against him. His creative output was almost entirely sacred, and even his contemporaries found him something of a religious fanatic. His images are often melancholy or morbidly realistic. His name, which means sweet, has led to such epithets as "dour Dolci." Nevertheless, his art represents one side of the spirit of the Counter-Reformation, which may seem foreign to us now but illustrates a certain type of devout piety. Dolci's attitude was consistent with the moral outlook of the late-sixteenth-century reformists, especially that of Cardinal Gabriele Paleotti, who recognized the need for a "Christianus pictor" (Heinz 1960, 197–198). According to Paleotti, it was the duty of such a Christian painter to induce a state of religious excitement or devotion in the viewer.

It was not only the viewer with

Cat. 6

Fig. 1. Andrea della Robbia, *Madonna and Child with Cherubim*, National Gallery of Art, Washington

whom Dolci was concerned; many of his paintings were clearly executed as private ex-votos. Filippo Baldinucci, Dolci's close friend and primary biographer, noted that the artist's paintings and drawings frequently contained ciphers or secret inscriptions invoking the holy name of Jesus or other pietistic sentiments (Baldinucci 1845, 5:364). On the back of the Munich painting is an inscription that reads, "1649. The first Friday of March of this year, the 33rd of my life, by divine grace the day of my final touch. I Carlo Dolce [sic]." The very act of painting was a religious exercise for Dolci and he offered the completed canvas as a prayer.

In an analogous gesture, the Virgin in this painting presents her son to the viewer for veneration. She respectfully bows her head and closes her eyes in prayer, while simultaneously offering her child a lily and the viewer her child, standing on an elaborate lace altar cloth, as the corporeal reality of the host. The idea behind this strikingly simple composition lies in a number of Florentine quattrocento reliefs that all depict a half-length Madonna and standing Christ Child who raises his hand in benediction (fig. 1). Throughout his career Dolci turned to earlier Renaissance artists for inspiration, but during the 1640s his work reveals his increased interest in sculpture by such artists as Bernardo Rossellino, Andrea della Robbia, and Michelangelo. Dolci transformed the austere purity of his three-dimensional prototypes into as-

tonishing, lifelike presences through his superrealist technique. This technique, which was partly based on Flemish examples, employed the use of multilayered glazes to produce glowing colors and marmoreal surfaces. Here the remarkably tangible Madonna and Child emerge from a softly illuminated yet unarticulated setting. The lack of specificity only increases the contemplative character of the painting. This supernatural materialization before the viewer is an answer to Dolci's prayer and an invitation for the viewer's own.

Dolci had a great capacity for still-life painting. Nowhere is this more evident than in the floral arrangement of the *Madonna of the Lilies*. Each flower is rendered with the painstaking care of a botanist, its chillingly perfect image preserved on canvas like a porcelain specimen. The flowers do, of course, have a graver, more solemn reason for being included in the painting. The Virgin holds a branch of lilies entwined with red carnations, denoting pure love. She presents these to Christ, who in turn offers her a white rose, another emblem of purity, but one that also symbolizes the Virgin's sorrow at the foreknowledge of Christ's Passion. This dual theme of purity and sorrow is reflected in the basket of flowers at Christ's feet, which contains blue iris for the Virgin's sorrow, white orange blossoms for purity, chastity, and generosity, and more varieties of carnations, roses, and lilies. The somber message of this emblematic flower language would have been immediately legible to a Counter-Reformation audience, and served as a spiritual aid to the viewer's quiet contemplation before the image.

Dolci's images of the Madonna and Child were among his most popular devotional pictures. Baldinucci records at least four, possibly five paintings by Dolci depicting the Virgin holding a lily, the Christ Child, and a basket of flowers (Baldinucci 1845, 5:349, 362). The earliest of these was apparently commissioned by the Marchese Carlo Gerini, two others by the Duca Salviati and the Monsignore Albizzi, and an-

other by an unidentified person; the fifth was a replica of the Gerini canvas left in Dolci's studio at his death. The Gerini picture can be identified as an oval painting now in the Musée Fabre, Montpellier (signed and dated 1642), and its replica as the painting now in the National Gallery, London (Levey 1971, 89–91). The octagonal picture now in Munich is most likely the version done for either Salviati or Albizzi.

<div align="right">B.L.B.</div>

PROVENANCE
entered the Düsseldorfer Galerie by 1691

LITERATURE
Filippo Baldinucci, *Notizie dei professori dal disegno da Cimabue in qua* (Florence, 1681), edited by F. Ranalli, 5 vols., Florence, 1845–1847; Günther Heinz, "Carlo Dolci Studien zur Religiösen Malerei im 17. Jahrhundert," *Jahrbuch der Kunsthistorischen Sammlungen in Wien* 56 (1960), 197–234; Carlo Del Bravo, "Carlo Dolci, devoto del naturale," *Paragone* 163, 14 (1963), 32–41; Michael Levey, *National Gallery Catalogues: the Seventeenth and Eighteenth Century Italian Schools*, London, 1971, 89–91; Charles P. McCorquodale, "A Fresh Look at Carlo Dolci," *Apollo* 97 (1973), 477–488.

Orazio Gentileschi
Pisa 1563–1639 London

7 The Conversion of the Magdalen

c. 1612
oil on canvas
133 x 155 (52⅜ x 61)
inv. no. 12726

There is an old tradition that Mary Magdalen was the sister of Martha and Lazarus. The story of the Magdalen's conversion focuses on the pivotal moment in her life when she is enlightened by divine love and relinquishes all signs of worldliness. The story derives from a passage in the Gospel of Luke (10:41–42), in which Christ visits the sisters and rebukes Martha for complaining of Mary's idleness, saying, "Mary hath chosen that part, which shall not be taken away from her." The Church Fathers interpreted this passage to mean that Mary had come to understand the message of divine grace. Mary and Martha came to symbolize the two types of religious life, the contemplative and the active.

Orazio Gentileschi's picture derives from a painting of the same subject by Caravaggio (fig. 1). Mary and Martha are not shown with Christ in a domestic setting, as in the paintings of Tintoretto or Le Sueur (see cats. 12, 58), but are seen alone, which emphasizes their emblematic role as the two Christian paths. It is clear in Gentileschi's painting that the repentant woman, who is dressed in a simple costume without jewels, has already been deeply moved by Christ's message and has rejected earthly vanities. She is no longer concerned with mere physical beauty and adornment, but rather with spiritual beauty, which allows her fully to love Christ.

Cat. 7

The mirror, which is so prominently placed in both Caravaggio's and Gentileschi's works, symbolizes the dual nature of Mary's beauty. On the one hand, it alludes to the vanity associated with physical beauty, just as the mirror does in Titian's painting of a young woman (see cat. 13); at the same time the mirror is an instrument of divine relevation, with which Mary looks beyond earthly appearances into her soul and sees the reflection of divine beauty. Dante, in his *Purgatorio* (canto 27, 101–108), introduces a mirror to contrast the Old Testament figures of Leah and Rachel, the first of whom led an active life and the second of whom sought truth through contemplation. Martha and Mary are the New Testament counterparts of Leah and Rachel.

Although Gentileschi's picture is closely related in meaning and composition to that of Caravaggio, Orazio should not simply be labeled as one of the "Caravaggisti." His Tuscan heritage was important to the formation of his style and fundamental in shaping his response to Caravaggio. In fact, it is Gentileschi's insistence on Tuscan monumentality, clarity, and high-key colors that distinguishes his work from Caravaggio's. Nevertheless it was from Caravaggio that he learned to exploit the expressive powers of dramatic contrasts in light and shade and to seek a moral authority through the use of naturalistic details. Orazio imbued the austere realism of Caravaggio with a humanistic charm, which in *The Conversion of the Magdalen* manifests itself in the earnest confrontation between the siblings.

There has been considerable controversy over the dating of the Munich picture, which has been placed anywhere from the early 1610s, to the Genovese phase (1621–1624) of Gentileschi's career, to the final years of his life in London. Bissell (1981, 172–173, no. 44) accepts a date of about 1620, suggesting that, since a conversion of the Magdalen is not mentioned among the many paintings attributed to Gentileschi in the Genovese sources, it was most likely executed in Rome just be-

Fig. 1. Caravaggio, *The Conversion of the Magdalen*, The Detroit Institute of Arts, Gift of the Kresge Foundation and Mrs. Edsel Ford

fore he left that city for northern Italy in 1621. However, the fullness and power of the female forms, their monumentality in both shape and scale, plus the cool, brilliant, and uncomplicated light and fresh pastel tonality of the Magdalen's violet dress all point to a stage in Orazio's evolution just after 1610. The painting is closest in affect and appearance to other works of 1611/1612, such as the *Madonna with Sleeping Christ Child* (Harvard University Art Museums, Cambridge, Mass.), *The Lute Player* (National Gallery of Art, Washington), and the set of paintings depicting Judith and Holofernes (Freedberg 1976; Pepper 1984). In all of these works the formal and expressive burden is carried to a large extent by the magnificent mass of drapery and the carefully staged hand gestures. The ultimate effect of the Munich picture is one of simple, powerful majesty presented with an unerring sense of actuality.

B.L.B.

PROVENANCE
gift of Georg and Otto Schäfer, 1957

LITERATURE
Alfred Moir, *The Italian Followers of Caravaggio*, 2 vols., Cambridge, Mass., 1967; Frederick Cummings, "The Meaning of Caravaggio's 'Conversion of the Magdalen'," *The Burlington Magazine* 116 (1974), 572–578; Sydney J. Freedberg, "Gentileschi's 'Madonna with the Sleeping Christ Child'," *The Burlington Magazine* 118 (1976), 732–734; R. Ward Bissell, *Orazio Gentileschi and the Poetic Tradition in Caravaggesque Painting*, University Park, Pa., and London, 1981; Stephen Pepper, "Baroque Painting at Colnaghi's," *The Burlington Magazine* 126 (1984), 315–316; *The Age of Caravaggio*, exh. cat., The Metropolitan Museum of Art, New York, 1985; Karen Finaly, "Review of *La Maddalena tra Sacro e Profano da Giotto a De Chirico*," *The Burlington Magazine* 129 (1987), 607–608.

Francesco Guardi
Venice 1712–1793 Venice

8 *The Ladies' Gala Concert in the Sala dei Filarmonici*

1782
oil on canvas
67.7 x 90.5 (26⅝ x 35⅝)
inv. no. 8574

Between 18 and 25 January 1782, the Archduke Paul Pavlovitch of Russia and Archduchess Maria Teodorovna made a state visit to Venice. The archduke was the son of Czarina Catherine II. The presence of the royal couple, who were generally known by the title "Conti del Nord," prompted a series of official festivities including balls, concerts, parades of allegorical floats, games, and a regatta (Pilot, 1914). No other city in history has offered such a magnificent setting for public ceremonies, and by the late eighteenth century the array of possible entertainments was dizzying in number. During important visitations such as that of the Conti del Nord, *la Serenissima*, as the Republic of Venice was known, staged a seemingly endless carnival. By 1797, as the reign of the Venetian republic neared its end and the once-gay city came under French and Austrian domination, the more opulent traditions surrounding public festivities disappeared. The archduke and archduchess from Russia had been there in 1782, the last foreign dignitaries accorded such splendid honors. Luckily, the pomp and ceremony staged on the occasion of their visit was documented in a series of six paintings by Francesco Guardi.

Unfortunately not all of Guardi's six paintings have survived (Morassi 1984, 1:182–184). Besides the magical *Ladies'* *Gala Concert in the Sala dei Filarmonici* in Munich, there is a painting in the collection of Vittorio Cini in Venice that depicts a parade of allegorical floats through the Piazza San Marco. The present location of three paintings, which show a regatta on the Grand Canal, a banquet in honor of the Conti del Nord, and a bullfight in the Piazza San Marco, is unknown. There are a number of preparatory drawings by Guardi related to the series (Byam Shaw 1951, 69; Bean and Stampfle 1971, 88; Morassi 1984, 1:357–358). It is sometimes assumed that Guardi based his paintings on a set of prints by A. Baratti and G. B. Canal; however, when a lost painting from the series, commemorating a dinner and dance at the Teatro San Benedetto, recently turned up in a Swiss private collection (Azzi Visentini 1985), the style was so unmistakably Guardi's that one must wonder if it was not the other way around.

Guardi's Conti del Nord series belongs to a well-established tradition. For centuries Venetian artists had depicted such ceremonial occasions, which in their own way had as much to do with preserving Venice's self-image at home as they did with promoting her image abroad. From Carpaccio to Tintoretto, Renaissance masters decorated scores of churches, *scuole* (Venetian confraternities), and public

Cat. 8

palaces with monumental scenes of historic events. By the seventeenth century the festivals, pageants, and state visits were recorded on a smaller scale and in a more portable form. Prints and drawings proliferated, and eager tourists snapped them up as souvenirs of their Venetian visit.

It had become customary for the state to commission the official paintings that commemorated great occasions, and in 1782 Pietro Edwards, the inspector-general of the Venetian public collections, most probably handed to Guardi the job of recording the Russian visit (Haskell 1960, 256, 260). Guardi would not necessarily have been Edwards' first choice, since the inspector-general had good cause to distrust the artist's ability to produce an accurate visual record. However, despite Guardi's flights of fancy, he was undoubtedly the best *vedutista* or "view" painter living in Venice at the time. Earlier in his career he had worked in the shadow of Antonio Canaletto, consciously attempting to imitate the popular master's painstakinging descriptions of Venetian life. But after Canaletto's death in 1768 Guardi developed his own vision, which was less reliant on any particular setting and more concerned with the intangible qualities of atmospheric impression. The veracity of the Russian series aside, it stands as one of the great achievements of Guardi's career because it so vividly captures the essence of the moment.

The Ladies' Gala Concert in the Sala dei Filarmonici is the most memorable of the series. It depicts with rare magic a concert in the old procurator's palace, held for the Conti del Nord who are seated at the extreme right. The evening's entertainment is provided by an all-female orchestra playing stringed instruments and singing from a three-tiered balcony above the ballroom. The room has been darkened for the concert, but it is as alive and vibrant as the music that floats across the hall. In the shimmering candlelight Guardi has orchestrated the rich and subtle harmonies of silver-blue and bronze.

White highlights flicker across the densely textured canvas, their loose and erratic line defining pieces of drapery with an ornamental flourish. We look down on the scene from above, like small children viewing a party from a secret hiding place. Spread below us is a world of charm and privilege, filled with music. Perhaps Guardi has given us the most privileged seat of all, the one where the party never ends, the candles never die, and the music never fades.

B.L.B.

PROVENANCE
acquired in 1909

LITERATURE
A. Pilot, *Spettacoli e feste per l'arrivo dei Conti del Nord a Venezia nel 1782*, Venice, 1914; James Byam Shaw, *The Drawings of Francesco Guardi*, London, 1951; Francis Haskell, "Francesco Guardi as *Vedutista* and Some of His Patrons," *The Journal of the Warburg and Courtauld Institutes* 23 (1960), 256–276; Rolf Kultzen, *Francesco Guardi in der Alten Pinakothek*, Munich, 1967; Jacob Bean and Felice Stampfle, *Drawings from New York Collections III: The Eighteenth Century in Italy*, New York, 1971; Terisio Pignatti, "Venetian Festivals and Amusements," *Apollo* 102 (1975), 208–215; Antonio Morassi, *Guardi: I dipinti*, 2 vols., Venice, 1984; Margherita Azzi Visentini, "Un Guardi ritrovato," *Arte Veneta* 39 (1985), 178–179.

Francesco Guardi

Venice 1712–1793 Venice

9 *The Fire at San Marcuola, Venice*

1789
oil on canvas
42.5 x 62.2 (16⅝ x 24½)
inv. no. HuW 12

On 28 November 1789, a fire broke out in an oil depot near the Ponte di San Marcuola in Venice. A burning oil slick transformed the canal in front of the bridge into a hellish river of flames, consuming everything in its path. It was, according to local newspaper accounts, the most horrible fire in the memory of the city (Kultzen 1968, 10). Sixty houses were destroyed and 140 families left homeless. A series of drawings and paintings by Francesco Guardi charts the course of the disaster. One can easily imagine the aging artist, sketchbook in hand, recording the blaze and the ensuing panic. Drawings, such as the sheet in the Metropolitan Museum of Art, New York (fig. 1), must have been made on the spot, and the paintings in Munich and the Museo Correr, Venice, completed soon afterward in Guardi's studio. Guardi depicted the conflagration, especially in the Munich canvas, with remarkable vividness although not with photojournalistic precision. The arrangement of the buildings is not topographically accurate. Nevertheless, the scene is one of the most brilliantly evocative records ever made of a contemporary event.

Guardi presents a visionary summation of the terrible disaster. One imagines that the fire broke out late in the evening and continued to burn throughout the night. The entire quarter is engulfed in flames. The darkened sky is full of billowing clouds of dense smoke. Below, the fire roars as flames leap higher and higher, lashing their angry tongues against the defenseless buildings, some of which have already crumbled in the intense heat. A few valiant firefighters try to avert further disaster by pumping water or beating out falling cinders on the rooftops. Others pull casualties from the scalding waters of the burning canal. A sizable group of curious onlookers, dressed in fashionable capes and tricornes, has gathered to watch the spectacle. Their backs are turned toward us and we, like them, stand mesmerized by the devouring wall of flames, unable to aid in its extinction.

The atmosphere is choked with thick yellow smoke, which blurs forms and renders details invisible. Through the haze we perceive the scene as three distinct horizontal bands of somber and muted color. Sandwiched between the grimly gray sky and blackish browns, dull rusts, and deep blues of the crowd is the fire, which rages with white-hot intensity consuming a line of ocher buildings as it goes. Guardi has painted the scene with a light and delicate touch, softly breaking the surface into small patches of color, accentuating the optical effect of the smoke-filled air. The seeming spontaneity of his technique gives the small canvas a breathless vibrance, palpably recreating for us

Cat. 9

Fig. 1. Francesco Guardi, *The Fire at San Marcuola*, drawing, The Metropolitan Museum of Art, New York, Rogers Fund, 1937

artist's son, Giacomo. Giacomo also added an inscription to the bottom of the sheet which has resulted in a minor but annoying misdating of the great fire in most of the literature. The inscription reads "Incendio di S. Marcuola L'anno 1789 28 Xbre," indicating a date of 28 December 1789; but as collaborative evidence clearly proves (Kultzen 1968), Francesco Guardi and his fellow Venetians watched this quarter of their beloved city transformed into an inferno a month earlier, on 28 November.

B.L.B.

PROVENANCE
acquired in 1968 for the collection of the Bayerische Hypotheken- und Wechsel-Bank A.G., on loan to the Alte Pinakothek

LITERATURE
Hermann W. Williams, "Drawings and Related Paintings by Francesco Guardi," *The Art Quarterly* (published by the Detroit Institute of Arts) 2 (1939), 265–275; James Byam Shaw, *The Drawings of Francesco Guardi*, London, 1951; Terisio Pignatti, *Disegni veneti del Settecento nel Museo Correr di Venezia*, exh. cat., Museo Correr, Venice, 1964; Rolf Kultzen, *Francesco Guardi in der Alten Pinakothek München, Nachtrag zum Bildband*, Munich, 1968; Jacob Bean and Felice Stampfle, *Drawings from New York Collectors III: The Eighteenth Century in Italy*, New York, 1971; Antonio Morassi, *Guardi I dipinti*, 2 vols., Venice, 1984.

the traumatic evening in Venetian history.

Guardi may well have envisioned creating a series of paintings to chronicle the catastrophic blaze, just as he had previously documented great ceremonial occasions (see cat. 8). He made at least four drawings of the fire, each showing it at a different stage. The earliest and most beautiful of the drawings (fig. 1) is characterized by a flexible line and spirited brushwork, and clearly served as the basis for the paintings now in Munich and Venice. Another drawing with important variations is also in the Museo Correr in Venice (Kultzen 1968, 15). The figures on this sheet are in Guardi's hand, but the rather dry and awkward architectural passages were added later by the

Cat. 10

Carlo Saraceni

Venice c. 1580/1585–1620 Venice

10 *The Vision of Saint Francis*

c. 1618–1620
oil on canvas
242 x 165 (95¼ x 64⅞)
signed on the table, *CARLO SARACENI VENETIANO. F.*
inv. no. 113

The period after the Council of Trent witnessed a general reshaping and redefinition of religious themes in the visual arts. Among the new themes introduced were stories stressing Saint Francis' mystical experiences during prayer, rather than the narrative aspects of his life. Carlo Saraceni's painting, which depicts Saint Francis' vision of a musical angel, is typical of the new subject matter to emerge during this period. Theologians drew parallels between Saint Francis' visionary experiences and the life of Christ. These experiences were seen as the embodiment of Christ's Passion, and revealed how the power of prayer might transform and reshape the inner life of any true believer.

The musical angel appeared to Saint Francis during his stay at the house of Canon Tebaldo Sarraceni in Rieti in 1225. This was the year after he had received the stigmata on Mount Alverna and a year before his death in 1226. Afflicted with ill health and apparently suffering great pain from the open wounds of the stigmata, Saint Francis asked one of the brethren to play some music to distract his mind. The friar, according to some sources (Askew 1969, 298–299; Rome 1982, 161–162), was reluctant to grant such a frivolous request. The following

night, however, Saint Francis was visited by an angel who played a melody so sweet that it ravished his soul and transported him to a realm beyond all bodily sense.

In Saraceni's painting Saint Francis is shown reclining on a simple wooden bed as a cloud-borne angel playing a *lira da braccia* appears before him. At his feet is a brother friar absorbed in a book and totally oblivious of the consoling strains of heavenly music. The necessities of their humble daily life are rendered with the minute precision of a northern still-life painter. The choice of an interior setting and the inclusion of these descriptive details probably owes something to Paolo Piazza's lost painting of the same subject, which was recorded in a print of 1604 by Raphael Sadeler (fig. 1). Piazza's sickroom is crammed with every imaginable aid to religious contemplation and several christological symbols. By comparison, Saraceni's monastic cell is an exemplar of spartan restraint.

The austerity of Saraceni's setting is underscored by the monochromatic palette, which ranges from cool beige and gray to warm brown in the lower part of the painting only. Above, the angel appears in a burst of vibrant color. Resplendent in red, blue, and gold robes, the angel ironically seems

Rogat in gram ægritudine D.Franciscus olim doctum fidibus canere F Pacificum vt leuando aliquantulum dolori,fidibus DEI laudes decantet dissuadet ille Patri bene accipienti timore offensæ aliorū & illico DEI nutu præsens Angelus vnico plectri per fides ductu miris implet Diui mentē gaudiis

Capit, et extemplo GENIVS chely ludere cessat: Vinctus Aligeri, nullenis ducitur antris: Lætitia tanno infabilis mania omnia nostri est
Omnis in ægroti corpore vena salit. In chely nonne tuis PACIFICE Æger ait. Mæror apud SVPEROS vnica gutta mari.

SERENISSIMÆ ELISABETHÆ VTRIVSQ. BAVARIÆ DVCISSÆ DOMINÆ
SVÆ CLEMENTISSIMÆ.
Raphael Sadeler eius Chalcographus D.D.

Fig. 1. Raphael Sadeler (engraving after Paolo Piazza), *Saint Francis Consoled by a Musical Angel,* Museo Francescano, Rome

more alive, more plausibly of flesh and blood than Saint Francis and his companion. This visual separation between the earthly and heavenly realms is also conveyed by the placement of figure and objects within the setting. The bed, chair, tables, and small necessities of earthly life are carefully woven into a dense pattern of interlocking diagonals. Saint Francis and his pain are quite literally tied to this world, while the angel floats unencumbered. Only in death will Christ's promise of everlasting life be fulfilled and Francis released to the angel's heavenly kingdom.

Saraceni was a Venetian by birth,

but the years of his artistic maturity were spent in Rome. Works such as *The Vision of Saint Francis,* which were done shortly after his return to Venice in 1618, show the marked influence of Caravaggio and his Roman followers. Saraceni shares Caravaggio's sense of rhetorical form, dramatic monumentality, and unflinching naturalism. Although his work lacks Caravaggio's authentic conviction of feeling, Saraceni could masterfully imitate the outward appearance of Caravaggio's style. In this picture the powerful contrast of light and shade is similar in principle to Caravaggio's, but less effective in shaping the emotional content of the work.

The large scale of *The Vision of Saint Francis* suggests that the painting was conceived as an altarpiece, although we do not know for which church it was intended. Apparently it is one of the paintings mentioned in Saraceni's will of 13 June 1620. An agent for the duke of Bavaria who was later to become Elector Maximilian I, Sebastian Füll von Windach, paid Saraceni 250 *scudi* for three paintings, one of which was an altar of Saint Francis (Ottani Cavina 1968, 90). In his will Saraceni also left a virtually identical but smaller version of the composition to the friars of the Venetian church Il Redentore, where it remains today. Like the Munich picture, this second version seems to have been painted during the last two years of the artist's life.

B.L.B.

PROVENANCE
obtained in 1620 by Sebastian Füll von Windach, an agent of the duke of Bavaria

LITERATURE
Ellis Waterhouse, *Italian Baroque Painting,* London, 1962; Alfred Moir, *The Italian Followers of Caravaggio,* 2 vols., Cambridge, Mass., 1967; Anna Ottani Cavina, *Carlo Saraceni,* Milan, 1968; Pamela Askew, "The Angelic Consolation of St. Francis of Assisi in Post-Tridentine Italian Painting," *The Journal of the Warburg and Courtauld Institutes* 32 (1969), 280–306; *L'immagine di San Francesco nella Controriforma,* exh. cat., Istituto Nazionale per la Grafica, Rome, 1982.

Jacopo Robusti, called Tintoretto
Venice 1518–1594 Venice

11 *Venus and Mars Surprised by Vulcan*

c. 1551–1552
oil on canvas
135 x 198 (53⅛ x 78)
inv. no. 9257

Jacopo Robusti, the son of a dyer or *tintore* (from which word the name Tintoretto is derived), possessed a voracious appetite for novelty. The origins of his artistic training remain a mystery, but perhaps this is of little consequence given the enormous originality and power of inventiveness his style showed from the very beginning. Early in his career Tintoretto heartily embraced the mannerist vocabulary that had been established in central Italy and Emilia during the 1520s and 1530s, but he never subscribed to its precious and jewellike quality. Instead, he unabashedly borrowed from Michelangelo's work, aggrandizing his figures and endowing them with the robust plasticity of sculpture. Although elements of his style were certainly inspired by others, in works such as *Venus and Mars Surprised by Vulcan* Tintoretto proved that he could shuffle, reshape, and infuse them with a sly sense of visual and literary wit expressly his own.

The story of the adulterous liaison between Venus and Mars is told by both Homer (*Odyssey,* 8: 266–369) and Ovid (*Metamorphoses,* 4: 170–193) and was well known during the Renaissance. Vulcan, the cuckolded husband of Venus, surprised the couple, caught them in a golden net, and subjected them to the ridicule of the assembled gods. Tintoretto's version departs from the classical texts in almost every aspect, and may well have been based on a contemporary version of the tale. The artist has transferred the scandal on Mount Olympus to the bedroom of a Venetian palace. Here a handsome yet obviously elderly and jealous Vulcan lifts drapery from Venus' creamy thighs in search of incriminating evidence. But he may be too late. Cupid appears to sleep peacefully in the afternoon sunshine, while the nimble young Mars, fully clad in a suit of shining armor, has ducked under a nearby table. The ruse is undone, however, by the small dog who excitedly yelps at the war god, giving away his tactical position.

The entire scene is staged with the tongue-in-cheek precision of a French farce, in which the actions of the gods are made to resemble the foibles of humanity. The betrayed husband, who peers beneath a scant cloth unlikely to conceal anything, cuts a ridiculous figure, but no more so than the "heroic" Mars who cowers on all fours. Venus, set by Tintoretto like a precious pearl in an opulent setting, raises her bedsheet in an ambiguous gesture that reveals and conceals her nudity all at once. Cupid repeats her gesture as if he alone were privy to the joke. The parody, of course, is intentional. Tintoretto's elaborate invention establishes a visual counterplay of forms that rivals

the complexity of the Tuscan mannerists. Like that of his central Italian predecessors, Tintoretto's visual intricacy is amplified by a series of intricately layered meanings. The key to these multiple readings lies in the mirror on the dressing table.

The large round mirror reflects, although slightly inaccurately, the comedy being played out before us. Its presence is integral both to the interpretation of the painting and to its perspectival system. As the preparatory sketch in Berlin (Kupferstichkabinett, no. 4193; Tietze 1948, fig. 55) clearly demonstrates, the mirror is the vanishing point for the obliquely arranged composition. It is also a type of alarm system. In the *Roman de la Rose,* a French poem that was popular in Italy, the observation is made that if the lovers had employed a mirror, they would have been forewarned of Vulcan's approach and Mars would have had time to hide (Lord 1970). Although the relationship between Mars and Venus may

not have been the most legal, it was nevertheless commonly used as an allusion to marriage (Panofsky 1962, 162–164; Barolsky 1978, 33–46, 90–96, 113–115; Christiansen 1986). Playful or satirical treatments of the couple were frequently executed for nuptial banquets or as gifts commemorating a wedding. The Munich picture contains several allusions to traditional wedding symbols, chief among which is the mirror. Like the clear crystal vase on the window ledge, which is penetrated but not broken by light, the spotless mirror is a symbol of virginal purity. Even the yapping dog can be seen as an emblem of marital faith. As the mother of love, Venus was the patroness of marriage. Tintoretto's combination of humor, sexual innuendo, and cunning references to fidelity strongly suggests that the painting was originally commissioned in connection with a Venetian wedding.

The mirror also held a more personal reference, if not a challenge for Tinto-

retto. In Venice in 1548 Paolo Pino published his *Dialogo di pittura,* in which he described how a painter might rival the three-dimensionality of sculpture by including a mirror in his painting to reflect the reverse of a figure (fol. 27v). The rivalry for supremacy between painting and sculpture was seen during the Renaissance as a contest known as a *"paragone."* Tintoretto, it would seem, entered into the dialogue of *paragone* with one particular sculptor in mind—Michelangelo. A variety of contemporary sources reports that Tintoretto had reduced-scale reproductions made of Michelangelo's best statues, especially those in the Medici Chapel (Coffin 1951, 119). Tintoretto and the members of his workshop freely adopted the poses of these statuettes for figures in their various paintings and drawings. It has been suggested that the Venus in the Munich painting derives from Michelangelo's *Aurora* in the Medici Chapel (Coffin 1951, 122–123; but see also Pallucchini and Rossi 1982, 1:163, no. 155, who disagree). However, as we have already noted, her pose is closely related to that of the sleeping Cupid and it was the sleeping Cupid, not Venus, that was probably based directly on a now-lost work by Michelangelo. There is no consensus as to the exact appearance of Michelangelo's *Sleeping Cupid* (Agosti and Farinella 1987, 43–47), but clearly a sleeping Cupid similar to the one now in the Methuen Collection at Corsham Court (fig. 1) was well known throughout Italy and generally believed to be by the great Florentine sculptor (see cat. 2). Michelangelo's *Sleeping Cupid* was famous as a counterfeit antique that had fooled even the most discerning connoisseurs. By overtly referring to it in his picture, Tintoretto may have claimed the su-

Fig. 1. Sixteenth-Century Italian, *Sleeping Cupid*, Methuen Collection, Corsham Court, Wiltshire

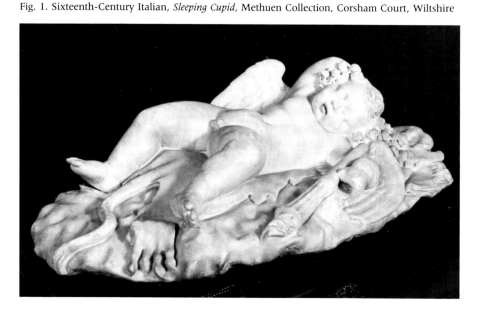

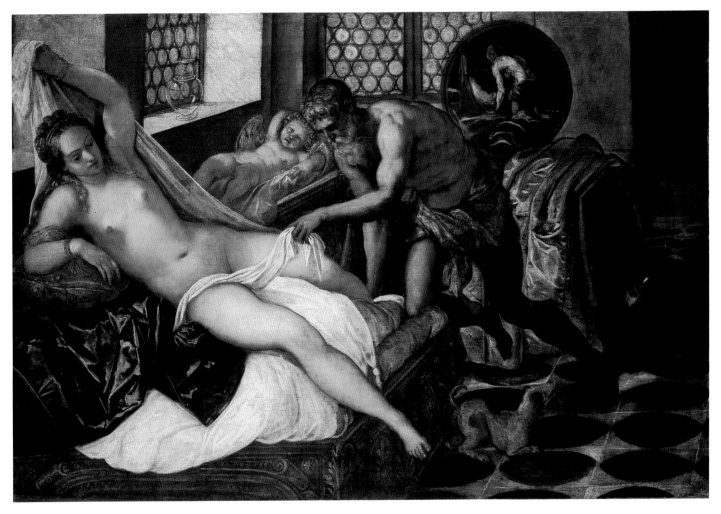

Cat. 11

premacy of his painting over Michelangelo's sculpture.

The union of Venetian and central Italian aesthetics is consummated in Tintoretto's work. The Venetian artist's acknowledged reliance on central Italian models was perhaps best expressed in 1648 by Ridolfi's famous account of a slogan supposedly hung on the wall of Tintoretto's studio: "Il disegno di Michel Angelo e'l colorito di Tiziano" ("the drawing of Michelangelo and the color of Titian." Ridolfi 1914–1924, 2:14). Actually this formula had already been proposed by Paolo Pino in 1548 (Pino 1946, fols. 24v–25r), but it is in works such as *Venus and Mars Surprised by Vulcan*, from Tintoretto's early maturity, that we find the words put into action. Through the means of light and color Tintoretto has transferred the sculptural form of Michelangelo into painted illusion.

B.L.B.

PROVENANCE
purchased in 1925

LITERATURE
Paolo Pino, *Dialogo di pittura* (Venice 1548), edited by Rodolfo and Anna Pallucchini, Venice, 1946; Carlo Ridolfi, *Le maraviglie dell'arte* (Venice, 1648), edited by D. von Hadeln, 2 vols., Berlin, 1914–1924; Detlev von Hadeln, "Early Works by Tintoretto—II," *The Burlington Magazine* 41 (1922), 278–288; Hans Tietze, *Tintoretto: the Paintings and Drawings*, New York, 1948; David R. Coffin, "Tintoretto and the Medici Tombs," *The Art Bulletin* 33 (1951), 119–125; Erwin Panofsky, *Studies in Iconology*, New York, 1962; Carla Lord, "Tintoretto and the *Roman de la Rose*," *Journal of the Warburg and Courtauld Institutes* 33 (1970), 315–317; Paul Barolsky, *Infinite Jest, Wit and Humor in Italian Renaissance Art*, Columbia, Mo., and London, 1978; Rodolfo Pallucchini and Paola Rossi, *Tintoretto: le opere sacre e profane*, 2 vols., Milan, 1982; Keith Christiansen, "Lorenzo Lotto and the Tradition of Epithalamic Paintings," *Apollo* 124 (1986), 166–173; Giovanni Agosti and Vincenzo Farinella, *Michelangelo e l' arte classica*, exh. cat., Casa Buonarroti, Florence, 1987.

Jacopo Robusti, called Tintoretto
Venice 1518–1594 Venice

12 *Christ in the House of Mary and Martha*

c. 1580
oil on canvas 200 x 132 (78¾ x 51⅞)
signed at lower left, *JACOBVS TINTORETVS. F.*
inv. no. 4788

Although Tintoretto's *Christ in the House of Mary and Martha* was probably commissioned by a patrician family from Augsburg for that town's Dominican church, it is quintessentially Venetian in conception. The altarpiece's simple and lucid narrative is typical of art following precepts of the Council of Trent, in which the legibility of the sacred story was of primary importance. Just as Tintoretto masterfully staged *Venus and Mars Surprised by Vulcan* (see cat. 11) as a piece of comic opera, so here he has created what may be termed "a theatre of religious piety" (Rosand 1982, 190–198). The human and dramatic value of the religious themes are manifest with a powerful clarity. Tintoretto sets the action so that the audience becomes a witness to an unfolding drama.

The story of Christ's visit to Martha and her sister Mary, who was generally presumed to be Mary Magdalen, is taken from the Gospel of Luke (10:38–42), which recounts how "a woman named Martha welcomed him [Christ] to her house. And she had a sister called Mary, who also seated herself at the Lord's feet and listened to his word. But Martha was busy about much serving and she came up and said 'Lord, is it no concern of thine that my sister has left me to serve

Cat. 12

alone? Tell her therefore to help me.' But the Lord answered and said to her, 'Martha, Martha, thou art anxious and troubled about many things; and yet only one thing is needful. Mary has chosen the best part, and it will not be taken away from her.'" This passage is often interpreted as a parable of the active and contemplative paths to salvation. After hearing Christ's words Mary repented, eschewing all worldly things. But unlike Gentileschi's *The Conversion of the Magdalen* (see cat. 7), in which Mary is shown in a chaste and pure state, here she has yet to cast away her mundane belongings and is bedecked in the jewels and dress of contemporary Venice.

Tintoretto has chosen the moment when the industrious Martha has come forward to question Mary's idleness. The story is told with extraordinary economy, the role of each protagonist being characterized through a single gesture. Martha points an accusatory finger toward her sister, whose gaze is fixed with rapt attention on Christ enumerating each point on his fingers. Christ and Mary are shown in profile, like two interlocking pieces of a jigsaw puzzle. Martha completes the triad, which seems to loom larger than life, dominating the vast Venetian interior. The space rises quickly and obliquely behind the protagonists. A table thrust diagonally across the space effectively separates the key actors from the three incidental players. The Apostles, who presumably accompanied Christ on his visit, witness the event from beyond an open door. But we, Tintoretto's privileged audience, are given a more immediate experience. We view the scene from close above, as if we were actually part of the perspectival system and involved in the drama itself.

The dynamic balance established between the foreground figures and the subsidiary scenes is orchestrated with a rhythmic elegance and supernatural illumination. Tintoretto employs a complex and contrasting chiaroscuro, in which the reverberating light silhouettes the figures against their neutral background. Within the general somber tonality there are isolated pockets of rich, intense light. The kitchen interior with its gleaming copper caldrons and silver plates seems artificially illuminated from a source unconnected to either the brightly burning fire or to the other interior spaces. Outside, the brilliant sunlight falls on the Apostles, sharply defining a calligraphic network of drapery folds. Mary and Martha are bathed in a radiant glow, which seems to emanate from within Christ himself. The compromise that Tintoretto makes, here, between illusionistic sleight of hand and narrative legibility is similar to that which he accomplished in one of his most impressive commissions— the main room on the upper story of the Scuola di San Rocco in Venice. Tintoretto worked on these decorations between 1575 and 1581, and the closeness of their style to *Christ in the House of Mary and Martha* makes it possible to date this work within the same period.

B.L.B.

PROVENANCE
acquired in 1803 from the Dominican church in Augsburg

LITERATURE
E. Von der Bercken, "Die Tintoretto-Ausstellung in Venedig," *Pantheon* 20 (1937), 229–254; Eric Newton, *Tintoretto*, London, 1952; Robert Oertel, *Italian Painting from the Trecento to the End of the Renaissance*, Munich, 1961; Rodolfo Pallucchini and Paola Rossi, *Tintoretto: le opere sacre e profane*, 2 vols., Milan, 1982; David Rosand, *Painting in Cinquecento Venice: Titian, Veronese, Tintoretto*, New Haven and London, 1982; *La Maddalena tra Sacro e Profano*, exh. cat., Palazzo Pitti, Florence, 1986.

Tiziano Vecellio, known as Titian

Pieve di Cadore c. 1488–1576 Venice

13 *Vanity*

c. 1515
oil on canvas
97 x 81.2 (38⅛ x 31¾)
inv. no. 483

The young woman in Titian's *Vanity*, who confronts the viewer in such a simple and straightforward manner, is neither as simple nor as straightforward as she first appears. The evolution of the composition, the identity of the subject, and even Titian's authorship have all been called into serious doubt. While recent advances in scholarship and technical analysis have answered some of these questions, many aspects of the painting's history remain unknown.

Attempts to identify *Vanity* with a picture in Emperor Rudolf II's celebrated *Kunstkammer* have proved unsuccessful. The first definite mention of the painting is found in a 1618 inventory of the Munich Residenz, where it is listed as a Palma Vecchio and paired with Paris Bordone's *Jeweller* (Alte Pinakothek, Munich). It appears in subsequent inventories as by Salviati, Palma, Titian, Palma again, Giorgione, and, since 1884, Titian (GK.IX, 171–172; Kat.AP.V, 119–120). Over the years scholars have considered it to be a copy after a lost work by Pordenone, Giorgione, or Titian. After extensive technical examinations in the mid-1960s, the painting was generally accepted as an early work of Titian (Verheyen 1966; Wethey 1975, 184–185, no. 37). It was acknowledged, however, that certain changes, most conspicuously the reflection in the mirror,

were made by other hands, probably between 1530 and 1550 and possibly again during the seventeenth century. Pallucchini (1969, 1:245–246) suggests that the sixteenth-century alterations were made by Lambert Sustris, but this seems difficult to verify.

Today the painting is most frequently interpreted as an allegorical representation of Vanity. The mirror that the young woman holds alludes to the sin of worldliness, the transitory nature of beauty, and the need for prudence and truth. These traditional meanings were augmented in the mid-sixteenth century by a reflection painted in the mirror showing a selection of coins and precious jewels—the corrupting treasures of an earthly existence—and a representation of Virtue in the guise of an elderly woman holding a distaff (Verheyen 1966; Panofsky 1969, 93–94). Possibly during the seventeenth century a smoking candle was added to the composition, reinforcing the idea that life and beauty are quickly snuffed out.

However, x radiographs of the Munich canvas (fig. 1) show that Titian originally planned a very different painting. Instead of a mirror, the woman held a book, her head was more erect, her gaze was more frontal, her dress was more revealing, and her left hand was raised toward her shoulder where it caught her flowing tresses

Cat. 13

in a manner similar to Titian's so-called *Laura Dianti* (Musée du Louvre, Paris). While it is true that Titian transformed his lady into an allegory of Vanity by giving her a mirror, the most overt references to the theme were supplied by later hands. Titian's initial conception was much closer to that found in his other paintings of the period, which celebrated the obvious and accessible beauty of Venetian women.

Around 1515 Titian produced a series of half-length female figures using various pretexts for subject matter. Besides *Vanity* and the so-called *Laura Dianti*, there was a *Flora* (Galleria degli Uffizi, Florence). The allegorical attributes of these comely ladies were minimized as Titian frankly concentrated on their sensuous appeal. In them he captured the appearance of existing reality with sharp acuity. Their softly curved female forms, firm pink flesh, and silken tresses are palpably real, so much so that Titian's images, in both their physical and psychological effect, lie on the verge of portraiture. It is entirely possible that these pictures are among the earliest representations of Venice's celebrated courtesans. It is a type of image that can be traced back to Giorgione's bare-breasted poetess *Laura* (Kunsthistorisches Museum, Vienna) and which Palma Vecchio and Paris Bordone were later to specialize in. But the poet Bernardo Tasso claimed that it was to Titian that a man should turn if he wanted a portrait of his mistress: "invitando Titiano, à far l' effigie d'una sua Favorita" (quoted in Ridolfi 1914, 1:195). Portraits of these Venetian ladies proved to be as extremely popular in northern Europe, where gentlemen avidly collected them (Kettering 1983, 54). During the next century, northern artists translated the genre into an arcadian idiom, as seen in Paulus Moreelse's *The Fair Shepherdess* (see cat. 37).

Prostitution was one of the great institutions of sixteenth-century Venice. It was dignified by a spurious association with cultural aspirations and classical philosophy (Lawner 1987, 52–60, 92–97). Garbed in ancient dress, cour-

Fig. 1. X radiograph, Titian, *Vanity*

tesans often carried elegantly bound volumes of poetry, whether they could read or not. Although the figure beneath Titian's *Vanity* is sometimes called a sibyl because she holds a book, there is nothing in the imagery that precludes her identification as a professional beauty. This is all the more likely in that her left breast was originally exposed. In fact, her entire demeanor conformed to the standard courtesan type: her dress was in conspicuous and purposeful disarray, her

gauzy white chemise revealed a plump and tender bosom, and her hair fell loosely about her shoulders (Ingenhoff-Danhäuser 1984, 55–64). Even after Titian's chastening revisions and allegorical additions, the Munich canvas retained its concupiscent connotations, for mirrors, even more than books, were the province of courtesans. Not only did mirrors have magical and seductive powers in the hands of sirens, but the sixteenth century expected that the sin of vanity and the temptation of

narcissism were greatest among dishonorable ladies who admired their own images in mirrors.

We do not know who Titian's *Vanity* was, or what gentleman may have asked for her likeness to be recorded. To be sure, Titian has idealized her, but her invitation to sensuous pleasure could not be more real. One is reminded of Hans Tietze's remark that, looking at Titian's ladies, "one is tempted to ask for their names, possibly even addresses" (Tietze 1936, 1: 159).

<div align="right">B.L.B.</div>

PROVENANCE
listed in 1618 in an inventory of the Munich Residenz

LITERATURE
Carlo Ridolfi, *Le maraviglie dell'arte* (Venice 1648), edited by D. von Hadeln, 2 vols., Berlin, 1914–1924; Hans Tietze, *Tizian: Leben und Werk*, 2 vols., Vienna, 1936; Julius Held, "Flora, Goddess and Courtesan," *Essays in Honor of Erwin Panofsky* 1 (1961), 201–218; Egon Verheyen, "Tizians 'Eitelkeit des Irdischen' Prudentia et Vanitas," *Pantheon* 24 (1966), 88–99; Rodolfo Pallucchini, *Tiziano*, 2 vols., Florence, 1969; Erwin Panofsky, *Problems in Titian Mostly Iconographic*, New York, 1969; Harold E. Wethey, *The Paintings of Titian III: The Mythological and Historical Paintings*, London, 1975; Alison McNeil Kettering, *The Dutch Arcadia: Pastoral Art and Its Audience in the Golden Age*, Montclair, N.J., 1983; Monika Ingenhoff-Danhäuser, *Maria Magdalena, Heilige und Sünderin*, Tübingen, 1984; Lynne Lawner, *Lives of the Courtesans*, New York, 1987.

Flemish Paintings

Adriaen Brouwer
Oudenarde 1605/1606–1638 Antwerp

14 *The Sense of Hearing*

c. 1635
oil on oak
24.3 x 20 (9½ x 7⅞)
inv. no. 629

In the dimly lit interior of an inn, a group of peasants lustily sings to the music of a violin player. This young man, jauntily seated on a barrel stool and dressed in a green jacket and red cap, looks directly out at the viewer as he plays a violin and joins joyfully in the song.

Through the rich atmospheric qualities of the scene, the spontaneous brushwork, and expressive characterization of the figures, one has the impression that Brouwer painted this lively picture while sitting in the inn. Rather than being a random view from life, however, this painting has been carefully conceived to represent the sense of hearing, and belongs to a long tradition of depictions of the five senses. The violin player, through his central placement, distinctive colors, and individual characterization, is the focus of the scene, while the subsidiary figures reinforce the theme. At least one series of the five senses is documented to Brouwer's lifetime, but it is not sure that this painting belonged to such a series (Renger 1986, 51). No other examples of representations of the senses with this precise compositional format exist.

In Haarlem, where Brouwer studied with Frans Hals during the late 1620s, representations of the five senses frequently had a strong moralizing character. The excesses of sensual pleasure, particularly among the upper classes, were shown to be weaknesses in man's moral character (Kauffmann 1943). No such negative message is apparent here, as one witnesses a celebration of song and music in a rustic setting. This emphasis may be a result of the strong Flemish orientation of Brouwer's art, particularly the influence of the tradition of Pieter Bruegel the Elder. Bruegel's positive vision of peasant life in his paintings, drawings, and prints was known to Brouwer not only firsthand, but also through painted copies by Bruegel's sons, and through reproductive prints. Early seventeenth-century artists working in the Bruegel tradition, among them David Vinckboons and Roelandt Savery, probably also influenced his work.

Despite these Flemish precedents and despite the fact that Brouwer apparently executed this work around 1635, a few years after he returned to Antwerp from the Netherlands, the expressive character of this small painting owes a tremendous debt to Frans Hals. The spontaneous quality of this image has precedents in such works as Hals' *Jolly Toper* (Rijksmuseum, Amsterdam) from the mid 1620s. Hals' smaller pictures on panels, such as *Young Boy With a Large Hat* (c. 1626, National Gallery of Art, Washington) are also thinly painted and executed in a comparable sketchy technique. Brouwer's

genius was in his ability to fuse Hals'
stylistic innovations with Flemish the-
matic traditions to produce a new vi-
sion of lower-class existence.

<div align="right">A.K.W.</div>

PROVENANCE
acquired in 1696 from Gisbert van Ceulen

LITERATURE
Hans Kauffmann, "Die Fünfsinne in der nie-
derländischen Malerei des 17. Jahrhunderts,"
*Kunstgeschichtliche Studien: Festschrift für Dago-
bert Frey zum 23. April 1943*, edited by Hans
Tintelnot, Breslau, 1943, 133–157; Gerard
Knuttel, *Adriaen Brouwer: The Master and His
Work*, The Hague, 1962; Konrad Renger, *Adri-
aen Brouwer und das niederländische Bauerngenre
1600–1660*, Munich, 1986.

Adriaen Brouwer
Oudenarde 1605/1606–1638 Antwerp

15 *Peasants Smoking*

c. 1635
oil on oak
35 x 26 (13¾ x 10¼)
inv. no. 2062

One of Bouwer's favorite themes was
the smoker. He often depicted, as he
does here, the various pleasures smok-
ers derived from this activity—from the
delight in slowly exhaling with up-
turned mouth to the gentle sleep in-
duced by the strong narcotic effect of
early seventeenth-century tobacco. That
he combines smoking and drinking in
this depiction of peasants within a
dimly lit tavern is no accident, for
smoking was often referred to as "to-
bacco drinking," and the stupefying ef-
fects it brought about were compared
to those induced by alcohol (Renger
1986, 35–38). Indeed, beer drinking
and pipe smoking were frequently en-
joyed together, and numerous seven-
teenth-century tavern scenes depict
revelers holding a clay pipe in one
hand and a beer stein in the other.

Tobacco was only introduced into
the Netherlands at the end of the six-
teenth century, one of the conse-
quences of the discovery of the New
World. While viewed by some as an
herbal panacea against disease and the
plague, smoking for enjoyment was
distrusted and often condemned (Gas-
kell 1987, 119–121). Associations were
made between the sensual pleasures of
smoking and immoral behavior. Peter
Scriverius, in his treatise *Het Gebruyk
ende Misbruyk van den Taback* (The Use
and Misuse of Tobacco) published in
Haarlem in 1628, about the time Brou-

Cat. 15

wer was in the city, railed against the effects of tobacco and emphasized the transitory pleasures of its effects.

To become unconscious through drunkenness, whether alcohol or tobacco induced, meant exposing oneself to derision. The figure dressed in a green jacket and red hat in the foreground of this painting is ridiculed by the man blowing smoke in his ear. Brouwer adds a commentary on the scene in the form of a drawing of an owl tacked up on the wall over the door. The owl recalls old proverbs such as "Drunk as an owl," and "What use are candles and spectacles if the owl won't see." Drunkenness thus becomes associated with ignorance and degradation (Schama 1987, 208–209).

As with *The Sense of Hearing* (see cat. 14), Brouwer has isolated one figure by the color of his clothes and by his placement in the foreground of the painting. The artist's intent in both pictures is to focus the viewer's attention on the theme or moral he is portraying within the context of a tavern scene.

A.K.W.

PROVENANCE
acquired in 1698 from Gisbert van Ceulen

LITERATURE
Konrad Renger, *Adriaen Brouwer und das niederländische Bauerngenre 1600–1660*, Munich, 1986; Ivan Gaskell, "Tobacco, Social Deviance and Dutch Art in the Seventeenth Century," in *Holländische Genremalerei im 17. Jahrhundert: Symposium Berlin 1984*, edited by Henning Bock and Thomas W. Gaehtgens, Berlin, 1987; Simon Schama, *The Embarrassment of Riches: An Interpretation of Dutch Culture in the Golden Age*, New York, 1987.

Jan Brueghel the Elder
Brussels 1568–1625 Antwerp

16 *Inn by a Riverside Road*

c. 1604–1608
oil on copper
diameter 21 (8¼)
signed at lower left, BRVEG. . .16. . .
inv. no. 837

Pieter Bruegel the Elder's vision of the world, evident in his paintings, drawings, and prints, transformed the way artists looked at nature. Pieter (active by 1551–died 1569) was the first master to convey both a sense of the majesty of the land and the delicacy and variety of natural forms contained within it. By the end of the sixteenth century, at the height of what is called the "Bruegel revival," few Dutch or Flemish artists could escape the overwhelming impact of his landscape images. Some artists, particularly Bruegel's oldest son, Pieter Brueghel the Younger, and Abel Grimmer, made a living by producing copies of the older master's art. Jacques Savery executed drawings in Bruegel's style, and falsely dated and signed them with Bruegel's name to create, in effect, forgeries. Joos de Momper specialized in fanciful, mountainous vistas inspired by Pieter Bruegel the Elder's famous alpine scene that had been engraved by Hieronymous Cock. By far the most sensitive and innovative of followers of Bruegel, though, was Jan Brueghel the Elder, the third child of Pieter Bruegel and Mayken Coecke.

Jan Brueghel, also known as "Velvet" Brueghel because of the delicacy of his brushwork, was an artist of remarkable versatility. Not only did he depict village views that focused on the

Cat. 16

activities of the wayfarers passing near picturesque inns on the outskirts of town, as is evident in two of his landscapes in this exhibition (see also cat. 18); he also painted seascapes and river views, mountain panoramas and forest interiors, and evocative scenes of hell and the underworld as well. He used many of his landscape vistas as settings for mythological, allegorical, and historical scenes (see cat. 17). Finally, he was a specialist in flower painting and in the depiction of precious objects.

Jan apparently received his early training in Brussels, the city of his birth, but the first recorded works by him date to the mid-1590s, when he was in Italy. His early style reflects the work of Paul Bril (1554–1626), an artist from Antwerp painting in Rome who was a close follower of Pieter Bruegel the Elder. In 1597, after returning to Antwerp, Jan entered the Saint Luke's Guild there and quickly established himself as an important member of the artistic community. He served as dean of the guild in 1602. In 1606 he entered the service of Archduke Albert and Archduchess Isabella, the regents in the southern Netherlands, and retained the position of court painter until his death. He frequently collaborated with Peter Paul Rubens after Rubens' return from Italy in 1608. In their collaborative works Rubens painted the large-scale religious or allegorical figures and Brueghel provided the setting, including landscape, animals, flowers, and other still-life elements. Brueghel's work was valued highly and sought after by kings and princes throughout Europe.

In this small roundel painted on copper, the artist has focused in the foreground on a family unloading a horse-drawn cart in the shadow of a large tree. They have stopped along a path that borders a river that stretches into the light-filled distance. Despite the delicacy of his touch, particularly in detailing the distant buildings, trees, and fields, Brueghel did not fully integrate the transitions between the foreground elements and the distant panoramic landscape. While he utilized the river to join the two, the differences in scale and color are so pronounced that one sees the landscape in zones rather than as a smooth progression from near to far.

This characteristic, reflective of sixteenth-century landscape traditions, is representative of Brueghel's style during the latter half of the first decade of the seventeenth-century (the last two digits of the date of this work are lost). Consistent with this dating is the delicacy of the artist's touch in the jewel-like details of the panoramic landscape, a vista that reflects the flatness of the Flemish countryside rather than an imaginary mountainous terrain such as Brueghel depicted in his earlier works. The feathery quality of the overarching trees suggests that he executed this painting shortly after he had visited Prague in 1604 and had seen the delicate landscapes being produced by Pieter Stevens (1567–after 1624) and Roelandt Savery (1576–1639) at the court of Emperor Rudolph II. An imitation of *Inn by a Riverside Road*, falsely signed and dated 1622, was on the art market in 1962 (Ertz 1979, 216).

<div style="text-align: right">A.K.W.</div>

PROVENANCE
from the Electoral Gallery

LITERATURE
Klaus Ertz, *Jan Brueghel der Ältere (1568–1625)*, Cologne, 1979; Klaus Ertz, "Jan Brueghel de Oude," *Brueghel: Een Dynastie van Schilders*, exh. cat., Paleis voor Schone Kunsten, Brussels, 1980, 165–208; Thomas DaCosta Kaufmann, *L'Ecole de Prague: La Peinture à la cour de Rodolphe II*, trans. Solange Schnall, Paris, 1985; John Oliver Hand et al., *The Age of Bruegel: Netherlandish Drawing in the Sixteenth Century*, exh. cat., National Gallery of Art, Washington, 1986.

Jan Brueghel the Elder

Brussels 1568–1625 Antwerp

17 *The Magnanimity of Scipio*

1600
oil on copper
72.5 x 107 (28½ x 42⅛)
signed at lower left, *BRVEGHEL 160 (0?)*
FEC.ANVERSA.
inv. no. 827

From a viewpoint high on a hill overlooking New Carthage and the Iberian Peninsula, Brueghel has evoked not only the tumultuous battle that has just engulfed the city, but also the equanimity of Publius Cornelius Scipio Africanus, the commander of the victorious Roman forces. Even while fires still rage in the vanquished city and troops continue to mill about far below in front of the fortified walls, Scipio sits before his tent to determine the fate of the many Celtiberian hostages from New Carthage brought before him by his soldiers.

Brueghel based his image on Livy's accounts of Scipio's virtuous actions in the aftermath of this battle, which took place in 209 B.C. Livy, in book 26, part 49, line 11 through part 50, line 14, focused on two incidents to illustrate Scipio's ideal that good government should "bind men by favour rather than by fear." The most famous of these is the one shown here unfolding before Scipio. It concerns a beautiful maiden who was brought to him as a hostage. Upon questioning her he learned that she was betrothed to a leader of the Celtiberians. Scipio immediately summoned her fiancé and her parents, who came bearing a ransom of gold. Scipio presented the maiden to her betrothed and asked only that he become a friend of the Romans. After the maiden's parents insisted that Scipio should accept the ransom, the commander did so, and then presented it to the young couple.

The other incident portrayed by Brueghel is far less famous, but illustrates equally well Scipio's consideration for victims of war. Livy recounted how an older woman came before Scipio from the midst of the hostages to implore that he change his guards so that young maidens might be more carefully protected and comforted. Around her stood her nieces "in the bloom of youth and beauty." Touched by their dignity and the respect they showed their aunt, Scipio turned them over to "a man of proved uprightness," and ordered him to protect them (Livy 1943, 7:191). This gentleman and his charges are clearly visible in the middle of the horde of hostages and soldiers in the center of the composition.

This vast panoramic landscape is one of a number of similar works Brueghel executed shortly after he returned to Antwerp from an extensive trip to Italy (Ertz 1979, no. 61). One of his first stops on his travels was Naples, where he is documented in 1590. The city, with its vast harbor and dramatic setting, made a lasting impression on the young artist. Not only does the Castel

Cat. 17

Fig. 1. Jan Brueghel, *View of Castel dell'Ovo*, pen and ink, Museum Boymans-van Beuningen, Rotterdam

same way, his father would choose a high viewpoint and place his large-scale figures on a hill in the foreground overlooking a distant landscape. Jan Brueghel eases the dramatic shift in scale between these zones by including figures who are seen just over the crest of the hill. He also modulates his landscape with alternating bands of sunlight and shadow to draw one's eye to the distant mountain range.

Brueghel's delicate touch and wide range of figural types give his scene a lively, dynamic quality. Among the prominent figures are those on the rearing horses, whom Brueghel derived from images of riders in hunting-scene prints by Jan van der Straet of Bruges (1523–1605), known as Stradanus, and his student Antonio Tempesta (1555–1630). These riders serve to enhance the drama of Brueghel's historical narrative. The forcefulness and energy of the horsemen and their mounts emphasize the domination of the victors over the vanquished; at the same time, the passions that they symbolize reinforce the restraint and sense of equanimity evident in the actions of Scipio, their leader.

A.K.W.

dell'Ovo (fig. 1), which he drew from life, reappear in this painting, but the general description of the landscape setting is reminiscent of contemporary views of Naples (fig. 2). Brueghel used these motifs again in his *Large Fish Market* of 1603, which is also in the Alte Pinakothek.

Brueghel's ability to suggest the vastness of the landscape and the magnitude of the epic drama, as well as the nuances of feeling and emotion that unfold among the soldiers and hostages in the immediate foreground, has roots in the large landscape paintings of Pieter Bruegel the Elder. In much the

PROVENANCE
from the Düsseldorfer Galerie

LITERATURE
Livy, *Livy,* trans. Frank Gardner Moore, vol. 7, Cambridge, Mass., 1943; Klaus Ertz, *Jan Brueghel der Ältere (1568–1625),* Cologne, 1979.

Fig. 2. Jan van Stinemolen, *View of Naples,* gray, black, and maroon ink, Graphische Sammlung Albertina, Vienna

Cat. 18

Jan Brueghel the Elder
Brussels 1568–1625 Antwerp

18 Landscape with Village Inn

c. 1615–1620
oil on copper
32 x 44.5 (12⅝ x 17½)
inv. no. 826

Jan Brueghel is justly famed for his detailed depictions of landscape, in which every facet of the scene is described with careful yet fluid strokes of his brush. Often underappreciated, however, are the remarkable atmospheric effects he achieved through his subtle use of perspective and delicate nuances of color. These qualities are particularly evident in this work, one of Brueghel's most successful compositions from the second decade of the seventeenth century. Here the land flows gently into the distance as dirt roads and paths, river, trees, and buildings lead the eye into depth. Alternating pools of light and shade, as well as the activities of the figures in the foreground and middle ground, slow the progression into depth to allow the viewer to find delight in the scene while visually passing through it. Along the horizon, forms blend together in a subtle harmony of blues that suggests the hazy mist of the distant landscape.

The realistic character of this scene is far more pronounced than in Brueghel's earlier *Inn by a Riverside Road* (see cat. 16), in which foreground and background elements are separated by abrupt shifts in scale and color. This work is also distinctive for its openness and for the discreet manner in which the activities of travelers near the inn are integrated into the landscape.

Such stylistic tendencies in landscapes are generally associated with an indigenous Dutch tradition that evolved during the 1610s and 1620s, particularly in Haarlem (Stechow 1966, 15–25). Dutch landscapes at this date, however, cannot easily be separated from the Flemish tradition, since so many northern artists had immigrated into the Netherlands from Flanders for religious and economic reasons and were familiar with Brueghel's early works.

The relationship between Brueghel's later landscape style and the innovations of the Dutch artists Esaias van de Velde and Willem Buytewech in Haarlem around 1613 is particularly intriguing, for Brueghel visited Haarlem in 1613 when accompanying Peter Paul Rubens on a diplomatic mission to the Netherlands. One could argue that the naturalistic flow of the landscape in this work, for example, developed from Brueghel's awareness of Dutch innovations in the representation of landscape, even if the style of these Haarlem artists had roots in his own work.

A.K.W.

PROVENANCE
from the Electoral Gallery

LITERATURE
Wolfgang Stechow, *Dutch Landscape Painting of the Seventeenth Century*, London, 1966; Klaus Ertz, *Jan Brueghel der Ältere (1568–1625)*, Cologne, 1979, 221, 592, no. 206.

Anthony Van Dyck
Antwerp 1599–1641 London

19 The Lamentation of Christ

c. 1616/1617
oil on canvas
203.5 x 156.3 (80⅛ x 61½)
inv. no. 404

The ten-year-old Anthony Van Dyck entered the workshop of the artist Hendrick van Balen in 1609, an auspicious year for the southern Netherlands, and in particular for the city of Antwerp. Peace, and perhaps relief from the economic depression that had affected every aspect of communal life, was at hand. After years of turbulence and uncertainty because of the struggle by the northern provinces of the Netherlands for independence from Spanish control, the signing in April 1609 of a truce lasting for twelve years unleashed a flurry of building activity in Antwerp that would transform the character of the city. Most of these enterprises were, as one might expect from this Catholic stronghold, undertaken by the churches. With the repair of old buildings and the construction of new ones—including the great Jesuit church, expressly designed as a symbol of triumphant Catholicism in the North—came numerous commissions for altarpieces (Baudouin 1977, 65–111). The prospects for commissions were sufficient to encourage Peter Paul Rubens to remain in Antwerp when he returned from Italy at the end of 1608; they probably also affected the decision of Frans van Dyck, a prosperous Antwerp silk merchant, to direct his son toward a career as a painter.

Although Van Dyck undoubtedly remained with Van Balen for a few years, no evidence of the master's influence is to be found in the young artist's work. Far more appealing to Van Dyck must have been the work of Rubens. By 1618, when Van Dyck enrolled as a master in the Antwerp Saint Luke's Guild, Rubens described the precocious young artist as his best disciple. Just when Van Dyck entered Rubens' studio as an assistant is not known, but by 1616 he had begun to produce large-scale religious scenes that reflect an intimate knowledge of the older master's most recent compositions. Among these early works is this powerfully evocative painting.

Rubens' bold classicizing style after his return from Italy immediately established him as the primary artistic spokesman for the Counter-Reformation, whose tenets informed his many commissions for altarpieces. One of the subjects that best captured these ideals was the Lamentation of Christ, both because of its strong eucharistic character and because of the powerful emotions that the image of the dead Christ aroused in the viewer (Glen 1977, 88–97). Rubens depicted this subject a number of times between 1610 and 1620, including an altarpiece executed with workshop assistance in 1616 for the church of the Capuchins in Brussels (fig. 1).

Van Dyck derived the compositional core of his depiction of this subject

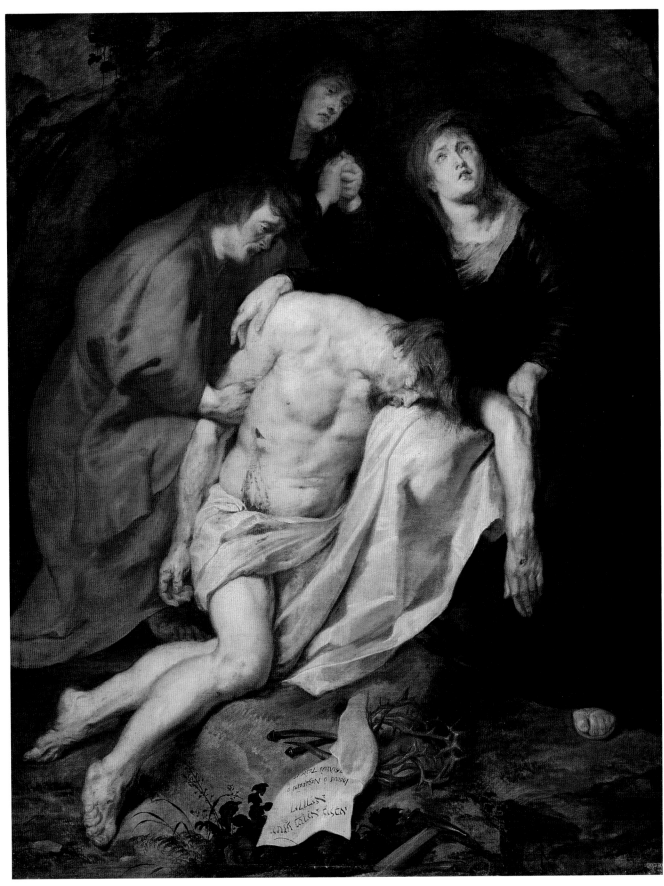

Cat. 19

awkwardly across the picture plane in a manner reminiscent of Christ's figure in Michelangelo's late *Pietà* (c. 1548–1556, Duomo, Florence). Saint John's anguished expression, as well as that of Mary Magdalen, heightens the emotional intensity of the scene. In the foreground lie reminders of Christ's cruel death: the crown of thorns, the nails and hammer, and the sheet of paper that was attached to the cross proclaiming Christ the "King of the Jews." Van Dyck's oil sketch for this painting is also in the Alte Pinakothek, Munich (inv. no. 67).

Nothing is known of the commission for this work, or how Van Dyck was able to produce major altarpieces before being named a master of the Saint Luke's Guild in 1618. Van Dyck's father possibly played some role in procuring him commissions. As president of the Confraternity of the Holy Sacrament of the Cathedral of Notre Dame, he must have had considerable influence within church circles.

A.K.W.

PROVENANCE
from the Düsseldorfer Galerie

LITERATURE
Frans Baudouin, *Pietro Paulo Rubens*, New York, 1977, 65–111; Thomas L. Glen, *Rubens and the Counter Reformation*, New York, 1977; Julius S. Held, *The Oil Sketches of Peter Paul Rubens*, 2 vols., Princeton, 1980; Christopher Brown, *Van Dyck*, Oxford, 1982.

Fig. 1. Peter Paul Rubens, *The Lamentation of Christ*, Koninklijk Musea voor Schone Kunsten van België, Brussels

from Rubens' altarpiece, a work that he certainly knew, perhaps even to the point of participating in its execution (for an oil sketch for Rubens' painting, once attributed to Van Dyck, see Held 1980, no. 362). In both works a recumbent Christ lies upright against the Virgin's knee while she gazes upward, offering the body of her dead son to God the Father. The mood in Van Dyck's painting, however, is quite different from that created by Rubens. Van Dyck has reduced the number of figures in the scene, focusing more strongly on the pathos of Christ's death and on the Virgin's role as an intermediary between heaven and earth. Christ is no longer a classically idealized figure. His head falls heavily to the side, while his hair hangs across his face. The rest of his body, supported only by the firm grasp of Saint John, droops

Anthony Van Dyck
Antwerp 1599–1641 London

20 *Self-Portrait*

c. 1618–1620
oil on canvas
82.5 x 70.2 (32½ x 27⅝)
inv. no. 405

Eugène Fromentin, a nineteenth-century writer, critic, and painter who commented perceptively on Dutch and Flemish art, described Van Dyck's artistic genius as a gift for giving "people who sat for him something of the grace of his own person—an appearance more habitually noble, a more gallant *déshabillé* [*sic*], a more elegant draping of the garments, hands generally more beautiful, purer and whiter than they really were" (Fromentin 1981, 84).

Van Dyck's genius as a portrait painter was also that he made the elegance and refinement with which he endowed his sitters seem integral to their character. Without doubt, as Fromentin suggests, this gift stemmed from his own personality, from his youthful, aristrocratic bearing and secure sense of his inherent artistic genius. As is evident in a contemporary description, Van Dyck's *Self-Portrait* accorded closely with reality: "he was remarkable for his seriousness and modesty and for the nobility of his appearance, even though he was slight of figure. His bearing resembled that of an aristocrat rather than a commoner; and he was conspicuous for his exquisite clothing. Accustomed to dealings with the nobility from Rubens' workshop and on account of his natural superiority, he was determined to attract attention to himself. He thus not merely attired himself in silk, but adorned his hat with feathers and wore a gold chain upon his breast" (Bellori 1972, 310, as translated by Kat.AP. 1986, 186).

Van Dyck's obvious pride in his appearance is evident in the number of self-portraits he made during his youth. Indeed, one of his first known paintings is a bust-length self-portrait, which he made when he was about fourteen or fifteen years old (Gemäldegalerie der Akademie der bildenden Künste, Vienna). The Munich *Self-Portrait* must have been painted in about 1618, at the time he joined the Antwerp Saint Luke's Guild. Although only eighteen or nineteen years of age, he had already established himself as a child prodigy and as Rubens' most valued assistant. In this work, however, he has portrayed himself not as a painter, but, following Rubens' example, as an elegant young aristocrat. His smooth skin and refined features give him a slightly effeminate quality as he peers out at the viewer with a pleasant and almost inquisitive expression. The elegant fingers of his right hand clasp a black satin cloak that is draped casually across his body to reveal a gold chain falling over his left shoulder.

The chain in this portrait has created some confusion about the intent and execution of this work. Gold chains were a traditional reward given by rulers or major nobility for outstanding

Cat. 20

service. By the sixteenth century, however, this honor was also bestowed on artists: Titian had received a gold chain from Charles II, and Rubens received one in 1609 from Archduke Albert and his wife, Isabella. In 1622 Van Dyck received a gold chain from Duke Ferdinand Gonzaga in Mantua, and the chain in this painting has been thought to depict that token of the Duke's esteem (Kat.AP. 1986, 184).

This explanation, however, seems unlikely. Chains had a broad range of emblematic meanings, and other explanations for this one's appearance are plausible, particularly since it is so discreetly displayed and since Van Dyck has not depicted a medallion hanging from it that would connect it with the gift from the duke. The chain, for example, was an attribute of *Honore*, honor, as well as of *Pittura*, painting (Ripa 1644, 116, 452), and as such it was a fitting attribute for a young artist who wished to project himself as an individual whose achievements and reputation were far greater than his youth would warrant.

Van Dyck's initial concept for this painting was quite different. X-rays reveal that he originally placed his right hand near his cheek, playfully fingering his collar. He expanded upon this initial idea a few years later, in a three-quarter-length self-portrait now in New York (fig. 1). When he changed his compositional scheme in the Munich picture, he enlarged the canvas on all four sides and painted in the chain and cloak as well as the new right hand. He probably felt that this restrained pose was more suitable for expressing the seriousness of his social and artistic aspirations than was the informal and casual pose of his initial endeavor. Stylistically the additions appear quite similar to the treatment of the head, and thus it seems probable that he executed the entire painting in Antwerp between about 1618 and about 1620.

A.K.W.

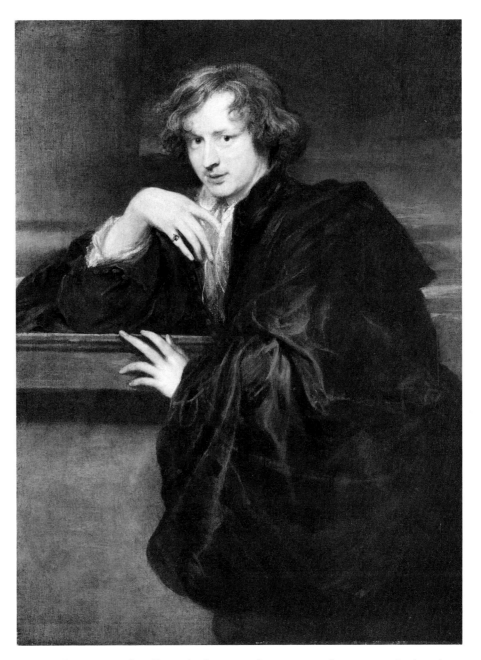

Fig. 1. Anthony Van Dyck, *Self-Portrait*, The Metropolitan Museum of Art, New York, The Jules Bache Collection, 1949

PROVENANCE
from the Düsseldorfer Galerie

LITERATURE
Cesare Ripa, *Iconologia, of Uytbeeldingen des verstands*, Amsterdam, 1644; G. P. Bellori, *Le vite di pittori, scultori et architti moderni* (Rome, 1672), reprint, Geneva, 1968; Alan McNairn, *The Young Van Dyck*, exh. cat., National Gallery of Canada, Ottawa, 1980; Eugène Fromentin, *The Masters of Past Time*, edited by Horst Gerson, translated by Andrew Boyle, Ithaca, 1981; Christopher Brown, *Van Dyck*, Oxford, 1982.

Jacob Jordaens
Antwerp 1593–1678 Antwerp

21 *The Satyr and the Peasant*

c. 1621–1625
oil on canvas mounted on oak
174 x 205 (68½ x 80¾)
inv. no. 425

La Fontaine wrote in the introduction to his book of fables that "a fable consists of two parts, which might be termed body and soul; the story being the body and the moral the soul" (La Fontaine 1954, 8). Aesop's fable of the satyr and the peasant is no exception, and whether treated by La Fontaine or by the seventeenth-century Dutch poet Joost van den Vondel, the basic outline of the story and the moral have a common core. As recounted by Vondel, whose text *Vorstelijcke warande der dieren* was published in Amsterdam in 1617 to accompany sixteenth-century engravings of Aesop's fables by Marcus Gheeraerts, a peasant brought to his home a satyr he had found in a cave, shivering from the cold. As the peasant family sat around the table to eat their evening repast, the satyr noticed to his astonishment that the peasant first blew on his hands to warm them and then on his soup to cool it. The satyr leapt up and fled the house in fear of a man who could blow both hot and cold. The moral, as is made clear in Vondel, is that one should avoid unpredictable people who show love and caring on one hand, but who are capable of fierce anger or meanness on the other (Blankert 1978, 126–129).

Jordaens, in this large and impressive painting from the early 1620s, has depicted the precise moment at which the satyr leaps from his chair after witnessing the peasant blowing on his soup. While the old woman holding the child stares wide-eyed in astonishment at the satyr's abrupt movement and the young woman bringing him fruit looks on quizzically, the peasant looks up with an uncomprehending expression. To underscore the moral, Jordaens places beneath his seat a cat, an animal traditionally symbolic of cunning and unpredictability.

Jordaens enriches his representation of the fable by alluding to one of his favorite themes, "as the old sing so the young peep." (This Netherlandish proverb is equivalent to the English "like father like son.") In the painting the young boy behind the peasant blows on his food just as his father blows on his soup. The child in the center, whose radiant expression makes her the focal point of the composition, may, however, have a different connotation. In her youthful innocence she has not yet developed the wiles of human adults, and thus occupies the realm halfway between the directness of the satyr's animalistic instincts and the unpredictability of the peasant.

Jordaens' rich, earthy palette and broad brushwork are eminently suited to capturing the rugged character of peasant life. An artist who never traveled to Italy, he remained throughout his life closely tied to Flemish traditions, and often represented, whether

Cat. 21

Fig. 1. Marcus Gheeraerts, *The Satyr and the Peasant*, engraving, Library of Congress, Washington, Rosenwald Collection

in his allegories, mythological paintings, or scenes of merrymaking, the coarse and vulgar members of the lower classes.

Despite this predilection in his art, he came from a well-to-do bourgeois family and trained with Adam van Noort (1562–1641), one of the foremost masters in Antwerp. He remained on close terms with Van Noort after he joined the Antwerp Saint Luke's Guild in 1615. In 1617 he married Van Noort's daughter, Catharina, his model for the woman serving fruit in this painting. By the 1630s he had established a position of prominence in Antwerp second only to Rubens. The shadow cast by Rubens' genius, however, was a large one, and it profoundly affected the style and character of Jordaens' art. Not only did Jordaens base a number of his religious and mythological compositions on prototypes by Rubens, but he could also paint in a manner suffi-ciently close to that of Rubens to become an indispensable member of Rubens' workshop.

Jordaens' most important contributions as an artist were probably his scenes of peasants eating and carousing around a table, a subject that Rubens never depicted. In these he fused his strong feelings for his northern heritage with compositional and stylistic ideas derived from Rubens' Italian experiences. The influence of Caravaggio on Rubens, particularly evident during the latter half of the second decade of the century, also affected Jordaens during the early years of his career. Jordaens' Caravaggism is evident in the rich earth tones of the peasant's red jacket, the strong chiaroscuro effects, and the reflected glow from an artificial light source that illuminates forms. Even the underlying concept of this composition, in which a figure leaps from his chair in sudden recognition of the meaning of a seemingly innocent gesture at the beginning of a meal, appears to hark back to Caravaggio's *The Supper at Emmaus* (National Gallery, London). While Jordaens' Caravaggism provided him with the stylistic vocabulary for his scene, the interior setting parallels that in the Gheeraerts engraving used by Vondel as a basis for his text (fig. 1). That 1617 publication may well have inspired Jordaens to depict this subject, since he represented it at least four times shortly after Vondel's text appeared. The other versions are in Brussels, Budapest, and Kassel.

A.K.W.

PROVENANCE
from the Düsseldorfer Galerie

LITERATURE
The Fables of La Fontaine, trans. Marianne Moore, New York, 1954; Edward Hodnett, *Marcus Gheeraerts the Elder of Bruges, London, and Antwerp*, Utrecht, 1971; Albert Blankert, *Museum Bredius: Catalogus van de Schilderijen en Tekeningen*, The Hague, 1978; R. A. d'Hulst, *Jacob Jordaens*, Stuttgart, 1982.

Jan van Kessel
Antwerp 1626–1679 Antwerp

22 *America*

1666
oil on copper
center panel 48.5 x 67.5 (19⅛ x 26⅝)
each of surrounding sixteen panels 14.5 x 21
(5¾ x 8¼)
signed at lower right, *Jan van Kessel fecit. Anno 1666*
inv. no. 1913

Van Kessel's *America*, which consists of a large allegorical painting surrounded by sixteen small scenes of individual cites, is one of a series representing The Four Continents: Europe, Africa, Asia, and America. Painted on copper and exhibited with its original frames, the series is one of the most poignant reminders of the complex cosmological approach to the world that underlay the scientific observations of the age.

Van Kessel's allegorical depiction of America followed sixteenth-century prototypes that identified this distant land with savage Indians, exotic animals, and incalculable wealth (Ripa 1644, 605). America, in the minds of most Europeans at this time, was essentially Brazil, and it is not surprising that Van Kessel chose as the center of America "Parajba en Brasil," one of the most important Brazilian cities of the day. The small surrounding panels represent cities from North, South, and Central America, although three panels represent locations that are not in the western hemisphere. In the foreground of each of these topographical views are strange and exotic animals, including a macaw, a turkey, monstrous bats, snakes, monkeys, and alligators that Van Kessel identified with the various regions. For good measure he also in-

cluded elephants, giraffes, a zebra, and a unicorn. These panels, which are numbered and identified by inscriptions on the frame, are as follows: 1. Bounes Aires (Buenos Aires); 2. Baÿo de todos Stos (Bayo de Todos os Santos, Brazil); 3. Olinde en fernabucos (Olinda, Brazil); 4. Amboina (the Island of Amboina, in the Moluccas); 5. Veracroes (Veracruz, Mexico); 6. Cabo Pagode en Ceÿlon (Pagoda Point, Burma, and Sri Lanka); 7. Porte Segore (Pôrto Seguro, Brazil); 8. Potesqui (Potosí, Bolivia); 9. Castel Mina (Ghana); 10. Corolina (Florida); 11. Cartagene (Cartagená, Colombia); 12. Porto Bello (Pôrto Belo, Brazil); 13. Domingo (Santo Domingo, Dominican Republic); 14. Mexico; 15. Havana (Cuba); 16. Cusco (Cuzco, Peru).

This ambitious project was a natural culmination of Jan van Kessel's artistic interests. His father, Hieronymus, a painter who worked in the atelier of Jan Brueghel the Elder, married Brueghel's daughter Paschasia. Jan van Kessel, who first studied painting with Simon de Vos, later trained with his uncle Jan Brueghel the Younger. His subsequent career as an animal and still-life painter, as well as his interest in allegorical and religious scenes, falls clearly within Brueghel's tradition. An-

Cat. 22

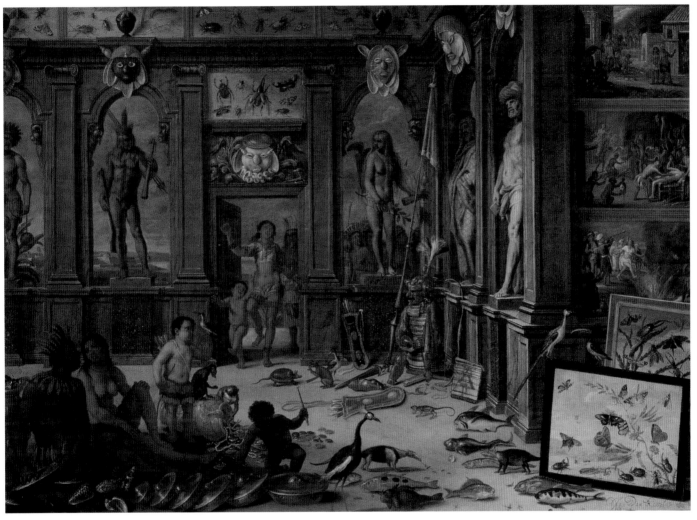

Detail, cat. 22

other important source of inspiration for Van Kessel were the delicate watercolor drawings of insects that Joris Hoefnagel executed on parchment in the late sixteenth century. Van Kessel made comparable images on small sheets of copper. The depictions of insects decorating the rear wall of the architectural structure in the central panel of *America* are patterned after those works.

As did Hoefnagel, Van Kessel sought to paint his images from reality. Jacob Weyerman, who was a pupil of Van Kessel's son, Ferdinand, wrote that Van Kessel made careful studies outdoors in good weather, and even visited the arsenal in Brussels to draw military objects and banners (Laureyssens in Brussels 1980, 314–315). Van Kessel used these studies in his compositions. Again like Hoefnagel, however, he freely combined drawings from nature with images based on works by other artists and, particularly in the instance of *America*, with drawings from illustrations in scientific treatises.

Van Kessel's primary source of information about Brazil was *Historia naturalis Brasiliae* by Georg Margkraf and Wilhelm Piso, published in Amsterdam in 1648. This book was one of the outgrowths of the scientific and artistic focus of Prince Johan Maurits van Nassau's tenure as governor of the Dutch settlement in Brazil from 1637 to 1644. Van Kessel based a number of animals in his paintings on images from this publication, specifically the guaperna, the four-legged fish in the foreground of the central panel, the two different types of anteaters, and the bearded monkey sitting on the vase containing gold coins (Krempel in Munich 1973, 16). Van Kessel also derived the statues of the Tapuya Indians, occupying the niches in the rear wall of the room, from designs in this book, which were based on paintings by Albert Eeckhout, one of the artists on Johan Maurits' expedition to Brazil. The Indian in the right-hand niche is a female cannibal with a human foot sticking out of her basket.

Earlier sources provided the artist with additional images. The armadillo standing near the far door came from J. E. Nierembergius' *Historia Naturas*, published in Antwerp in 1635, while a number of animals in the foreground of the surrounding city views were based on images in a much older, but still frequently used source, K. Gesner's *Historia Animalium* (Zürich, 1551). J. H. van Linschoten's *Itinerario Voyage ofte Schipvaert naar Oost ofte Portugaels Indien 1579–1592* (Amsterdam, 1596) provided models for the two sculptures in the side wall in the central panel, and for the painted scene of the sacrifice of a widow in the lower image on the right wall. The existence of this rite and of man-eating savages who are depicted directly above the sacrifice scene were among the many misconceptions behind Europeans' ideas of Indian life. While the sources for most of Van Kessel's city views for *America* have not been identified, that of Castel Mina in Africa is based on an image in G. Braun and J. Hogenbergh's *Civitates Orbis Terrarum*, published in Cologne between 1572 and 1618.

The strange conglomeration of rare animals and shells, careful depictions of birds and insects, artifacts of strange and foreign people, and other exotica was characteristic of *Kunst und Wunderkammern* (art and curiosity cabinets), which flourished in the sixteenth and seventeenth centuries. Prince Maurits brought back Indians as well as such artifacts to the Mauritshuis when he returned to The Hague from Brazil, and his example may well have inspired Van Kessel in his depiction of America.

A description of this work in an inventory of 1681 indicates that Van Kessel collaborated in his scenes of The Four Continents with Erasmus Quellinus (1607–1678), a figure painter who often worked together with still-life artists in Antwerp. The series must have been popular; various versions are documented, although the Munich series is the only one that is still complete. The earliest known series, dated to 1660, is in the Prado, Madrid, in which none of the center panels remain. Van Kessel's son Ferdinand painted at least two replicas of the series. In the Kunsthistorisches Museum in Vienna are forty-four city views, similar to those in the Munich painting, which Ferdinand executed in 1689.

A.K.W.

PROVENANCE
from the Düsseldorfer Galerie

LITERATURE
Cesare Ripa, *Iconologia, of Uytbeeldingen des verstands*, Amsterdam, 1644; Ulla Krempel, *Jan van Kessel D. 'A'. 1626–1679: Die Vier Erdteile*, exh. cat., Alte Pinakothek, Munich, 1973; Hugh Honour, *The European Vision of America*, exh. cat., National Gallery of Art, Washington, The Cleveland Museum of Art, Grand Palais, Paris, Cleveland, 1975, no. 109; *Zo Wijd de Wereld Strekt*, exh. cat., Koninklijk Kabinet van Schilderijen, Mauritshuis, The Hague, 1979–1980; W. Laureyssens, "Jan van Kessel de Oude," in *Brueghel: Een dynastie van schilders*, exh. cat., Paleis voor Schone Kunsten, Brussels, 1980, 313–332.

Peter Paul Rubens
Siegen, Westphalia 1577–1640 Antwerp

23 *The Rape of the Daughters of Leucippus*

1617/1618
oil on canvas
224 x 210.5 (88⅛ x 82⅞)
inv. no. 321

Rubens' greatest contribution as an artist was as an interpreter of the powerful passions inherent in stories from the Bible and mythology. From his fertile imagination have come images that have transformed our vision of our cultural heritage. The lives of gods and mortals, heroes and villains, lovers and enemies have been revealed to us in ways no other master has ever achieved.

The genius of Rubens' interpretive powers are nowhere better evident than in this majestic painting. No precedents for the subject of *The Rape of the Daughters of Leucippus* are known in European painting, and the story is only cursorily mentioned by the probable literary source for Rubens' scene, Ovid: "The brothers Tyndarids, the one a horseman, the other a boxer, had ravished and carried away Phoebe and Phoebe's sister" (Fasti 5: 693–717). These few lines, however, were sufficient to evoke in Rubens' classically trained mind further associations with the lives of these heroes, as well as with other stories of forceful sexual conquest, that allowed him to conceive of his composition.

Rubens received his classical training from many sources. After his family moved from Cologne in Westphalia to Antwerp around 1588, the eleven-year-old boy attended a school that emphasized the classics. Rubens served

for a short time as a page in the house of a widow of a count, and then began his formal artistic training in the studios of Tobias Verhaecht (1561–1631), Adam van Noort (1562–1641) and, most significantly, Otto van Veen (1556–1629). Through the influence of the latter and Rubens' older brother Philip, Peter Paul developed an intense interest in classical culture. In May 1600, having joined the Saint Luke's Guild in Antwerp two years previously, he left for Italy.

His experiences there affected him for the rest of his life. In Venice, Mantua, Rome, Florence, Bologna, and Genoa he encountered firsthand the classical tradition, not only in the sculptures and architectural ruins of antiquity, but also in the works of Renaissance artists. He copied incessantly, and by the time he returned to Antwerp in 1608 he had fully assimilated the lessons to be learned from artists as diverse as Michelangelo and Caravaggio, Giovanni da Bologna and Veronese.

Rubens' artistic successes upon returning to Antwerp were enormous. He was appointed court painter to the Archduke Albert and Archduchess Isabella, but was allowed to remain in Antwerp rather than moving to the court in Brussels. He married Isabella Brandt in 1609 and shortly thereafter purchased land for his home and stu-

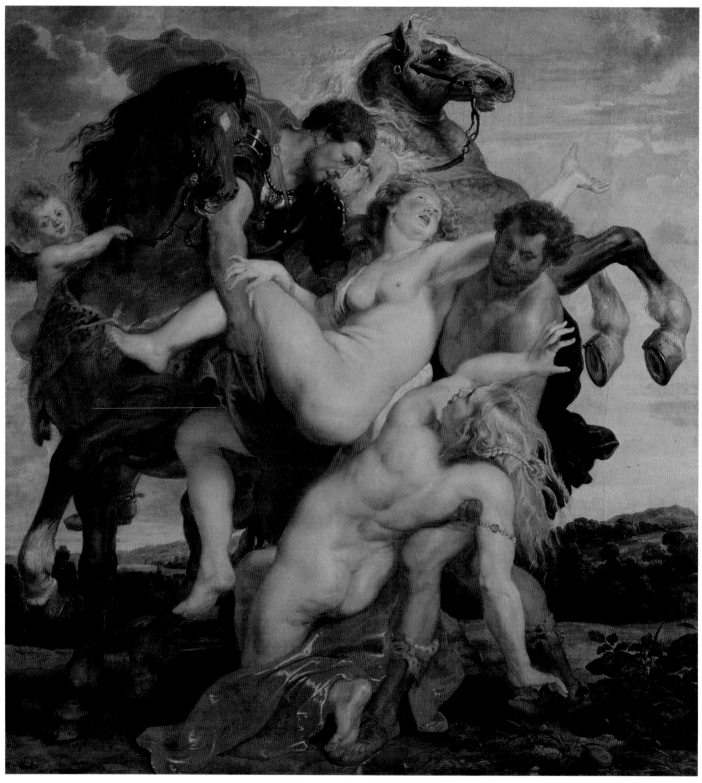

Cat. 23

dio. His reputation spread throughout Europe, and soon he was receiving important commissions from Germany, England, France (see cats. 25, 26) and Italy as well as from churches and nobility in the southern Netherlands.

The Rape of the Daughters of Leucippus was painted in about 1617/1618, at a time when the impact of his experiences in Italy was still vividly in Rubens' mind. The mass and weight of the fully sculpted, idealized forms, the carefully controlled, tightly orchestrated composition, and the rich earthy colors are classicizing concepts that underlie this remarkable image of conflicting passions of lust and fear, violence and tenderness. While the swirling movement of the rearing horses and the emphatic gestures heighten the emotional intensity, the drama is contained within itself. Rubens' narrative suggests no past and no future.

The "brother Tyndarids" described by Ovid were Castor and Pollux, twins who were commonly referred to as the Dioscuri (meaning the "sons of Zeus"). They were hatched from Leda's eggs after Jupiter (Zeus) had lain with her in the guise of a swan. Although Ovid credits only Castor with being a warrior, by the Renaissance both brothers were renowned as warriors and expert horsemen.

At the time of the abduction, the daughters of King Leucippus, Phoebe and Hilaira, were betrothed to another set of twins, cousins of Castor and Pollux. After the abduction a battle ensued between the four males. All died except Pollux, who offered to share his place in heaven with Castor. The two became stars and were worshipped by sailors as harbingers of calm.

The greatest monument to the memory of the Dioscuri was a pair of large statues of Castor and Pollux holding the reins of their rearing horses. The statues were brought to the Monte Cavallo of the Quirinal in Rome by Pope Sixtus V in 1589. These Hadrianic copies of Greek originals fascinated Renaissance artists, and Rubens, among others, made drawings after them (Held 1959, 116, no. 52). Reflections

of that sculptural group are evident here in the dappled horse behind Pollux (Stechow 1968, 64–65). Rubens has fused Ovid's account with this later tradition by placing Castor, dressed as a warrior, on his horse, while depicting Pollux, the boxer, with bare chest and legs, standing on the ground before his rearing steed.

The dynamic interplay between gods and mortals was one of Rubens' favorite themes throughout his career. Here, while winsome cupids help control the reins of their horses, Castor and Pollux tenderly lift the two maidens who turn and twist, revealing the supple shapes and shimmering flesh of their bodies. The woman held aloft by the two brothers gestures imploringly above, as though beseeching Jupiter to control the passions of his sons. In her struggle, however, her lower body assumes the position of Michelangelo's famous depiction of *Leda and the Swan*, a painting Rubens copied (Gemäldegalerie, Dresden), a subtle reference to Zeus' own rape of the mother of Dioscuri.

Nothing is known about the commission for this work; hence it is difficult to determine why Rubens chose to depict this unusual theme. By the time the painting was acquired by the Elector Johann Wilhelm for the Düsseldorfer Galerie, the true subject of the work had been forgotten. Until 1777, when the correct interpretation was made by the poet Wilhelm Heinse, the painting was thought to represent the rape of the Sabine women. While this traditional theme may, in fact, lie behind Rubens' composition, the conflicting emotions felt by the maidens, who at once resist and yield, are entirely inappropriate for that violent conflict between enemies.

This abduction concerns four people who previously knew each other; for this reason the riveting gaze between Castor and the woman on the ground with her back to the viewer is so poignant. On ancient sarcophagi, which occasionally depict the rape of the daughters of Leucippus, the story assumed an allegorical meaning of salvation. Nevertheless, it seems unlikely

that Rubens intended his painting to represent such an allegory, or, as has been recently argued, an allegory of marriage (Alpers 1967, 287–289), even though the eventual marriage of the Dioscuri to the daughters of Leucippus is mentioned by Apollodorus in book 3, part 11. Rather, the subject could have political implications. Castor and Pollux were regarded as messengers of the supreme divinity, and as such they occasionally served as allegorical representations of royalty (Stechow 1968, 61–65). The underlying meaning of such an association was that being chosen by these heroes, even forcibly, was a great honor. One might speculate that the actions of the Dioscuri could be thus allegorically associated with the efforts of Philip II and Albert, his regent in the Spanish Netherlands, to overcome the resistance of the Dutch republic and to fuse the two political entities into one under the jurisdiction of the Spanish king. Rubens, in his own diplomatic efforts to help resolve the conflict between the northern and southern Netherlands, actually proposed such a solution to the Dutch diplomat Albert Joachimi when he was in London in the winter of 1630.

Finally, while there seems no reason to suggest, as has occasionally been the case, that the landscape was executed by Rubens' assistant Jan Wildens (Adler 1980, 31, 100), Rubens may well have expanded the composition during its execution. Additions to the top and right are clearly visible to the naked eye. One could imagine that Rubens originally conceived the painting to include only one horse, and expanded it to add the rearing, dappled gray horse behind the figure group. The earlier composition would have followed more literally the description of the scene in Ovid, which mentions a horseman and a boxer, but would have lacked the allusions to the Dioscuri's heroic reputation as warriors, which is suggested in the present composition.

A.K.W.

PROVENANCE
acquired by Elector Johann Wilhelm for the Düsseldorfer Galerie before 1716

LITERATURE
Ovid, *Ovid's Fasti*, trans. James George Frazer, vol. 5, London, 1931; Hans G. Evers, *Rubens und Sein Werk*, Brussels, 1944; Apollodorus, *Apollodorus*, trans. Sir James George Frazer, vol. 2, Cambridge, England, 1946; Julius S. Held, *Rubens: Selected Drawings*, London, 1959; Svetlana L. Alpers, "Manner and Meaning in Some Rubens Mythologies," *Journal of the Warburg and Courtauld Institutes* 30 (1967), 272–295; Wolfgang Stechow, *Rubens and the Classical Tradition*, Cambridge, Mass., 1968; Wolfgang Adler, *Jans Wildens: Der Landschafts-mitarbeiter des Rubens*, Fridingen, 1980; Otto von Simson, "Der Raub der Leukippiden, Rubenes begegnet der Antike," *Von Geschichte umgeben, Joachim Fest zum Sechzigsten*, Berlin, 1986, 232–244.

Peter Paul Rubens
Siegen, Westphalia 1577–1640 Antwerp

Frans Snyders
Antwerp 1579–1657 Antwerp

24 *Garland of Fruit*

c. 1615–1617
oil on canvas
120 x 203.8 (47¼ x 80¼)
inv. no. 330

With intense concentration and impish expressions, seven putti with tousled hair do their utmost to carry a richly laden garland of fruit through a rocky landscape. Their efforts at teamwork notwithstanding, the task seems daunting, and the viewer is able to watch with amusement when the caravan pauses to regroup.

This delightful image of fecundity and abundance is a primary example of the type of collaboration Rubens developed in the 1610s with both members of his workshop and independent artists active in Antwerp. The wonderfully fresh and vivid rendering of the fruit in this painting is the work of Frans Snyders, one of the preeminent Flemish still-life and animal painters of the seventeenth century. Snyders, who was only two years younger than Rubens, became a master in the Antwerp guild in 1602, after studying with Pieter Brueghel the Younger. He traveled briefly to Italy in 1608/1609, with a recommendation from Jan Brueghel the Elder that he was "one of the best painters in Antwerp." After he returned to Antwerp he married Margaritha, the sister of the painters Cornelis and Paul de Vos. He brought to fulfillment the sixteenth-century genre of large market scenes, which included

figures standing near tables heavily laden with fruit, fish, and meat; but he also painted smaller fruit and flower still lifes. Although his most significant collaborative efforts were with Rubens, he worked with other figure and landscape artists, among them Anthony Van Dyck and Jan Wildens. His artistic success made him wealthy and prosperous, as can be clearly judged by the elegant portraits Van Dyck painted of him and his wife around 1620 (Frick Collection, New York).

Rubens worked together with Snyders on a number of paintings, the most famous of which is *Prometheus Bound* (c. 1610–1612, Philadelphia Museum of Art). Rubens described this painting on 28 April 1618 in a letter to Sir Dudley Carleton, the British ambassador to The Hague, as a collaborative effort. He said he painted the figure of Prometheus and Snyders the eagle plucking Prometheus' liver. In other paintings on which the two artists worked together, Snyders contributed animals and flowers as well as fruit. His style was a perfect complement to that of the older master. He painted with bold strokes and vivid colors and preferred to work on a large scale. In this respect his collaborations with Rubens are more successful than those

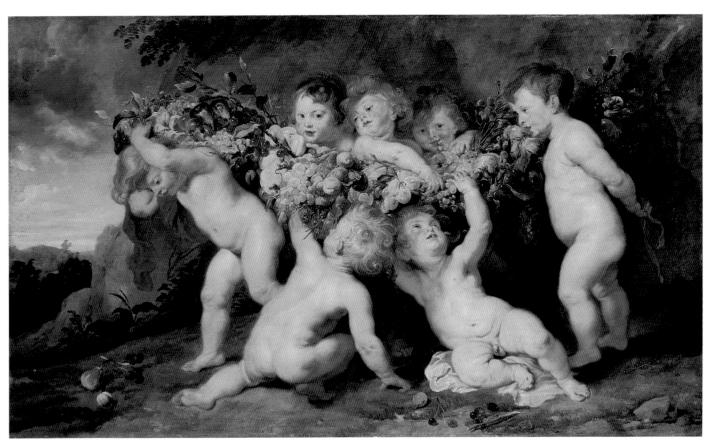

Cat. 24

Rubens undertook with Jan Brueghel the Elder, whose delicate strokes and light, featherly touch differ markedly from Rubens' broadly executed forms.

The extent of Snyders' contributions to Rubens' compositions is often difficult to determine, since their styles mesh so well. Confusion about this also existed in the seventeenth century, as is evident in a letter written to Sir Dudley Carleton in February 1617 by Toby Matthew, his agent in Louvin. Matthew explains that he was mistaken in reporting previously that a hunt scene was executed jointly by Rubens and Snyders: "For in this Peece the beasts are all alive . . . in the expression thereof Snyder doth infinitlie come short of Rubens and Rubens saith that he should take it in ill part, if I should compare Snyders with him in that point" (Jaffé 1971, 194–195).

That Rubens intended this image of putti carrying a garland of fruit to represent abundance is evident if one compares the painting with Rubens' allegorical depiction of a statue of Ceres, goddess of the harvest, whose niche is being bedecked with a fruit and vegetable garland by six equally intent putti (The State Hermitage Museum, Leningrad). This work, which was also painted with the assistance of Snyders around 1615, includes a putto who resembles the lead figure carrying the garland on his back in the Munich painting. Not surprisingly, Rubens derived it from an antique sculpture he had seen in Italy (Haberditzl 1911, 278–279; Keiser 1933, 120). Both of the putti on the ground below the garland, moreover, are freely adapted from an antique source, a marble sculpture of *Romulus and Remus Suckled by the Wolf*, which Rubens had seen in the Belvedere of the Vatican and had carefully copied in a chalk drawing (Biblioteca Ambrosiana, Milan). Rubens executed his own painting of the subject (Museo Capitolino, Rome), in which Romulus and Remus appear in a manner even more closely resembling the putti in the Munich painting (Stechow 1968, 37–39).

The motif of putti carrying festoons has its origins in antiquity. Rubens would have been familiar with it through its appearance on sarcophagi or terra-cotta reliefs (Greenhalgh 1982, fig. 38); he would also have encountered it in fifteenth- and sixteenth-century adaptations of the motif in prints (by Master B with the Die), sculpture (Donatello's Cavalcanti altar, Santa Croce, Florence), paintings (Mantegna's *Enthroned Madonna and Child with Saints*, San Zeno Maggiore, Verona, where it appears on the entablature at the back of the room), or tapestries—Rubens made a drawing of cupids and garlands based on a tapestry by Giovanni da Udine (Musée du Louvre, Paris, inv. 20.293). Because the traditional function of this motif was decorative, Rubens probably intended this work to be part of a larger ensemble of paintings designed to fit into wall panels or above doorways.

A.K.W.

PROVENANCE
from the Düsseldorfer Galerie

LITERATURE
F. M. Haberditzl, "Studien über Rubens," *Jahrbuch der Kunsthistorischen Sammlungen des allerhöchsten Kaiserhauses* 30 (1911), 257–297; Emil Kieser, "Antikes im Werke des Rubens," *Münchner Jahrbuch der Bildenden Kunst* 10 (1933), 110–137; Wolfgang Stechow, *Rubens and the Classical Tradition*, Cambridge, Mass., 1968; Hella Robels, "Frans Snyders' Entwicklung als Stillebenmaler," *Wallfraf-Richartz-Jahrbuch* 31 (1969), 45–94; Michael Jaffé, "Rubens and Snijders: A Fruitful Partnership," *Apollo* 93 (1971), 184–196; Michael Greenhalgh, *Donatello and His Sources*, London, 1982.

Peter Paul Rubens
Siegen, Westphalia 1577–1640 Antwerp

25 *The Reception of Maria de' Medici at Marseilles*

c. 1622
oil on oak
64 x 50 (25¼ x 19⅝)
inv. no. 95

26 *The Coming of Age of Louis XIII*

c. 1622
oil on oak
65 x 50 (25⅝ x 19⅝)
inv. no. 104

Among the many large-scale projects that occupied Rubens during his prodigious career, probably none is so well known and admired as is the series of twenty-one paintings depicting the Life of Maria de' Medici. The entire series, which Rubens executed between 1622 and 1625, hangs today in the Louvre in Paris, not far from the Palais du Luxembourg for which it was originally intended. As remarkable as it may be that this series has remained intact, it is almost more extraordinary that fifteen of the preliminary studies for the series have been preserved together and are today in the Alte Pinakothek. Two of these studies have been included in this exhibition, *The Reception of Maria de' Medici at Marseilles* and *The Coming of Age of Louis XIII*.

This group undoubtedly remained intact because of the considerable importance Rubens' contemporaries attached to his oil sketches. The appeal of these sketches was twofold. In sixteenth-century art theory great value was placed on *disegno*, the artist's initial designs that revealed the nature of his inspiration. Although the term *disegno*

generally applied to drawings, it also included oil sketches. Indeed, Rubens seems to have used the designation "dissegno" when referring to his oil sketches (Held 1980, 1:7). Rubens' oil sketches had an added appeal for collectors since they were unquestionably by the hand of the master and not the product of workshop collaboration, as were so many of his large-scale compositions. In them one could experience Rubens' fluid touch as he composed his scene with a sure sense of form and with deft strokes of his brush. Characteristically he executed these sketches on thin oak panels that had been prepared with a streaky gray ground. His paint layers are thin, with the exception of the highlights that accent the forms.

The Munich sketches, which are relatively large and fully conceived, represent the final preparatory step before the execution of the canvases (figs. 1, 2). Five sketches in the Hermitage that are also related to the series are smaller and painted primarily in grisaille; they must thus represent an earlier stage in the development of Rubens' concept.

Fig. 1. Peter Paul Rubens, *The Reception of Maria de' Medici at Marseilles*, Musée du Louvre, Paris

was best suited to create an allegorical portrayal of her life that would convey her noble character, her triumphs, and her steadfast concern for the state in the face of adversity.

By the end of February, when Rubens returned to Antwerp, he had signed a contract stipulating that he would deliver half of the paintings within one year and the rest later. He also agreed to complete a second series devoted to the Triumph of Henry IV within four years. The essential program must have been worked out by the time the contract was signed, since it seems probable that Rubens executed the grisaille oil sketches for the queen's approval while he was still in Paris. The more elaborate sketches, among them those now in Munich, were executed after he returned to Antwerp. The majority of these were certainly completed by September 1622, at which time Rubens had virtually finished seven or eight of the large canvases.

The gallery in which the series was displayed was decorated on all sides. The allegorical account of Maria de' Medici's life, which Rubens completed in June 1625, unfolded clockwise around the room. It began with *The Destiny of Maria de' Medici*, in which three Fates spin the thread of her life beneath the watchful gaze of Jupiter and Juno, and ended with *The Triumph of Truth*, in which Maria and her son Louis XIII join in union and concord while below them Time lifts his daughter, the personification of Truth. The sketches included in this exhibition are designs for two of the sixteen large vertical canvases (394 x 295 cm, nearly 13 x 10 feet) that hung between windows on opposite sides of the gallery.

The Reception of Maria de' Medici at Marseilles, the sixth episode in the series, depicts that moment of great hope and expectation when the young queen, who was married by proxy to Henry IV on 5 October 1600 in Florence, first reached the shores of France. In Rubens' dramatic composition Maria de' Medici stands regally in a white gown under the canopy of the boat as

Because of their more elaborate character, the Munich panels were almost certainly once part of the collection of oil sketches for this series that Claude Maugis, the abbot of Saint-Ambroise and the chaplain and close advisor to Maria de' Medici, acquired from the artist (Held 1980, 1:93). This powerful individual acted as the mediator between Rubens and the queen for this project and was probably also instrumental in

devising the complex program that underlay Rubens' artistic concept.

The precise nature of this program and the circumstances surrounding the queen's decision to commission Rubens to decorate the Palais du Luxembourg have never been fully determined. Nevertheless, it is clear that when Maria de' Medici summoned Rubens to Paris in January 1622 she fully recognized that Rubens, above all others,

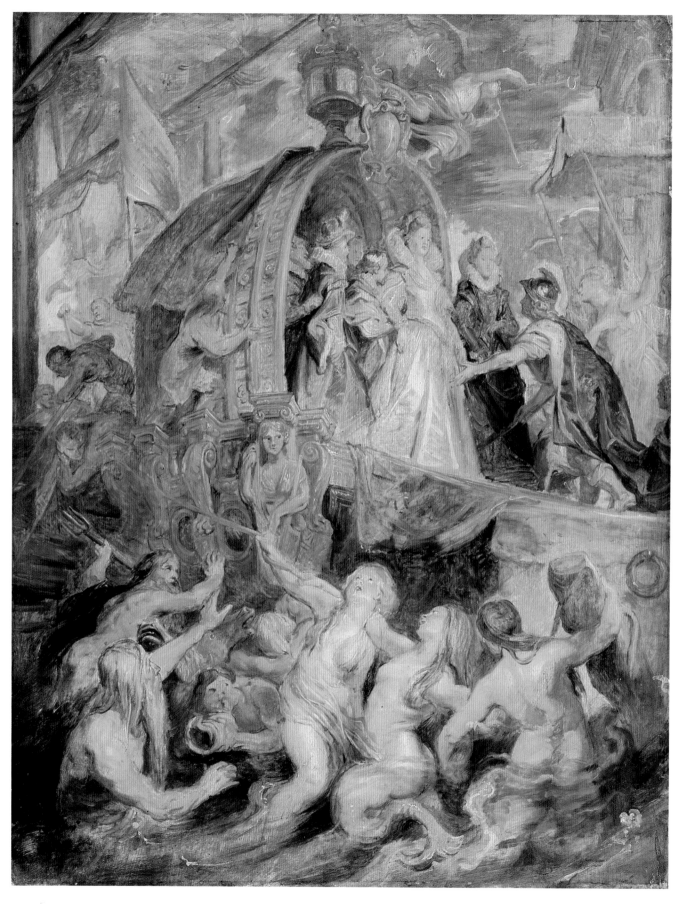

Cat. 25

Cat. 26

Fig. 2. Peter Paul Rubens, *The Coming of Age of Louis XIII*, Musée du Louvre, Paris

Rubens' painting allegorically represents the moment when the queen turns over the ship of state to the new helmsman. Behind them, overseeing the transfer of power, stands the personification of France, holding the sword of justice aloft in her right hand and the symbolic orb of government in her left. The boat is powered by four strong women, one of whom is pushing off from shore with her oar, and by a sail that is being raised by another female attendant. Cherubs blowing horns in the sky above Louis' head proclaim his fame.

A preliminary drawing for this composition (Musée du Louvre, Paris) is one of only two for the series that has survived (Held 1959, no. 50v). In the drawing the boat faces in the opposite direction and only two rather than four women handle the oars. Inscriptions over the figures, however, indicate that they have allegorical meanings. Prudentia, for example, handles the sails, while Constancy and Strength row. In the final painting, these virtues have been specifically identified through emblems painted on the women's shields. The woman pushing off is Force; Piety looks toward Louis, while Justice and Concord row in unity.

The reasons for the change in the position of the boat are not certain, although there may have been some initial uncertainty about the nature of the installation of the series, since several preliminary oil sketches for other compositions are also in reverse (Held 1980, 1:94f). In the process of revising the composition in the oil sketch, Rubens made a number of changes in the positions of the women at the oars. These figures are thus more densely painted than is normally the case in his oil sketches.

In his final paintings, Rubens followed the general ideas developed in these two sketches, although a number of modifications occur in both instances. The primary difference is that these scenes are given a more vertical orientation, since the proportions of the large-scale canvases are more elongated than those of the panels. As a result,

she is greeted by allegorical figures representing France and the city of Marseilles. Beside her stands her sister, Eleanor of Mantua, and her aunt, Christina, Grand Duchess of Tuscany. Fame flies above trumpeting her arrival, while below, Neptune, after having insured her safe voyage, holds fast the ship with the help of three voluptuous naiads who celebrate the happy occasion with songs of joy. Finally, at the lower left, an old sea god, identi-

fied as Proteus in a contemporary account of the episode, gestures toward the queen to signify that she has now been safely delivered to her destination.

The Coming of Age of Louis XIII depicts an event that occurred some fourteen years later. After the assassination of Henry IV on 14 May 1610, the queen, whose coronation had been celebrated the previous day, assumed the regency of the country until the young Louis XIII came of age on 20 October 1614.

the final compositions have an added aura of dignity that enhances the heroic character of the allegories so sensitively rendered in these preliminary studies.

<div align="right">A.K.W.</div>

PROVENANCE
from the Electoral Gallery

LITERATURE
Julius S. Held, *Rubens: Selected Drawings*, London, 1959; Jacques Thuillier and Jacques Foucart, *Rubens' Life of Marie de Medici*, trans. Robert E. Wolf, New York, 1967, 78, 89; Julius S. Held, *The Oil Sketches of Peter Paul Rubens*, 2 vols., Princeton, 1980; Rüdiger an der Heiden, *Die Skizzen zum Medici-Zyklus von Peter Paul Rubens in der Alten Pinakothek*, Munich, 1984.

Peter Paul Rubens
Siegen, Westphalia 1577–1640 Antwerp

27 *Meleager and Atalanta*

c. 1635
oil on canvas
199 x 153 (78⅜ x 60¼)
inv. no. 355

Rubens had a lifelong preoccupation with the art of Titian. Even before he traveled to Italy in 1600 he seems to have known prints after Titian's compositions. During his eight-year stay in Italy he made a number of copies of Titian's paintings, including one after *Venus with a Mirror* (another version of Titian's now-lost painting is in the National Gallery of Art, Washington, fig. 1). These copies, as well as those he made later, remained with Rubens throughout his life. In the inventory of his estate are listed no less than eleven copies after Titian. Rubens' admiration for Titian was such that he also owned at his death eight paintings and two sketches by the great Venetian master.

Many of the copies after Titian listed in Rubens' estate were made between 1628 and 1629, when Rubens traveled to Spain on a prolonged diplomatic mission on behalf of Albert and Isabella, the regents in the Spanish Netherlands. The royal collection in Madrid and at the palace of El Escorial outside the capital was particularly rich in Venetian art, and a contemporary account indicates that Rubens copied all of the paintings by Titian there (Held 1982, 306). This extraordinary devotion on the part of one great artist for another, which led Rubens to study and internalize the lessons that could be learned from his famous predecessor, is unique in the history of art. The

Fig. 1. Titian, *Venus with a Mirror*, National Gallery of Art, Washington, Andrew W. Mellon Collection

impact of this experience on Rubens' style and choice of subject matter during the last decade of his life cannot be overestimated.

Rubens painted *Meleager and Atalanta* around 1635, at a time when he had removed himself from political and diplomatic affairs and had begun to live a quieter, more idyllic life in his country house, the Château Steen, with his young wife Hélèna Fourment. His paintings from those years often focused on mythological stories drawn from Ovid's *Metamorphoses*. In this

work, painted in a broad technique that derives from Titian, Rubens suggested the sensual essence of the scene through the luminous character of flesh tones, rich vibrant colors, and the easy interaction of the figures as they respond to each other's presence. For his figure of Atalanta, Rubens returned to his early copy after Titian's *Venus with a Mirror*, transforming the cold reserve of her expression and gesture to a tender acquiescence to Meleager's affection.

This story from Ovid *(Metamorphoses,*

8:260-546) is one that attracted Rubens throughout his career. Significantly, however, until this period of his life, he preferred to depict an earlier moment in the narrative, the hunt scene, known as the Calydonian boar hunt, in which Atalanta, the virgin huntress, shoots an arrow at the rampaging boar while Meleager stands beside her with spear raised to deliver the final blow. The boar had been sent by Diana to ravage the countryside of Calydon, because Meleager's father had offended the goddess. After the hunt Meleager presented the trophies of the boar's head and pelt to Atalanta. This gesture of love, however, boded tragedy, as is evident in the worried expression of the Fate hovering above in Rubens' painting. Meleager's uncles, furious that these trophies had been given away, retrieved them from Atalanta. Meleager then slew his uncles, but in doing so he enraged his mother, who fulfilled the prophesy of the Fates at his birth—that Meleager would die when a log of wood burning in the hearth had been consumed by fire. His mother had removed the log from the fire at Meleager's birth, but now threw it back into the hearth.

Rubens originally conceived the painting as a vertical composition with the figure group sitting near a tree, much as it appears today. Meleager, with the help of a robust, blond cupid, presents Atalanta with the head of the boar. At Atalanta's feet is her bow and a quiver of arrows, while Meleager's spear lies on the ground behind her. As can be seen in an old copy of this initial stage, Rubens originally depicted Atalanta bare to the waist. When the artist added the white robe covering her upper torso he may well have asked Jan Wildens, a specialist in landscape and animals, to paint a substantial addition to the right of the composition (fig. 2). The transformation thus placed the figures within an extensive landscape setting along with more dogs as reminders of the hunt. This addition is still attached to the painting, but has been folded behind the stretcher. A smaller addition on the left, which

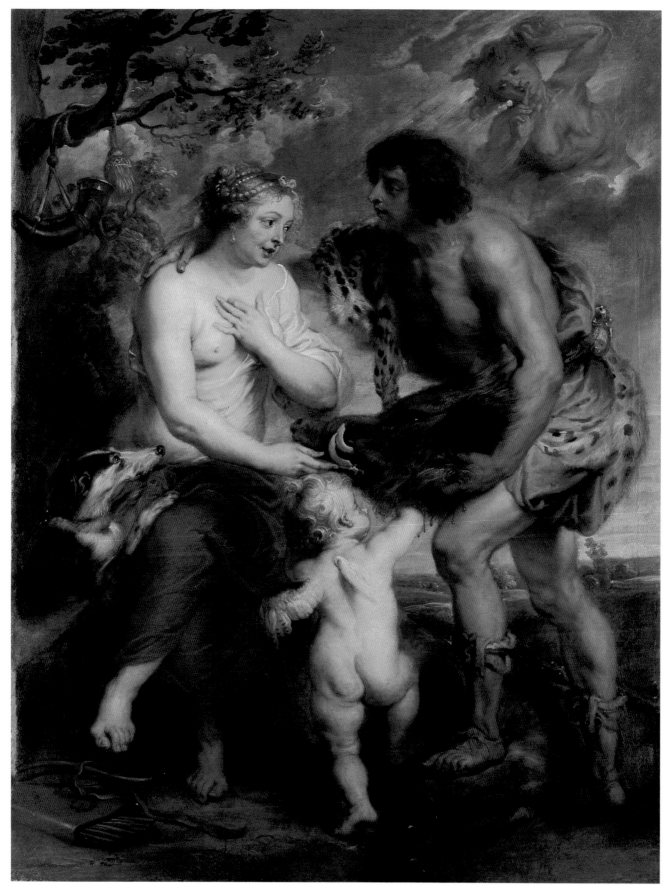

Cat. 27

Fig. 2. Peter Paul Rubens, *Meleager and Atalanta* (with addition)

Fig. 3. Peter Paul Rubens, *Venus and Adonis*, The Metropolitan Museum of Art, New York, Gift of Harry Payne Bingham, 1937

dated to a later period, has been removed.

Hubertus von Sonnenburg has reiterated earlier suggestions that the addition was made to relate this work to another composition (Von Sonnenburg and Preusser 1980, 52). This hypothesis seems likely, and indeed, a probable pendant for this painting in its enlarged, horizontal state exists today in the Metropolitan Museum of Art: Rubens' free adaption of Titian's *Venus and Adonis*, which he executed between 1635 and 1637 (fig. 3). Not only do these works have virtually the same dimensions (*Venus and Adonis* with added strips on all four sides, 197.5 x 242.9 cm; *Meleager and Atalanta* with addition at right, 195 x 246 cm), but the scale of the figures and the tragic outcome of the love stories are also comparable. The provenances of the two works also are related, since *Venus and Adonis* was in Munich in the collection of Maximilian II Emanuel, elector of Bavaria, until 1706 (Liedtke 1984, 1:1557). Contemporaries of Rubens clearly perceived the relationship between the stories, for both were included in a series of eight hunting scenes commissioned from Rubens by Philip IV of Spain in the late 1630s (Balis 1986, 218–227).

A.K.W.

PROVENANCE
from the Electoral Gallery

LITERATURE
Ovid, *Metamorphoses*, translated by Rolf Humphries, Bloomington, Indiana, 1955; Hubertus von Sonnenburg and Frank Preusser, "Peter Paul Rubens' 'Meleager and Atalanta'," in *Rubens, Gesammelte Aufsätze zur Technik*, Munich, 1980; Julius Held, "Rubens and Titian," in *Titian, His World and His Legacy*, edited by David Rosand, New York, 1982; Walter A. Liedtke, *Flemish Paintings in The Metropolitan Museum of Art*, 2 vols., New York, 1984; Arnout Balis, *Rubens Hunting Scenes, Corpus Rubenianum Ludwig Burchard*, part 18, trans. P. S. Falla, New York, 1986.

Bartholomeus Spranger
Antwerp 1546–1611 Prague

28 *The Lamentation of Christ*

c. 1585
oil on copper
15 x 12 (5⅞ x 4¾)
inv. no. 2370

"When Nature, by benevolence and heavenly grace, occasionally endows a mind with creative power, she gives us delightful and noble fruits, with no special effort. Ordinary minds are able to produce nothing but awkward and ugly things, with painstaking efforts. It seems almost obvious that only those who have been born to be artists may enter the realm of painting. Fortune provided the excellent painter, Spranger, of Antwerp, with paint and brushes, when he was still in his early youth; and beautiful Pictura smiled on him constantly. She claimed him for her own, and the Graces were her dowry" (Van Mander 1969, 309).

Within the hyperbole of Carel van Mander's introduction to his handbook for artists, *Het Schilder-Boeck*, of 1604, is contained the highest compliment one mannerist artist could give another: that his inventions flew from his brush without the appearance of labor or effort. In an era that valued grace and elegance above all other artistic virtues, Spranger ruled supreme. Whether depicting evocative scenes of the loves of the gods or, as in this instance, images of worship, his works epitomize both the artificiality and sensuality of late-sixteenth-century art.

Van Mander first met Spranger when the two artists worked together on a triumphal arch for the entry of Rudolf II into Vienna in July 1577. Spranger

had come to Vienna by a circuitous route. After training in Antwerp he had traveled to Italy in 1565, via Paris. His initial extended stay in Italy was in Parma, where he encountered firsthand the work of Parmigianino and Correggio. He then traveled to Rome where, through the office of Giulio Clovio, he worked for Cardinal Alessandro Farnese. From 1570 to 1572 he was in the employ of Pope Pius V. Eventually he traveled north with the sculptor Hans Mont to work for the court of Maximilian II in Vienna until the emperor's death in 1576. Shortly after his encounter with Van Mander, Spranger moved to Prague where he was named court painter on 1 January 1581. Although he later traveled briefly to Flanders and Holland, he remained in Prague for the rest of his life.

This small painting on copper, probably intended as a private devotional piece, depicts Christ being supported by a sorrowful angel. The Virgin Mary kneels beside him, her head bowed and her arms crossed, while a second angel attempts to comfort her from behind. In the far distance rises Golgotha as a reminder of the cruel death suffered by the Savior.

The intent of such a devotional piece was that the viewer should experience for himself the suffering undergone by Christ. Thus Spranger has thrust forward Christ's body: his contorted form

Cat. 28

seems pressed against the picture surface, while his wounds are prominently displayed as a reminder of the pain he experienced on the cross. Spranger further intensifies the emotional experience by compressing all of the figures within this small compass, the only escape from the intense grief being the distant view of the cross.

When Van Mander moved to Haarlem in 1583, he enthusiastically recommended Spranger's work to Hendrick Goltzius. Goltzius, the preeminent graphic artist in the Netherlands, soon began to produce elaborate engravings after Spranger's drawings. The sinuous line and elegant rhythms of these biblical and mythological scenes by Goltzius helped determine the character of Dutch mannerism. While it was once believed that the designs by Spranger after which Goltzius made his engravings dated from the late 1570s and had been brought by Van Mander from Vienna, it now seems probable that Spranger's drawings were sent to Haarlem during the 1580s. This reassessment of the relationship between the date of Spranger's designs and of Goltzius' engravings has affected opinion about the date of this small painting. It used to be dated to the mid 1570s,

largely because of the strong Michelangelesque quality of Christ's pose and the clear references to Parmigianino in the faces of the angels (Oberhuber 1958, 89). The angular treatment of the drapery and compressed composition, however, are reminiscent of some of Goltzius' engravings from the mid-1580s after Spranger's designs (Kaufmann 1985, no. 297). Strauss has argued that in 1587, Goltzius engraved *The Body of Christ Supported by an Angel* after a terra-cotta relief by Spranger from 1585 (Bartsch 1982, 3:no. 273), a work that offers stylistic and thematic parallels to the Munich painting.

A.K.W.

PROVENANCE
from the Electoral Gallery

LITERATURE
Carel van Mander, *Het Schilder-Boeck*, Haarlem 1604 (translation taken from Carel van Mander, *Dutch and Flemish Painters*, trans. Constant van de Wall, New York, 1936), reprint ed., New York, 1969, 309–329; Konrad Oberhuber, "Die Stilistische Entwicklung im Werk Bartholomäus Sprangers," Ph.D. diss., University of Vienna, 1958; Walter L. Strauss, ed., *Hendrik Goltzius, The Illustrated Bartsch*, vol. 3, New York, 1982; Thomas DaCosta Kaufmann, *L'Ecole de Prague; la peinture à la cour de Rodolphe*, trans. Solange Schnall, Paris, 1985.

Michael Sweerts
Brussels 1624–1664 Goa

29 *Interior of an Inn*

c. 1660
oil on canvas
100 x 95.9 (39⅜ x 37¾)
inv. no. 854

Depictions of young men congregating in a tavern to smoke, drink, and converse are frequently found in Dutch and Flemish paintings, but this enigmatic scene by Sweerts has a different mood from that in other examples. Instead of the boisterous, rowdy, and often drunken revelers in Adriaen Brouwer's tavern scenes (see cats. 14, 15), for example, these young men are quiet and subdued, their manners, dress, and decorum above reproach. Sweerts seems to accept them as they are, for he offers no commentary on their behavior. More significant to the artist than social concerns were formal ones, specifically the careful arrangement of the three main figures into a triangular arrangement and the accents of light and dark that draw one's eye in a controlled fashion throughout the image.

Sweerts' formation as an artist is quite complex. When he was in Rome from around 1646 until 1654 he developed an interest in low-life genre painting of the type developed by Pieter van Laer and his followers there, who are called the Bamboccianti. Sweerts also became an academician, however, and was an assistant at the Accademia di San Luca. From documents and various paintings he made, we know that he established an "academy for drawings from life" after he returned to Brussels in about 1656. This dual interest in low-life genre and academic forms is evident in this work. The large, broadly painted figures of this controlled composition were almost certainly derived from carefully posed figure studies that were drawn from life in his studio (Schatborn 1981).

Although the tavern scene is not an unusual subject in Dutch and Flemish art, it is for Sweerts. This painting is the only known representation of this subject by him. Partly for this reason, and partly because of the work's place within Sweerts' own stylistic evolution, it seems probable that the artist painted this scene late in his career, when he was in Amsterdam, between 1660 and 1661. Another recent arrival in Amsterdam at that time was Pieter de Hooch, who had moved there from Delft, and Sweerts may have been struck by the careful organization of interior spaces that characterizes de Hooch's work from that period. Sweerts, however, maintained the dark, somber palette he had first used in Italy, with the result that his work has a sense of gravity not seen in the Delft artist's paintings.

A.K.W.

PROVENANCE
from the Zweibrücker Galerie

LITERATURE
Rolf Kultzen, "Michael Sweerts," Ph.D. diss., Hamburg University, 1954; Peter Schatborn, *Dutch Figure Drawing from the Seventeenth Century*, The Hague, 1981.

Cat. 29

David Teniers II
Antwerp 1610–1690 Brussels

30 *View of the Gallery of the Archduke Leopold Wilhelm in Brussels IV*

c. 1655
oil on canvas
93 x 127 (36⅝ x 50)
inv. no. 1841

In a spacious interior whose walls are lined with Italian paintings from his collection, Archduke Leopold Wilhelm, elegantly dressed in a cloak and top hat and wearing a chain with a cross of the Teutonic order of which he was grand master, has come to inspect various masterpieces assembled in the foreground by the curator of his collection, David Teniers II. While Teniers presents to him Titian's *Madonna of the Cherries*, the archduke directs his stick toward a painting by Domenico Fetti that sits on the floor and rests against the easel. Also brought forward for the archduke's attention are masterpieces by Giorgione, Veronese, Raphael, Tintoretto, and Pordenone (the paintings are identified by Speth-Holterhoff 1957, 147–148). A third figure stands nearby to discuss with the archduke selected drawings, prints, and rare shells that lie on an elegant table. This man, who has not been identified, can be recognized as another artist in the employ of the archduke, because he wears virtually the same style of clothing as does Teniers. Among the artists employed by Leopold Wilhelm were Robert van den Hoecke, Jan Baptist van Heil, Jean Antoine van der Baren, and Peeter Franchoys.

Leopold Wilhelm's collection was extensive; in his inventory from 1659 are listed 517 Italian paintings, 810 German and Netherlandish works, in addition to drawings, statues, and other curiosities (see Berger 1883 for a complete inventory). Being of the Austrian branch of the Hapsburg family, he was from an early age imbued with an interest in collecting and patronizing the arts through the example of Emperor Rudolf II. Indeed, the table in the foreground was a particularly famous piece made for Rudolf around 1597/1598. Its *pietre dure* top, made with jasper, agate, and other semiprecious stones, was constructed by Florentine craftsmen, and the base, which represents Jupiter in the guise of an eagle, was fashioned by Rudolf's court sculptor Adriaen de Vries (Fock 1982, 267).

Before being appointed governor of the Spanish Netherlands, Leopold Wilhelm was in Spain where, influenced by the collections of Charles V and Philip II in Madrid and at the Escorial, he developed a passion for Italian and, in particular, Venetian painting. When Leopold Wilhelm moved to Brussels in 1647, he assembled his collection at the Château de Conderberg on the outskirts of the city, and soon employed Teniers as his court painter and director of his gallery. One of Teniers' functions was to purchase works for the archduke's collection, among which were

Cat. 30

certainly the majority of his Netherlandish paintings. Another was to make copies, in miniature, of paintings in Leopold Wilhelm's collection, from which engravers might work to produce a visual catalogue (only *Theatrum Pictorium Davidis Teniers* [Antwerp, 1658], the volume containing the Italian paintings, was published). Finally, Teniers painted scenes of the gallery, which could be sent as gifts to friends and relatives of Leopold Wilhelm.

Most of the paintings Teniers included in this gallery scene are documented as being part of Leopold Wilhelm's collection and were taken with him to Vienna when he moved there in 1656. Some paintings that appear in Teniers' gallery scenes, however, are not mentioned in the 1659 inventory and thus seems to have been sold or given away at some point during the archduke's life. Leopold Wilhelm's collection subsequently formed the core of the Kunsthistorisches Museum in Vienna, and masterpieces by Titian, Tintoretto, and Bassano that were proudly displayed on his walls can today be found in that museum.

Despite the accuracy of Teniers' copies of these works, the assemblage was clearly an invention of the artist. In his various versions of this subject, many of the same paintings reappear in different arrangements and in different interior settings. Whether or not thematic as well as compositional considerations underlie the artist's selections of paintings, however, is not known. That Teniers may occasionally have based the works in his gallery scenes on engravings made after his copies of the originals is suggested by his reversal at upper left of Giorgione's *Three Philosophers*, a painting that appears in its correct orientation in at least two others of his gallery assemblages.

While Teniers brought this type of composition to its culminating point, he was not the innovator of this genre. Gallery pictures had already been developed as a specialty by a number of artists, including Frans Francken II, by the end of the second decade of the seventeenth century (Speth-Holterhoff 1957). Francken's paintings are ultimately indebted to Jan Brueghel the Elder's series The Senses, particularly to the *Sense of Sight* (c. 1617, Prado, Madrid), in which paintings, drawings, and sculpture, as well as flowers, shells, and precise objects adorn an interior space in the company of allegorical figures. Aside from the resonances of that tradition in this work, which may account for the small bouquet of narcissi held by Leopold Wilhelm, the compositional formula that developed in Flanders also drew upon Pliny's account of Alexander the Great's patronage of Apelles. Both Leopold Wilhelm and Teniers stood to benefit from such associations: Leopold Wilhelm for his enlightened patronage in the tradition of Alexander the Great, and Teniers for having such an exalted status that this great Maecenas would honor him with the care of his collection.

It is with no little pride that Teniers stands before the archduke dressed as an elegant gentleman and carries the symbols of his status, a sword by his side and a gold chain around his neck. Teniers was conscious of his social position and sought to enhance it throughout his life. He in fact received two gold chains, one from Leopold Wilhelm and one from Queen Christina of Sweden. The one he wears in this painting is probably that given to him by Leopold Wilhelm, since from it hangs a portrait medallion of the archduke. Finally, on a cord at the artist's waist is a large key denoting the insignia of his office as *Ayuda de cámara* (gentleman of the bedchamber).

A.K.W.

PROVENANCE
presumably acquired in 1698 by the Elector Maximilian II Emanuel

LITERATURE
Adolph Berger, "Inventar der Sammlung des Erzherzogs Leopold Wilhelm von Österreich," *Jahrbuch der Kunsthistorischen Sammlungen des allerhöchsten Kaiserhauses* 1 (1883), part 2, 79–177; S. Speth-Holterhoff, *Les Peintres flamands de cabinets d'amateurs au XVII siècle*, Brussels, 1957; Jane Davidson, *David Teniers the Younger*, Boulder, 1979; C. Willemijn Fock, "Pietre dure work at the court of Prague; some relations with Florence," *Leids Kunsthistorisch Jaarboek* 1 (1982), 259–269; Zirka Zaremba Filipczak, *Picturing Art in Antwerp 1550–1700*, Princeton, 1987.

Dutch Paintings

Carel Fabritius
Midden-Beemster 1622–1654 Delft

31 *Self-Portrait*

c. 1649–1650
oil on canvas
62.5 x 51 (24⅝ x 20⅛)
signed at lower right, *C*
inv. no. 2080

This striking portrait of a young man with somber expression and piercing gaze has been the subject of extensive speculation as to the identity of both sitter and artist. The painting has been called a self-portrait by Carel Fabritius, a self-portrait by Barent Fabritius, his brother (1624–1673), a portrait of Carel Fabritius by Barent, and vice versa (see Brown 1981, no. R4).

Despite this confusion, the painting is undoubtedly a self-portrait by Carel Fabritius. It is remarkably close to two images generally accepted as self-portraits, a painting in the Museum Boymans-van Beuningen, Rotterdam, executed around 1648, and one in the National Gallery, London, dated 1654 (fig. 1). Present in all these paintings is the severe expression, full, broad lips, broad chin, and high cheekbones. The shape of the nose is also similar, the only difference being that it seems somewhat more turned up in this painting because of the low vantage point of the viewer. Comparisons with images of Barent such as his *Self-Portrait as a Shepherd* from the early 1650s (Gemäldegalerie der Akademie der bildenden Kunste, Vienna) are less close, since Barent had a wider face and a dimple on his chin.

The execution of this painting also differs from those by Barent. Barent never developed the same sensitivity for facial modeling with nuances of light and shade that characterizes portraits by his brother. In this work, as in other portraits by Carel, forms are built by the layering of thicker and lighter impastos over a darker underlying layer. The remains of a signature, *C.*, confirm the stylistic attribution.

Carel Fabritius, one of the foremost Dutch artists of the late seventeenth century, is an intriguing yet elusive personality. Although only about a dozen or so of his works are extant, he is considered the most gifted and original pupil of Rembrandt, the initiator of the Delft school of painting around 1650, and a major influence on the life of Johannes Vermeer. At the time of his tragic death at the age of thirty-two, when an explosion of the city arsenal leveled a large portion of Delft including the studio in which he was working, he had established a reputation as "a very fine and outstanding painter, who in matters of perspective and natural coloring or the placement of his color was so skillful and powerful, that . . . [he] has never had his equal" (Bleyswijck 1674?, 2:852).

Carel, the eldest son of Pieter Carelsz. Fabritius, moved to Amsterdam in 1641 and studied there with Rembrandt until 1643. In the latter year his wife died and he returned to Midden-Beemster, a village north of Amster-

. 31

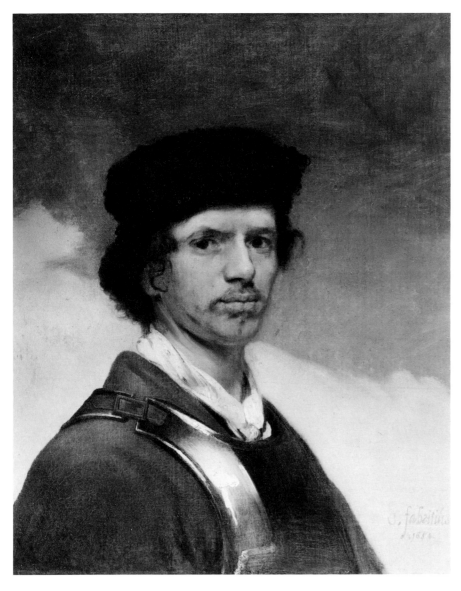

Fig. 1. Carel Fabritius, *Self-Portrait*, National Gallery, London

dam. He remained there until about 1650, at which time documents indicate he was living in Delft. In 1650 he married Agatha van Pruysen, a widow, who was a resident of that city. The reasons for his move to Delft are not known, although he may have gone there with the expectation that he could enter into the employment of Prince Willem II, perhaps as a mural painter (Wheelock 1981, 25).

Fabritius' style and subject matter in the 1640s were both heavily influenced by Rembrandt. Among the few works securely attributed to him from this period are religious and mythological scenes, portraits, and figure studies. In this painting, the intense expression of the sitter and the dramatic flair of the pose, particularly the upturned brim of the hat, are reminiscent of Rembrandt's self-portraits from the late 1630s and early 1640s. Because its modeling is executed with fewer impastos than are evident in Fabritius' Rotterdam self-portrait, the painting probably dates to somewhat later than that work, but presumably before the artist's move to Delft. Because of the fragmentary nature of the signature and the relatively tight composition, the painting may have been trimmed on all sides.

A.K.W.

PROVENANCE
acquired in 1842 by King Ludwig I of Bavaria

LITERATURE
Dirck van Bleyswijck, *Beschryvinge der Stadt Delft*, 2 vols., Delft, 1667–[1674?]; D. Pont, *Barent Fabritius, 1624–1673*, The Hague, 1958; Christopher Brown, *Carel Fabritius*, Oxford, 1981; Arthur K. Wheelock, Jr., *Jan Vermeer*, New York, 1981.

Hendrick Goltzius
Mühlbracht 1558–1617 Haarlem

32 *Venus and Adonis*

1614
oil on canvas
141 x 191 (55½ x 75¼)
signed on the rock beneath Adonis, *HG*
(monogram) *1614*
inv. no. 5613

The devastating siege of Haarlem in 1573, in which Spanish forces outlasted the determined resistance of the citizens and town militia, marked the nadir of this Dutch city's economic and political fortunes. By the beginning of the seventeenth century, however, prosperity had returned and with it an extraordinarily rich and dynamic intellectual and artistic environment, fueled in part by an influx of immigrants who had fled Antwerp after its occupation by the Spanish in 1585.

Among the artists who arrived in Haarlem in the early 1580s was Hendrick Goltzius. A masterful engraver and draftsman, Goltzius was one of the most diverse and influential artists of the period. Along with the art theorist Carel van Mander (1578–1606) and the painter Cornelis Cornelisz. van Haarlem (1562–1638), he established Haarlem as the preeminent artistic center in the Netherlands. His engravings after mannerist designs by Bartholomeus Spranger during the mid to late 1580s established the character of late sixteenth-century mannerism in the Netherlands. Goltzius, however, was not solely a mannerist artist. In 1590/1591 he traveled to Italy, where he made careful drawings and prints after classical and Renaissance sculptures; his drawings and prints from the 1590s

in the style of Albrecht Dürer and Lucas van Leyden fostered an interest in early sixteenth-century northern traditions; and finally, he made exquisite nature studies, including landscape drawings, that anticipated developments in Dutch realism.

Equally important but less understood were Goltzius' contributions as a painter. Goltzius only started painting in 1600, when his eyesight deteriorated so that he could no longer make engravings. Although his large paintings, primarily with mythological subjects, are few in number, they significantly influenced the classicizing tradition in seventeenth-century Dutch art.

Venus and Adonis is one of Goltzius' most imposing paintings. In the lyrical yet idealized forms of the figures, the delicate rendering of landscape and still-life elements, and the symbolic resonances of the scene, it combines all the various elements of Goltzius' style. Venus, who has come to Adonis on her swan-driven chariot, embraces the young hunter as she implores him to beware of dangerous game. Adonis gazes intently into her eyes and wraps one arm around her. He holds his spear erect between his legs, a gesture that has explicit erotic connotations as well as being evidence of his readiness to hunt. Beside them, Cupid, holding

Cat. 32

his arrow triumphantly aloft, mounts a large dog as he peers at the couple with a laughing expression.

Goltzius has depicted the scene as an Arcadian idyll that betrays no evidence of the tragic conclusion of Ovid's tale (*Metamorphoses* 10:529–559). Ovid's text was well known in the Netherlands. It had appeared in a number of Dutch translations by the end of the sixteenth century, and a contemporary viewer would not only have known the story, but also the moral that had been attached to it (Sluijter 1986, 225–232). In Van Mander's commentary on Ovid that he appended to his artistic treatise *Het Schilder-Boeck* of 1604, Adonis, in his decision not to heed the warnings of Venus, is seen as a symbol of reckless youth who casts good advice to the wind (Van Thiel in Washington 1980, no. 8).

The pronounced classicizing qualities of this work, evident not only in the idealized forms of the large-scale figures, but also in the pyramidal composition of the main protagonists, differs from the more mannered examples of this scene painted earlier by Goltzius and by his contemporary, Cornelis Cornelisz. van Haarlem. This work may be a response to Rubens' classicizing style from the 1610s. In 1613 Rubens visited Goltzius' studio in search of a reproductive engraver for his workshop; thus, we know that the two artists were in contact at that time. Rubens' painting of *Venus and Adonis* (c. 1610, Kunstmuseum, Düsseldorf) is a clear prototype for this work. In it Venus clasps Adonis in much the same way as she does in this evocative painting by the Haarlem master (Sluijter 1986, 40).

A.K.W.

PROVENANCE
from the Bayreuth Palace

LITERATURE
Carel van Mander, "Wtlegghingh op den Metamorphosis Pub. Ovidii Nasonis," in *Het Schilder-Boeck*, Haarlem, 1603–1604; Pieter van Thiel in *Gods, Saints and Heroes: Dutch Painting in the Age of Rembrandt*, exh. cat., National Gallery of Art, Washington, Detroit Institute of Arts, Rijksmuseum, Amsterdam, Washington, 1980, no. 8; Eric Jan Sluijter, *De 'Heydensche Fabulen' in de Noordnederlandse Schilderkunst circa 1590–1670*, The Hague, 1986.

Jan Davidsz. de Heem
Utrecht 1606–Antwerp 1683/1684

Nicolaes van Veerendael
Antwerp 1640–1691

33 *Flowers with Crucifix and Skull*

c. 1665
oil on canvas
103 x 85 (40½ x 33½)
signed at upper right, *Ni.V.Veerendael*; at
bottom center, on table edge, *J. De Heem f.*
inv. no. 568

The collaboration of independent masters on a single painting normally occurs in Dutch and Flemish art when specialists in different genres, for example landscape and portraiture, work together. This *vanitas* still life is unusual in that it was jointly executed by two still-life specialists who worked in similar styles and painted comparable subjects. The collaboration is all the more remarkable because it was carried out by a well-established and important master in Antwerp, Jan Davidsz. de Heem, and a much younger artist, Nicolaes van Veerendael. Van Veerendael, who joined the Guild of Saint Luke in Antwerp in 1656/1657 at the age of sixteen, painted the vase of flowers, while De Heem, who was thirty-four years his elder, executed the other objects resting on the table, including the crucifix and skull, the watch, fruit, and shell.

While the reasons for this collaboration are not known, clearly the artist who devised the theoretical concepts underlying this work was De Heem. Not only did he sign the painting on the edge of the table in the lower center, but his signature, written in elegant calligraphy, also appears on the sheet

of paper at the lower left. Van Veerendael's signature is relegated to the upper right corner of the canvas.

De Heem conceived his work so that its meaning could only be understood by relating a text to the pictorial image, just as in emblematic literature. Above his signature on the sheet of paper is inscribed in Dutch: "but one does not turn to look at the most beautiful flower of all." The crucifix resting on the sheet of paper indicates that the most beautiful flower is not to be found in the vase, but is Christ himself. Human life is too often spent searching for transitory pleasures, such as the smell and beauty of flowers, or the sensuous enjoyment of ripe fruit. The watch and empty shell indicate that life is not lasting. De Heem's message is not positive. Man remains oblivious to the promise of salvation by focusing on temporal pleasures rather than on the message of Christ's suffering, death, and resurrection.

By the seventeenth century, fruit, flower, and grains had developed complex symbolic associations that reinforce the emblematic meanings of such *vanitas* paintings. The ivy and ears of corn wrapped around the skull, for ex-

. 33

ample, were meant to suggest salvation and resurrection from the dead. The white lily, roses, and white jasmine in the bouquet are symbols of the Virgin Mary and of purity (Segal 1982, 46).

After his early training in Utrecht with the fruit and flower painter Balthasar van der Ast (1593/1594–after 1656), De Heem moved to Leiden around 1625, where, through the influence of the still-life painter David Bailly, he developed an interest in *vanitas* still lifes, which focus on the transitoriness of life (Bergström 1956, 172–173). When he left for Antwerp around 1635/1636, he began to enlarge upon the character of floral and fruit symbolism by adding explicit religious elements to his compositions. The crucifix and skull in this painting occur in a number of his still lifes, including a *Vanitas Fruit-Piece* in the National Gallery of Ireland that is signed and dated 1653.

The date of this still life is probably some years later than the painting in Ireland. The delicate nuances of color and texture in the flowers, the subtle reflections of the window on the vase, and the floral bouquet, in which the diagonal thrust of the tulip stem balances the diagonal of the crucifix, is comparable in character to flower pieces executed by Van Veerendael in the early 1660s. At that time De Heem was enormously popular, and he must have had an extensive workshop to help him produce his many large and complex paintings. Van Veerendael, who was greatly influenced by De Heem's work, painted in a style that was compatible with that of the master, and thus was a logical choice as a collaborator. An identical composition, co-signed by Jan Davidsz. de Heem and his son Cornelius, also exists (sale, Sotheby's, London, 10 December 1975, no. 95). That painting probably also dates from the mid-1660s, since Cornelius only joined the Saint Luke's Guild in Antwerp in 1660/1661.

A.K.W.

PROVENANCE
acquired in 1698 from Gisbert van Ceulen

LITERATURE
Ingvar Bergström, *Dutch Still-Life Painting in the Seventeenth Century*, London, 1956; Sam Segal, *A Flowery Past*, Amsterdam, 1982.

Jan van Huysum
Amsterdam 1682–1749 Amsterdam

34 *Fruit, Flowers, and Insects*

c. 1710–1720
oil on canvas
40 x 32.9 (15¾ x 13)
signed at lower right, on the marble ledge, *Jan Van Huysum. fecit.*
inv. no. 267

Visual language, like spoken and written language, draws upon a variety of sources and traditions. When expressed by great artists who through intuition or training have understood its fundamental structures and the nuances possible within it, that language can capture the essence of its culture and enrich its meaning.

The Dutch artist who used visual language most clearly at the beginning of the eighteenth century was Jan van Huysum. The elegance and delicacy of his masterful still lifes mirror the refinement of Dutch society at that time. Van Huysum's language was immediately understood, and he was lavishly praised and highly paid in his lifetime. In 1729 Jacob Campo Weyerman called him the "Phoenix of flower painters" in his lexicon of artists. George Vertue wrote in his diary in 1741 that his works "are the most inimitable pictures that were ever seen" (White 1964, 7). Van Huysum counted among his patrons not only the Dutch elite, but also kings, dukes, and counts of England, France, and Germany.

This artist's lasting fame has centered on his technical virtuosity and his precise observations of flowers and fruit. In this painting he has suggested the soft, fuzzy surface of the peaches as well as the smooth, glistening skins of the grapes. The rich nuances of reds and purples in the plums create an almost iridescent glow, while the blues of the morning glory, whites of the peony and carnations, and various shades of green on the grape leaves are accurately and subtly rendered. His compositions are also sensitively conceived, with thin stems of flowers or grape tendrils creating fluid rhythms that enliven the tightly massed group of fruit.

Although Van Huysum was trained by his father, his compositional ideals and technical prowess owe a tremendous debt to Jan Davidsz. de Heem. His methods and techniques for achieving his pictorial effects are not well understood, however, for he was a secretive man who isolated himself from the world. He had only one pupil, Margaretha Haverman (1720–1795), apparently because he wanted no distractions from his work. It appears that he often executed his paintings over an extended period of time, because he insisted on painting from life. To complete these compositions that contained flowers that blossomed at various periods of the year, he would have to wait for the appropriate seasons.

Van Huysum was not merely an accomplished technician. He also sought to convey religious and moralizing

Cat.

ideas in his paintings. When one compares the type of fruit and flowers he depicted with those in De Heem's *vanitas* still life (see cat. 33), it becomes apparent that he also adapted De Heem's symbolic vocabulary. The basic clue that this painting has religious overtones is not a crucifix, but the three acorns lying on the marble slab just above the artist's signature. Acorns were traditionally considered symbolic of Christ because of their three components: the husk, the shell, and the edible core. The husk was associated with Christ's suffering on the cross, the shell with the strength of his all-embracing divinity, and the kernel with his sweetness (Segal 1983, 36). To emphasize these associations Van Huysum has depicted the first acorn with its husk, the second with its shell, and the third opened to the kernel. This Christian symbolism continues with the purple plums and red grapes, both of which represent Christ's suffering and death. As with acorns, peaches have three layers, pulp, skin, and seed, that were symbolically associated with Christ (Segal 1983, 38). A branch and leaf attached to peaches also had emblematic connotations of sincerity and truth, for as the leaf relates to the fruit, so should the tongue relate to the heart (Ripa 1644, 590–591). Finally, the flowers

Van Huysum has chosen to represent, among them the peony, the carnation, and the morning glory, have comparable emblematic meaning. The morning glory, for example, probably symbolizes the light of truth, since it opens at the break of day and closes in the dark of night.

Included in the extensive symbolic program Van Huysum devised for his work are ants, snails, beetles, and butterflies that crawl on or hover around the still-life elements. According to tradition, they carried with them the symbolic connotations of sin and resurrection. Thus, despite the seemingly random arrangement of fruit, flowers, and insects, Van Huysum has conceived of a powerful symbolic statement of Christ's sacrifice for the redemption of mankind. Although far more subtle than De Heem's explicit symbolism, the underlying message is every bit as powerfully expressed.

A.K.W.

PROVENANCE
documented at Schleissheim since 1748

LITERATURE
Cesare Ripa, *Iconologia of Uytbeeldinghe des Verstands*, trans. D. P. Pers, Amsterdam, 1644; Christopher White, *The Flower Drawings of Jan van Huysum*, Leigh-on-Sea, England, 1964; Sam Segal, *A Fruitful Past*, Amsterdam, 1983.

Pieter Janssens Elinga
Bruges 1623–1682 Amsterdam

35 *Woman Reading*

c. 1658–1660
oil on canvas
75.5 x 63.5 (29¾ x 25)
inv. no. 284

Although Pieter Janssens Elinga was born in Bruges in 1623, the first record of his profession as a painter did not occur until 1653, in an inventory of his effects made in Rotterdam after the death of his first wife. Nothing is known of his artistic training, but his specialization in domestic genre scenes suggests that he came into contact with Ludolf de Jongh (1616–1679) and Pieter de Hooch (1629–1684) in Rotterdam. Janssens Elinga seems to have left Rotterdam in 1653, the year after De Hooch moved from there to Delft. He spent the rest of his life in Amsterdam, where he continued to paint genre scenes and still lifes. Documents indicate that he also worked as a musician.

The tranquil, contemplative quality of this interior scene characterizes the essence of Janssens Elinga's artistic vision. The woman seated beneath the windows on the far side of the room is completely absorbed in her book. Hers is a self-contained world; the bottom shutters are closed and she is turned away, her face hidden by the large white cap that covers her head. Light filtering into the room through the upper windows falls directly upon her and creates a radiant glow around her form.

The unusually reflective mood of this image raises questions about Janssens Elinga's underlying intentions that unfortunately cannot be fully understood, particularly because the book the woman reads has not been convincingly identified. It may well be a prayerbook, since on the left page is text and on the facing page an image. The title appears to read *MAh* (?), although it has also been interpreted as *malo* or *male* (Eikemeier 1984, 65). The centrally placed mirror may well have symbolic implications, particularly since the artist has explicitly depicted within it a reflection of a window that has no logical optical explanation. The placement of the bowl of fruit on a chair and the prominently displayed shoes in the foreground of the scene are other striking elements that probably relate to the meaning of this carefully arranged image.

The essential compositional characteristics of the interior space are similar to those in paintings by De Hooch, and, indeed, until the late nineteenth century this painting was considered to be a work by that well-known master. Even after the correct attribution was made by Hofstede de Groot in 1891, the painting was used to demonstrate Janssens Elinga's dependence on De Hooch, who moved to Amsterdam around 1661 (Sutton in Philadelphia 1984, 203). The focus on a single individual quietly involved in an activity, however, is not characteristic of De Hooch's work, and there seems little reason to suggest a dependent relation-

35

Fig. 1. Esaias Boursse, *Interior with a Woman at a Spinning Wheel*, Rijksmuseum, Amsterdam

ship with the Delft master. Closer to Janssens Elinga's image are paintings by Esaias Boursse (1631–1672), another artist of Flemish origin who was active in Amsterdam during the 1650s. In his *Interior with a Woman at a Spinning Wheel* (1661, Rijksmuseum, Amsterdam, fig. 1), Boursse includes a man and a woman quietly sitting in an interior that is softly illuminated like this painting, by light filtering through windows along the rear wall of the room. The vague, distorted form of an adjacent building can be seen through the leaded-glass windows in both works. The striking simplicity of Janssens Elinga's interior, as well as the nature of the woman's costume, are completely characteristic of the 1650s, and there is no reason to date it to the 1660s or 1670s as has previously been done.

Janssens Elinga's painting *The Sweeper* (The State Hermitage Museum, Leningrad), once thought to form a pendant to this work, probably dates to this late period (Brière-Misme 1948, 354). It is painted in a crisper style and depicts a far more elegant interior than does the Munich example. A painting similar in style and composition to *Woman Reading* is the artist's *A Dutch Interior with a Girl Playing a Guitar* (c. 1660, fig. 2).

It seems quite probable that Janssens Elinga, Boursse, and perhaps also Jacobus Vrel, an enigmatic figure who probably also worked during the 1650s, established a mode of genre

Fig. 2. Pieter Janssens Elinga, *A Dutch Interior with a Girl Playing a Guitar*, Phoenix Museum of Art. Gift of Mr. and Mrs. Donald D. Harrington

painting that paralleled yet differed from the work being created in Delft at that same time by Vermeer and De Hooch. In many ways reflective of Flemish manuscript traditions, these works, in their contemplative, almost sacramental mood, sensitivity to optical effects of light and color, and provocative subject matter, represent a fascinating yet little-understood facet of Dutch genre painting of the mid-seventeenth century.

A.K.W.

PROVENANCE

acquired in 1791 from the art dealer de Vigneux in Mannheim

LITERATURE

C. Brière-Misme, "A Dutch Intimist: Pieter Janssens Elinga," *Gazette des Beaux-Arts* 33 (1948), 347–366; Peter C. Sutton et al., *Masters of Seventeenth-Century Dutch Genre Painting*, exh. cat., Philadelphia Museum of Art, Gemäldegalerie, Berlin, Royal Academy of Arts, London, Philadelphia, 1984, no. 44; Peter Eikemeier, "Bücher in Bildern," *De Arte et Libris: Festschrift Erasmus*, Amsterdam, 1984.

Gabriel Metsu
Leiden 1629–1667 Amsterdam

36 *The King Drinks*

c. 1655
oil on canvas
80.9 x 97.9 (31¾ x 38½)
signed on the child's chair, *GMetsu* (*GM*
monogram)
inv. no. 871

The feast of the Epiphany or Three Kings was traditionally celebrated in the Netherlands on 6 January with a meal at which friends and relatives joined to eat, drink, and be merry. The high point of the evening was the moment when a king was chosen to preside over the festivities. The king assumed his prestigious position by chance, either by finding a bean in a special cake cooked expressly for the occasion or, as in this instance, by lottery. Here, the piece of paper that the king drew is firmly attached to his paper crown. Once assuming his role, he appointed other members of his court, including a jester. He then raised his glass and drank while the whole company shouted "the king drinks!"

As the king finishes his draft in Metsu's painting, the figures around the table watch him with attitudes that range from the open-mouthed awe of the boy by his side to the disdainful gaze of the woman at the opposite end of the table. The jester stares at the viewer with a wry expression as he points to the king's glass to be sure that the significance of the moment is not overlooked. Behind the king an old woman kneels beside burning coals to cook pancakes, traditional fare for this feast. More food is being brought by the woman holding the candlestick in the background, as well as by a man carrying a basket on the stairs at the upper right.

This moment of festive celebration was one that sparked the imagination of a number of Dutch and Flemish artists for its narrative possibilities and for its moralizing ones. Also, because of the role chance played in the selection of one individual to be king, and because of the transitory nature of the king's position, the subject had *vanitas* connections (see cat. 33). The emphasis on drinking and gluttony in the scene, moreover, often made the king as much an object of ridicule as of respect.

Many of the thematic and moralizing characteristics evident in this work are found in depictions of this subject by Metsu's contemporaries. David Teniers, for example, painted a *Twelfth Night* scene (1635, National Gallery of Art, Washington) in which a jester directs the viewer's attention to the king while an old woman busily cooks pancakes for the feast. In Teniers' example the king is a youth, but in most representations by Jacob Jordaens, the artist who specialized in this theme, he is an elderly bearded man, similar to the king in Metsu's painting. The closest thematic comparison to Metsu's painting is Jan Steen's *Twelfth Night* (c. 1656,

Cat. 36

Fig. 1. Jan Steen, *Twelfth Night*, The Collection of Her Majesty the Queen, Buckingham Palace, London

fig. 1). Although Metsu includes fewer figures and minimizes the humorous, anecdotal quality of the scene, the underlying message is the same. While Steen utilizes explicit gestures and attributes to indicate that the king was revered by children but often mocked by adults, Metsu conveys his message primarily through expressive gazes.

Metsu's fluid brushwork and sensitivity to human psychology, particularly to that of women, are aspects of his paintings that have been admired by collectors and connoisseurs. In his early works, as in this instance, he often depicted narrative moments in which emotions were at their most intense. Although he was born in Leiden and was one of the founding members of the Leiden Saint Luke's Guild in 1648, he probably did not develop his style under the tutelage of the Leiden painter Gerard Dou (1613–1675), as has sometimes been thought. Aside from stylistic and thematic associations with the work of Jan Steen, there are in Metsu's early output a number of connections with paintings by artists from Utrecht, particularly Steen's teacher Nicolaes Knupfer and Jan Baptist Weenix (Plietzsch 1936, 6). Metsu may well have spent some time in Utrecht in the early 1650s, when documents indicate he was absent from Leiden.

By 1657 Metsu moved to Amsterdam, where he remained for the rest of his life. His style became more refined and his subject matter more elegant in his later work, although in at least one instance, his *Duet* (c. 1665, National Gallery, London), he alluded to his earlier work by including on the back wall of the room a depiction of *The King Drinks* that is similar to the one in this painting, although in reverse (Robinson 1974, 23).

A.K.W.

PROVENANCE
from the Düsseldorfer Galerie

LITERATURE
Eduard Plietzsch, "Gabriel Metsu," *Pantheon* 17 (1936), 1–13; Franklin W. Robinson, *Gabriel Metsu (1629–1667): A Study of His Place in Dutch Genre Painting of the Golden Age*, New York, 1974.

Paulus Moreelse

Utrecht 1571–1638 Utrecht

37 *The Fair Shepherdess*

1624
oil on canvas
76.1 x 63.2 (30 x 24⅞)
signed at upper right, *PM* (monogram) *1624*
inv. no. 13183

With her evocative gaze and explicitly erotic gesture, this young shepherdess smilingly encourages the viewer to partake of the sensual pleasures of Arcadian existence. While she holds a *houlette*, a traditional attribute of a shepherdess, against her body, little else in her dress or demeanor suggests that she is remotely concerned with the fate of her flock. Her straw hat, with its brim stylishly raked on one side to reveal its blue lining, is adorned with a variety of flowers, fruits, and stalks of wheat, elegant but impractical. The delicate lace edging of her white chemise sets off her sensuous appearance, but is hardly appropriate for the rigors of country life.

This painting belongs to one of the most intriguing yet little-understood aspects of Dutch culture in the early seventeenth century. During this period, artists, writers, and poets developed a fascination with pastoral images and with creating a mythology of the Dutch Arcadia. Essential to this mythology was not only the purity and bounty of country existence, but also the romantic ideals of love and beauty that derived from Renaissance literary and pictorial traditions (Kettering 1983, 7–62).

These concepts were first expressed in the Netherlands in plays written in the first decade of the seventeenth century, the most famous of which was Pieter Cornelisz. Hooft's *Granida*, published in 1615. Although essentially aristocratic and intellectual in origin, the Arcadian ideal of bucolic life, as well as the romantic imagery associated with it, had wide appeal. Pastoral images in painting appeared in the early 1620s, partially in response to the plays and to pastoral poetry, but also because of the influence of Dutch Caravaggist painters returning to Utrecht from Rome. Gerrit van Honthorst and Dirck van Baburen, in particular, brought with them stylistic and thematic predilections appropriate for expressing the sensuous, idealized concepts of this Arcadian subject matter.

The sudden emergence of pastoral images in 1621 and 1622 is so remarkable that one wonders if discussions did not focus on this issue at the welcome-home party for Honthorst in Utrecht in July 1620. Unfortunately, Aernout van Buchell, an important Utrecht jurist, writer, and art enthusiast who described the occasion in his diary, does not say. We do know, however, that Honthorst's work and that of Peter Paul Rubens was discussed. We also know that among the artists present were some who immediately began to specialize in Arcadian subject matter,

Cat.

including Honthorst's teacher Abraham Bloemaert, and Paulus Moreelse (Blankert and Slatkes 1986, 277).

Moreelse, who was a generation older than Honthorst, was at this time the preeminent portrait painter in Utrecht. A student of the Delft portraitist Michel van Mierevelt, he had traveled to Italy in the early 1590s, returning to Utrecht by 1596. He was instrumental in establishing the Utrecht Saint Luke's Guild in 1611, and continued to be an active participant in the organization throughout his life. He was also involved in the broader political fabric of the city, serving as a *kerkmeester* (church warden) of the Buurkerk from 1624 to 1625, as head of the militia company in 1625, and from 1625 to 1627 as alderman of the city council. In 1637 he became city treasurer. His interest in Arcadian subject matter, as evident in his numerous depictions of idealized shepherds and shepherdesses during the 1620s, should thus be seen as accepted, and even valued, by the upper echelons of Utrecht society. As an indication of the esteem in which the paintings were held, in 1627 the Utrecht city council included a *Shepherd* and *Shepherdess* by this master among the four works of art they chose as wedding presents for Amalia van Solmes and Prince Frederik Hendrik.

The sensuous appeal of Moreelse's *The Fair Shepherdess* is consistent with the Arcadian imagery in contemporary pastoral literature, which is often at once playful and erotic. The shepherdess' gesture, in which she holds her breasts together under the nipples and inserts her forefinger into the crevice between them, probably was intended as a visual play with a now-lost pendant image of a shepherd holding a flute, a traditional phallic symbol. Such a pair of images, signed and dated 1622, is in the Krayer-La Roche Collection, Basel (Kettering 1983, figs. 3, 4). One Dutch poem, published in 1640 but probably written earlier, begins "He stuck his pretty flute between my breasts" (Kettering 1983, 42).

As in most Dutch pastoral literature, sensual allusions are only part of a broader context that stresses the fertility and allure of the Dutch Arcadia. Allegorical allusions to abundance and fertility certainly exist in this work in the unusual arrangement of the fruits, flowers, and grain in the hat and in the shepherdess' well-endowed body. Even her elegant, costly chemise would appear to reinforce the allegorical quality of her persona. A similar costume is worn by Pomona in Moreelse's later mythological scene *Vertumnus and Pomona* (c. 1630, Museum Boymans-van Beuningen, Rotterdam).

Finally, Aernout van Buchell's comment that the work of Rubens was a primary topic of conversation at the party given for Honthorst points out that Rubens' paintings were well known to this small group of artists in Utrecht (Blankert and Slatkes 1986, 277, 278, n. 9). In this regard it is perhaps more than coincidental that *The Fair Shepherdess* bears a striking resemblance to Rubens' famed *Le Châpeau de Paille*, painted in about 1621 (National Gallery, London). Interestingly, Moreelse's painting was even thought at one point to represent Rubens' wife (see Kat. AP 1986, 436).

A.K.W.

PROVENANCE
from the Düsseldorfer Galerie

LITERATURE
C. H. de Jonge, *Paulus Moreelse, portret en genre-schilder te Utrecht (1571–1638)*, Assen, 1938; *Nieuw Licht op de Gouden Eeuw: Hendrick ter Brugghen en tijdgenoten*, exh. cat., Central Museum, Utrecht, Herzog Anton Ulrich-Museum, Braunschweig, Utrecht, 1986; Alison McNeil Kettering, *The Dutch Arcadia: Pastoral Art and Its Audience in the Golden Age*, Montclair, 1983.

Cat. 38

Rembrandt van Rijn

Leiden 1606–1669 Amsterdam

38 *The Holy Family*

c. 1635
oil on canvas
183.5 x 123 (72¼ x 48⅜)
signed at lower right, *Rembrandt f. 163[?]*
(perhaps a later inscription)
inv. no. 1318

With loving tenderness the Virgin nestles the sleeping Christ Child in her lap while Joseph leans forward to view the infant more closely. Content from his feeding, Jesus lies wrapped in his robes on a soft, fur-lined throw, his head resting against Mary's breast. The strong light entering the carpenter's shop from the upper left falls directly on the Virgin and child, illuminates Joseph's kindly and expressive face, and comes to rest on the child's empty cradle. Visible on the light gray rear wall and on a table in the shadows on the left are the carpentry tools of Joseph's trade.

This remarkable painting, which in so many ways is imbued with the deep humanity and sensitivity of Rembrandt's religious images, has never fit easily into the art historian's conception of Rembrandt's stylistic evolution. The painting formerly carried a signature and date of 1631, which presumably indicated that Rembrandt executed it at the end of his Leiden period. At that early stage of his career, however, Rembrandt preferred relatively small-scale religious scenes on panel, which were painted in a delicate and refined style. After Dr. E. Brochhagen discovered in the late 1960s that the last digit of the picture's date was painted on a strip added to the right, the painting

was dated c. 1635 for stylistic reasons (Bredius-Gerson 1969, no. 544). Gerson associated it with other large-scale religious and mythological scenes Rembrandt executed in Amsterdam between 1633 and 1635, when he was emulating the boldly conceived paintings of Peter Paul Rubens (see Rubens' *Holy Family* 1630–1635, formerly in the Cook collection; Oldenbourg 1921, 342). Technical examination has now confirmed this general dating, since the canvas Rembrandt used for this work served as the support for other paintings from 1634 and 1635, including *Samson Threatening His Father-in-Law* (Bruyn 1986, 452; fig. 1). Also characteristic of this period are the thick impastos Rembrandt used in the modeling of the forms, and the expressive brushwork of Joseph's face. Now that the painting has been cleaned, the subtle transparency of the Virgin's veil, the rich nuances of color in her reddish-purple dress, and the striking greens of the Christ Child's robes are once again revealed.

Despite the clear stylistic and technical connections that exist between this work and other paintings of the mid-1630s, *The Holy Family* still seems exceptional. Its intimate domesticity differs in concept from the exuberant and dramatic expressiveness that character-

Fig. 1. Rembrandt van Rijn, *Samson Threatening His Father-in-Law*, Gemäldegalerie, Berlin

izes so many other paintings of this period, such as *Samson Threatening His Father-in-Law*. The differences, however, are not so marked if one takes into account Rembrandt's numerous drawings and etchings of the early to mid 1630s that represent women and children in a wide variety of scenes derived from daily life. Many of these drawings depict an infant in swaddling clothes comparable to those of the Christ Child (Benesch 1954, 2:nos. 258, 259, 280b), while others portray a child nestled in his mother's arms (Benesch 1954, 2:nos. 275, 280a). In

one drawing, the figures are so peacefully entwined that they take on the aura of a Madonna and Child (Benesch 1954, 2:no. 113, recto; fig. 2); in another, Rembrandt added the figure of Joseph to complete the image of the Holy Family at rest in their home (Benesch 1954, 1:no. 114). Indeed, the distinctions between a drawing from daily life and a religious scene are often difficult to establish, since Rembrandt conveyed many of the same emotions in both.

The infants in Rembrandt's many drawings from this period cannot be

conclusively identified. In some works they may represent the children of Hendrick van Uylenburgh, in whose home the artist was living at this time. Rembrandt's increased interest in depicting children, however, is noticeable around 1635, and not unexpectedly this timing coincides with the birth of Rumbartus, his and Saskia's first son. Although Rumbartus, who was baptized on 15 December 1635, lived only a few months and was buried on 15 February 1636, the warmth of Saskia's love for the child is implicit in a wonderful sheet of studies in the Museum

Fig. 2. Rembrandt van Rijn, *Madonna and Child*, pen and bister, wash, British Museum, London

Boymans-van Beunigen in Rotterdam (Schatborn 1975; fig. 3).

For representations of the Holy Family these personal associations were extremely important, since this domestic scene is never described in the Bible. In his first image of this subject, *Holy Family in an Interior*, an etching of 1632 (Bartsch 1797, 1:no. 62; fig. 4), Rembrandt relied in part on a print by Annibale Carracci, but adapted it to enhance its domestic character. He situated the Holy Family in an interior setting and represented the Virgin nursing the Christ Child. In *The Holy Family*,

executed some years later, he composed the scene to emphasize the protective nurturing of the child by Mary and Joseph. Mother and child create a self-contained unit through Mary's gesture of holding the child's toes with her right hand. Her own circular form is then echoed by the arch of Joseph's back and head rising over her, an arch that is implicitly extended by the circular configuration of the bricks on the back wall.

Rembrandt's depiction of the Holy Family appears so natural and informal that it is hard to appreciate the radical

nature of this image. Rembrandt was the first artist to isolate the Holy Family within Joseph's carpentry shop. The family, moreover, is alone, its privacy uninterrupted by the presence of the Virgin's mother or John the Baptist, other figures who are normally included in the scene. Rembrandt has also tightened the family bond by bringing Joseph forward, in contrast to iconographic conventions that relegated him to a subordinate role in the background. The artist seems to have adapted compositional elements traditionally associated with images of the

Fig. 3. Rembrandt van Rijn, *Four Studies of Saskia*, pen and wash in bister, Museum Boymans-van Beuningen, Rotterdam

Rest on the Flight into Egypt. In Lucas Cranach's 1509 woodcut of this scene (Hollstein 1954, no. 7), for example, Joseph bends forward to watch the nursing child while the Virgin sits beneath a large tree. Rembrandt's own etching of the *Rest on the Flight into Egypt* of about 1626 (Bartsch 1797, 1:no. 59), which was based on a print by Lucas van Leyden, actually depicts Joseph holding a spoon to help feed the child. Interestingly, in 1644, Rembrandt's pupil Ferdinand Bol adapted Rembrandt's figure group from *The Holy Family* for his depiction of the *Rest on the Flight into Egypt* (Gemäldegalerie, Dresden).

As is always the case with Rembrandt, no single explanation accounts for the varied characteristics of his works. It is tempting, for example, to ascribe compositional innovations in Rembrandt's interpretation of the scene to his own domestic situation at the end of 1635. The Virgin's face bears a striking resemblance to that of Saskia, who frequently served as a model for Rembrandt's religious and mythological heroines from this period. Rembrandt's fascination with the theme of mother and child and his acute observations in the nurturing and feeding of infants, so strikingly evident here in the way he has depicted a drop of milk on the Virgin's exposed nipple, were certainly crucial to his underlying concept of this scene.

Fig. 4. Rembrandt van Rijn, *Holy Family in an Interior*, etching, National Gallery of Art, Washington, Rosenwald Collection

fur that could serve as a shroud, offers a premonition of the Pièta.

A large painting such as this would have been a commissioned piece, perhaps intended to be placed over a fireplace, as it presumably was in the eighteenth century when its shape was altered. At that time the width was reduced and an arched segment was cut out of the bottom to match an arch cut at the top (Bruyn 1986, 2:452). This painting may well be the work ("een schilderij van Joseph en Maria") listed in an inventory of 24 June 1660 of the estate of Maerten Daey. Daey was the second husband of Oopjen Coppit who, along with her first husband Marten Soolmans, was a patron of Rembrandt. Rembrandt executed full-length pendant portraits of Coppit and Soolmans in 1634 (Bruyn 1986, 2:nos. A100, A101). No firm conclusions can be reached about the identity of the painting mentioned in the inventory, however, since the description is so cursory and the dimensions are not indicated. Hence, the reasons for the commission and the patron's expectations for this work cannot be determined.

A.K.W.

PROVENANCE

acquired in 1760 by the court painter Lambert Krahe on behalf of the Mannheimer Galerie

LITERATURE

Adam Bartsch, *Catalogue raisonné de toutes les estampes qui forment l'oeuvre de Rembrandt et ceux de ses principeaux imitateurs*, 2 vols., Vienna, 1797; Rudolf Oldenbourg, *P. P. Rubens: Des Meisters Gemälde*, Stuttgart, 1921; F. W. H. Hollstein, *German Engravings, Etchings and Woodcuts, c. 1400–1700*, vol. 6, Amsterdam, 1954; Otto Benesch, *The Drawings of Rembrandt*, 5 vols., London, 1954–1957; Abraham Bredius, *Rembrandt: The Complete Edition of the Paintings*, revised by H. Gerson, London, 1969, no. 544; Peter Schatborn, "Over Rembrandt en kinderen," *De Kroniek van het Rembrandthuis* 27 (1975), 9–19; Peter C. Sutton et al., *Masters of Seventeenth-Century Dutch Painting*, exh. cat., Philadelphia Museum of Art, Gemäldegalerie, Berlin, Royal Academy of Arts, London, Philadelphia, 1984; J. Bruyn et al., *A Corpus of Rembrandt Paintings*, 2 vols., The Hague, 1986; Simon Schama, *The Embarrassment of Riches: an Interpretation of Dutch Culture in the Golden Age*, New York, 1987.

Rembrandt's image clearly reflects broader cultural concerns, too. In Dutch society at this time, a great deal of emphasis was being placed on the role of the father within the family structure (Schama 1987, 541). Proper nurturing included breast-feeding by the mother, whose milk was seen not only as essential nourishment, but also as a means of transmitting her moral character to the child (Sutton in Philadelphia 1984, 222). Finally, the painting expresses a profound religious conviction of both the awe and the humility with which one must approach the Christ Child. The Virgin sits near the floor in a pose traditionally associated with the Madonna of Humility. The way she gently holds Jesus's bare feet is a subtle reminder of the Lamentation, in which the wounds of his feet are kissed by Mary Magdalen. Indeed, the quietly sleeping child lying across his mother's lap, partially wrapped in a

Cat. 39

Rembrandt van Rijn

Leiden 1606–1669 Amsterdam

39 *Resurrected Christ*

1661
oil on canvas
oval 78.5 x 63 (30⅞ x 24¾)
signed at left, above the shoulder, *Rembrandt.*
f. 1661 (perhaps a later inscription)
inv. no. 6471

In this haunting image Rembrandt presents the resurrected Christ as an austere yet vulnerable and deeply human savior. His stark body and white robe, brilliantly lit from the upper left, glow out of the surrounding darkness while a pale nimbus hovers above his head. Posed frontally, as in a medieval icon, he nevertheless looks directly at, rather than down to, the viewer. His wide-eyed expression and parted lips suggest warmth and understanding, as though he has learned to appreciate human suffering and anguish through his own pain.

Throughout his career Rembrandt sought to express both the humanity and the mysteries contained in the life of Christ. His deep reverence for the Bible may have been instilled at an early age by his mother, whom he often represented praying or in the guise of an Old Testament prophetess. His early training in Amsterdam with Pieter Lastman taught him an artistic vocabulary for representing biblical narrative, a vocabulary he enlarged upon by studying and collecting images by other great artists, including Raphael, Albrecht Dürer, Lucas van Leyden, Titian, Hendrick Goltzius, and Peter Paul Rubens.

The nature of Rembrandt's personal beliefs are not precisely known. Although he never seems to have officially left the Reformed Church, he developed close ties with the Mennonites, a more liberal sect whose creed derived from a literal account of the Bible. He painted portraits of a number of distinguished Mennonites, and one seventeenth-century biographer, Filippo Baldinucci, actually wrote that Rembrandt was a member of the sect (Slive 1953, 111). Rembrandt's relationships with the Jewish population in Amsterdam were also crucial to his characterizations of biblical types. From the early 1630s, when Rembrandt moved to Amsterdam to work with the painter and dealer Hendrick van Uylenburgh on the Sint Anthoniebreestraat, he came in contact with Jews in the neighborhood. Rembrandt drew and etched their poor as well as their distinguished doctors and religious leaders. During the 1640s and 1650s he intensified his interest in Jewish figure types and made paintings and oil sketches that focus on their expressiveness. He painted a number of studies of one young man in particular, who seemed to embody the qualities that he identified with the figure of Christ (fig. 1).

The transformation of such a study into an image as powerfully evocative of Christ's presence as is this *Resurrected*

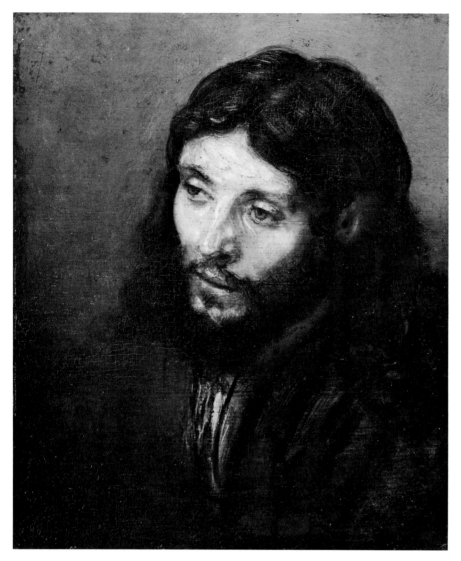

Fig. 1. Rembrandt van Rijn, *Study of a Young Jew*, Gemäldegalerie, Berlin

The image, striking though it is in its oval format, has probably been cut down from a rectangular shape. Christ's extended left arm may well have held a staff or a cross with a banner attached, the traditonal iconography for the resurrected Christ (Kat.AP. 1986, 426). In its original shape it would have related much more closely than it does now to a number of powerfully evocative half-length depictions of evangelists and apostles that Rembrandt executed from the late 1650s to the early 1660s (Benesch 1970, 196–203).

The precise relationship of these paintings to each other has never been determined, partially because not all of the apostles and evangelists are represented. No documents refer to these works, either individually or as a group. Although precedents for series of apostles exist in the work of Rubens and Van Dyck, these paintings by Rembrandt are not of the same size and format; thus it does not seem he planned to depict a consistent series. Nevertheless, it is hard to believe that no internal connections between these works exist. Perhaps Rembrandt intended to pair certain apostles and evangelists. One could imagine the *Resurrected Christ* as a central image in a triptych of such paintings, or as a striking counterpart to the depiction dated to 1661 of the sorrowful Virgin Mary in the Musée Departmentale des Vosges, Epinal (Bredius-Gerson 1969, no. 397).

A.K.W.

Christ is the result of more than a change of pose and wardrobe. Rembrandt has idealized the head of Christ with his broad brushwork, and has accented the force of Christ's gaze through the strong light that strikes the left side of his face.

The resulting image, however imbued with Rembrandt's spirit, conforms to traditional concepts of Christ. Samuel van Hoogstraten, a pupil of Rembrandt in the mid 1640s who published a treatise on painting in 1678, quoted a description of Christ by the ancient writer Publius Lentulus that parallels closely Rembrandt's painting: "His hair is the color of a ripe hazelnut, parted on top in the manner of the Nazirites, and falling straight to the ears but curling below, with blonde highlights and fanning off his shoulders. He has a fair forehead and no wrinkles or marks on his face, his cheeks are tinged with pink . . . his beard is large and full but not long, and parted in the middle. His glance shows simplicity adorned with maturity, his eyes are clear and commanding, never apt to laugh but sooner inclined to cry" (Hoogstraten 105, trans. by Schwarz 1985, 284).

PROVENANCE
from the collection of Hugo Franz (d. 1779), dean of Mainz Cathedral, count of Eltz

LITERATURE
Samuel van Hoogstraten, *Inleyding tot de Hooge Schoole der Schilderkonst*, Rotterdam, 1678; Seymour Slive, *Rembrandt and His Critics*, The Hague, 1953; Abraham Bredius, *Rembrandt: The Complete Edition of the Paintings*, revised by H. Gerson, London, 1969, no. 630; Otto Benesch, "Wordly and Religious Portraits in Rembrandt's Late Art," in *Collected Writings*, edited by Eva Benesch, London 1970, 1:190–203, first published in *The Art Quarterly* 19(1956), 334–355; Gary Schwarz, *Rembrandt: His Life, His Paintings*, New York, 1985.

Jacob van Ruisdael
Haarlem 1628/1629–1682 Amsterdam

40 *Torrent with Oak Trees*

1670s
oil on canvas, mounted on oak
71.7 x 90.1 (28¼ x 35½)
signed at lower right, *vRuisdael* (signature
presumably a later inscription)
inv. no. 1038

Landscape was a source of endless fascination for Dutch artists, whether the vast panorama of the flat countryside, the rolling dunes on the outskirts of Haarlem, or the wooded and hilly terrain of the eastern provinces of Overijssel and Gelderland. The Dutch found in their native land not only the beauty of fauna and flora, but also the forceful presence of the sky, and particularly of the clouds as thin forms passing over the sun that affected the play of light against the earth. Jacob van Ruisdael was the greatest of the Dutch landscape artists, for not only did he explore all the facets of the Dutch countryside, but he also imbued his scenes with a grandeur unmatched by any of his contemporaries.

In this landscape, which he painted rather late in his career, Ruisdael has depicted a view of a wooded rise on the far bank of a roaring stream. Large oak trees, their gray, craggy limbs silhouetted against the rich green foliage in the middle ground, accentuate a family resting leisurely beside the bridge crossing the stream. Their forms are small in comparison to the surrounding landscape elements, and yet their presence is not insignificant. They project an element of serenity into the dynamic rhythms of their surroundings. Another human form that serves a similar function is the shepherd gazing toward his flock on the far side of the rise.

Ruisdael carefully composed his landscape to create its dynamic character. The path and stream cross at diagonals and the clump of trees is slightly off center. Light falls in diagonal bands across the scene to enhance the flow of movement into depth. The rhythms of the reeds along the water's edge work in conjunction with the stream's rapids to suggest the movement of air and water.

Despite all of its verisimilitude, this landscape was not painted from life, but was created in the artist's studio. Ruisdael frequently made careful drawings from life and used them when composing his paintings. This landscape contains a number of motifs, including the broken tree stump and roaring stream, that recur in various forms in other compositions. Occasionally these landscape elements have allegorical connections that suggest the passage of time and the transitoriness of life (Bruyn 1987, 99). In this work Ruisdael seems to suggest the dynamic flow of life's forces as they surround and envelop the human element in nature.

A.K.W.

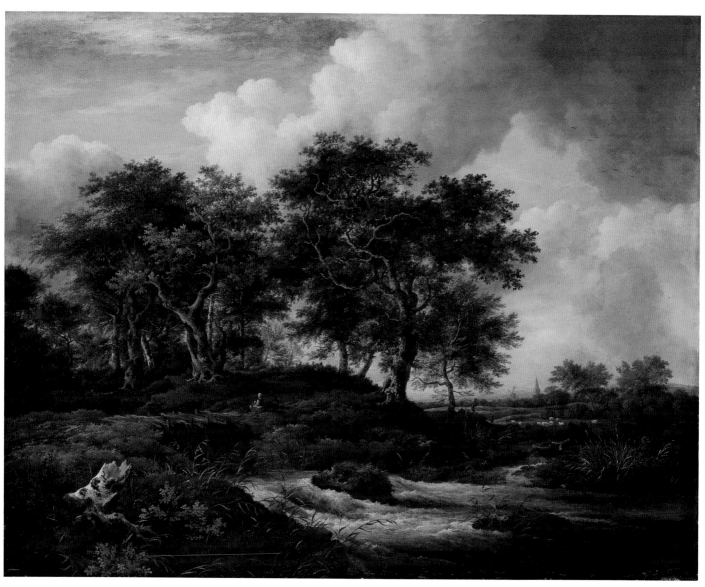

Cat. 40

PROVENANCE
entered the collection in 1815 from the estate
of King Maximilian I of Bavaria

LITERATURE
Seymour Slive, *Jacob van Ruisdael*, exh. cat.,
Mauritshuis, The Hague, and Fogg Art Mu-
seum, Harvard University, Cambridge, 1981;
Joshua Bruyn, "Toward a Scriptural Reading
of Seventeenth-Century Dutch Landscape
Painting," in Peter C. Sutton et al., *Masters of
17th Century Dutch Landscape Painting*, exh. cat.,
Rijksmuseum, Amsterdam, Museum of Fine
Arts, Boston, and Philadelphia Museum of Art:
Boston, 1987, 84–103.

Jan Steen
Leiden 1625/1626–1679 Leiden

41 *The Lovesick Woman*

c. 1660–1664
oil on canvas
61 x 52.1 (24 x 20½)
signed on the letter in the hand of the young
woman, *JSteen* (*JS* monogram)
inv. no. 158

The delights to be found in a painting
by Jan Steen are many: the beautifully
rendered textures of satins and fur, the
subtle effects of daylight passing into
an interior through translucent curtains
or open doorways, but above all, a
narrative that is played out before us
with poignant humor. As though he
were the director of a small theatrical
group, Steen carefully orchestrates his
setting and props to reinforce the
drama to be played out by the actors.

The doctor's visit was one of Steen's
favorite scenes, which he depicted with
subtle variations at least eighteen times
during the 1660s, when he was active
in Haarlem (De Vries 1977, 98–101).
Invariably the object of the doctor's at-
tention is a languid young woman, in
this instance dressed in a red velvet
jacket edged with white fur. The doc-
tor, with top hat and ruffled collar,
takes the maiden's pulse and leans over
to look into her forlorn eyes. She sits
in a chair and rests her arm on a pil-
low laid on the table beside her, while
an older woman peers over her shoul-
der. In the doorway at the left a gentle-
man hands a letter to the maid while a
spaniel looks inquiringly in the maid's
direction.

That the woman's illness is lovesick-
ness is made evident by the text of a
letter she holds in her hand, which

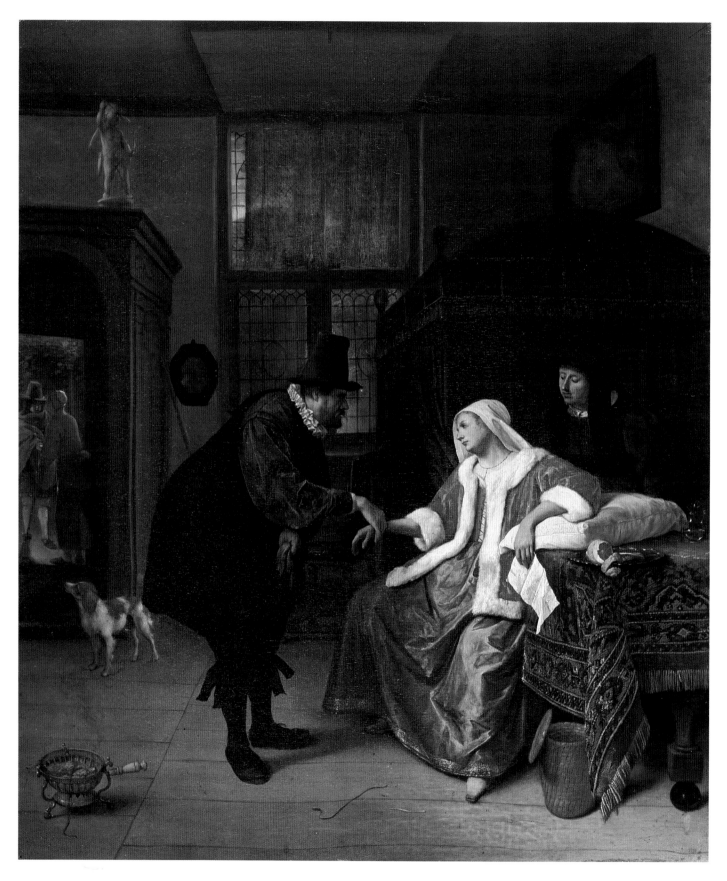

Cat. 41

reads: "No medicine will help since it is the pain of love." To reinforce the message, Steen has depicted above the door a small sculpture of a cupid aiming an arrow at the woman. On the wall over the canopied bed behind her hangs a painting of two lovers, probably Venus and Adonis. The small brazier with a smoldering ribbon hanging across it in the lower left of the painting has been variously interpreted. While some sources indicate that the smell of the smoldering ribbon, which had previously been dipped in the woman's urine, was used by quack doctors to revive a fainted woman, a more likely explanation is that the smell was used to determine whether or not she was pregnant (Naumann 1981, 102). Whatever the explanation, Steen has clearly indicated the inadequacy of the doctor's ability to cope with the maiden's unhappiness by dressing him in an outmoded costume of the type worn by actors from the commedia del l'arte (Gudlaugsson 1975, 15). Indeed, Steen's comical images of doctors' visits offer visual parallels to ideas being expressed in contemporary theater, particularly in the plays of Molière.

Because of Steen's predilection for low-life genre scenes, and his humorous commentaries on the foibles of his fellow man, the fact that he was an educated and literate artist is often forgotten. In 1646 at the age of twenty he enrolled at the University of Leiden. Although he probably did not remain there long, since he joined the Leiden Saint Luke's Guild in 1648, he seems to have gained from his education an abiding interest in classical mythology and biblical history. Not only did he produce a large number of remarkable history paintings over his long career, but he also, as in this work, frequently commented on contemporary situations in his genre paintings by associating such situations with figures and events drawn from the Bible and mythology.

One visual reference, more subtle than the cupid or the painting of Venus and Adonis, adds a poignant dimension to this remarkable painting: Steen has based the languid expression and limply extended arm of the maiden on Michelangelo's figure of Adam on the ceiling of the Sistine Chapel. As Adam reaches out to receive the spark of life from God the Father, so here the maiden yearns for a cure to revive her despondent, melancholic state of being. Unfortunately, the doctor's limp wrist will not quicken her pulse nor cure the pain of love. A far more likely cure is the letter that at that moment is being delivered to the maid at the outer door, but Steen does not reveal its contents, and we, the viewers, are left to revel in this humorous yet poignant depiction of a moment when all hope of a cure for life's travails seems lost.

A.K.W.

PROVENANCE
from the Düsseldorfer Galerie

LITERATURE
Sturla J. Gudlaugsson, The Comedians in the Work of Jan Steen and His Contemporaries, trans. James Brockway, Soest, 1975; Lyckle de Vries, Jan Steen "de kluchtschilder," Groningen, 1977; Otto Naumann, Frans van Mieris, the Elder (1635–1681), 2 vols., Doornspijk, 1981; Peter C. Sutton, "The Life and Art of Jan Steen," in Jan Steen: Comedy and Admonition, Philadelphia Museum of Art Bulletin 78 (1982/1983), 3–43.

Gerard Terborch
Zwolle 1617–1681 Deventer

42 *A Boy and His Dog*

1655
oil on canvas
34.4 x 27.1 (13½ x 10⅝)
signed at lower left, *GTB* (monogram)
inv. no. 589

With total concentration and loving concern, the young student in this painting leans over his dog to search for fleas in its fur. The spaniel, whose plaintive gaze is visible from under the boy's arm, lies contentedly in its master's lap. While the subject is not complicated and certainly derives from actual experience, Terborch has created an image that is far from anecdotal. Indeed, the psychological bond that he has conveyed between man and animal is unique in Dutch art.

Toy spaniels are frequently seen in Dutch genre scenes because, particularly after mid-century, the dogs had become integral members of many Dutch families. In other paintings by Terborch these pets are often found in the presence of rich bourgeois women in elegant interiors. Whether standing attentively at the feet of their mistresses or lying contentedly beside them, however, the spaniels in these works are mere adjuncts to the broader composition and not the focus of concern.

The relationship between this boy and dog seems particularly touching in a room that is so barren, with furniture so rudimentary and with clothes so simple. Other than the youth's blue leggings, the colors are monochromatic browns and ochers. As is so frequently the case in Dutch art, the subject, beyond its quality as a representation of an everyday event and of a psychological relationship between two friends, has broader moralizing resonances. The boy, for example, cares for his dog in much the same way that the mother cares for her child in Terborch's memorable painting from the early to mid-1650s in the Mauritshuis (fig. 1). This type of domestic virtue, which emphasizes careful grooming and nurturing, was often stressed in Dutch family life (Schama 1987, 395). In this instance Terborch's sympathetic portrayal of the boy's concern indicates he intended no negative commentary on the boy's neglect of his studies, which is implicit in the pen and book that sit idly on the table beside him. One could even argue, given the presence of the boy's hat in the immediate foreground, that he has just returned from school and is attending to his dog's needs before commencing his homework. As in *A Boy and His Dog*, in which his half-brother Moses modeled as the student, Terborch often based his images on members of his immediate family.

Although Terborch spent most of his life in the provincial city of Deventer, where he specialized in small-scale, full-length portraits and genre scenes of upper-class life, in his earlier years he traveled extensively throughout the Netherlands and to other European countries. Perhaps because of these

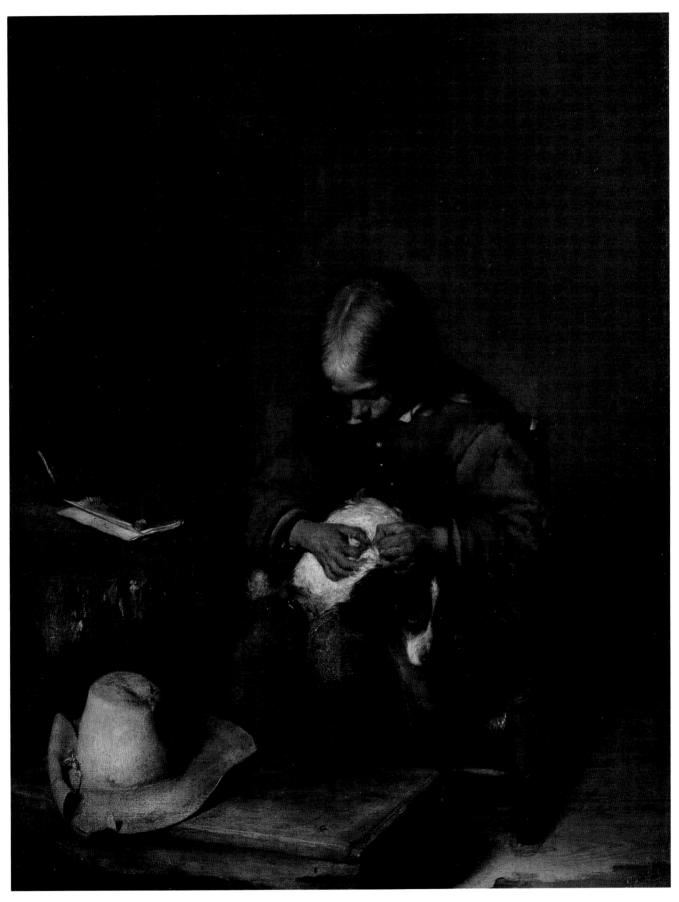

Cat. 42

Fig. 1. Gerard Terborch, *A Mother Fine-Combing the Hair of Her Child*, Koninklijk Kabinet van Schilderijen, The Mauritshuis, The Hague

travels, which took him to England, Spain, Italy, and France, it is difficult to explain the stylistic and thematic origins of his work. Certainly, however, his dual interest in portraiture and in scenes from daily life led him to explore the psychological responses of individuals to everyday events. In the early 1650s he developed these investigations in a new type of genre painting, in which he focused on a single figure in a simple and often undefined interior setting. This compositional type had great influence on other artists, in particular Johannes Vermeer.

A.K.W.

PROVENANCE
from the Düsseldorfer Galerie

LITERATURE
Sturla J. Gudlaugsson, *Gerard ter Borch*, 2 vols., The Hague, 1959–1960; Simon Schama, *The Embarrassment of Riches: An Interpretation of Dutch Culture in the Golden Age*, New York, 1987.

German Paintings

Hans von Aachen
Cologne 1552–1615 Prague

43 *The Triumph of Truth*

1598
oil on copper
56 x 47 (22 x 18½)
signed at lower left, *HANS V. ACH FEC. 1598*
inv. no. 1611

The Holy Roman Emperor Rudolph II, who ruled from his court in Prague from 1576 to 1611, had by all accounts an unsuccessful reign. The political and religious struggle that shook Europe during these years, and that eventually led to the Thirty Years' War (1618–1648), overwhelmed him and destroyed his power and prestige. Yet the legacy of his court cannot be judged solely in political terms, for he surrounded himself with a vast array of scientists, astrologers, and artists whose work has had a profound effect on human thought and understanding. Rudolph sought to create a climate for probing the mysteries of the universe, both rational and irrational. Although particularly entranced by the mysteries of alchemy, Rudolph brought to Prague and Vienna famed astronomers Tycho Brahe and Johannes Kepler, the botanist Carolus Clusius (Charles L'Ecluse), and artists such as Joris Hoefnagel who were trained as scientific naturalists and who specialized in exquisitely detailed renderings of flora and fauna. Other artists he patronized, among them Hans von Aachen and Bartholomeus Spranger (see cat. 28), depicted complex allegorical and mythological scenes that were executed in a refined, jewellike style. Indeed, the art of this court often has the nature of a precious object, not different in character from

the exquisite gold and silver reliefs made for the emperor by the Dutch sculptor Paulus van Vianen or from the famous *pietre dure* table made for Rudolph by Florentine craftsmen (see cat. 30).

This small masterpiece by Hans von Aachen, like many paintings made at the court of Rudolph II, was executed on copper, a smooth support that allowed the artist to paint his image with a fine, enamellike finish. In this work Von Aachen powerfully asserts the concept that Truth and Justice and, as a consequence, Peace, Abundance, and Concord, can only flourish under the protection of the emperor. Here Rudolph is symbolically represented as a lion attacking a figure who, to judge from the mask, papers, and money bag lying near him, represents deceit, heresy, and avarice. The lion attacks in the name of Justice, who is represented by the allegorical figure holding the sword and scales. She, in turn, defends Truth, the naked woman who looks fearfully down at the fallen man. In the background can be recognized Abundance holding a cornucopia and a sickle, Peace holding an olive branch, and Concord standing behind them (Kaufmann 1978, 71). A preliminary drawing for the work is in the Kunstsammlungen der Universität Göttingen.

This allegory, which was clearly de-

43

vised to propagate Rudolph's ideals of good government, may have been offered as a gift to the young Maximilian I (1581–1651), duke of Bavaria (An der Heiden in Munich 1980, no. 823). In 1597 Maximilian's father, Wilhelm V, weary of office, had abdicated his position in favor of his son, whom he had already named coregent in 1595. Indeed, Maximilian, one of the founders of the Catholic League in 1609, worked closely with Rudolph in his struggles against the Protestants during the latter years of the emperor's rule. A second small painting on copper by Von Aachen, in the Staatsgalerie Stuttgart, has been interpreted as a related imperial allegory (Kaufmann 1985, 186).

Hans von Aachen was named imperial *Kammermaler* (court painter) in 1592, after having worked for three years in Munich at the Bavarian court. He was entrusted with a number of responsibilities by the emperor, including diplomatic missions and the acquisition of works of art for Rudolph's enormous collection, which included more than two thousand paintings as well as sculpture and pieces of applied art.

Von Aachen's own style was a fusion of his northern heritage and Italian mannerism, which he learned on his extended stays in Venice, Rome, and Florence between 1574 and 1587. The elegant, elongated proportions of his figures are characteristic of works produced in Rudolph's court and can be compared to those of Spranger and the sculptor Adriaen de Vries. Although this court style quickly passed out of fashion, the imperial imagery codified by Von Aachen was continued by another great court painter, Peter Paul Rubens. When Rubens was asked by Charles I to decorate the ceiling of the Whitehall Palace in London in the early 1630s, he devised an allegory comparable to this one for his depiction of the *Benefits of the Government of James I*.

A.K.W.

PROVENANCE
from the Electoral Gallery

LITERATURE
Rudolf Arthur Peltzer, "Der Hofmaler Hans von Aachen, seine Schule und seine Zeit," *Jahrbuch der Kunsthistorischen Sammlungen des Allerhöchsten Kaiserhauses* 30 (1911/1912), 59–182; Thomas DaCosta Kaufmann, "Empire Triumphant: Notes on an Imperial Allegory by Adriaen de Vries," *Studies in the History of Art* 8 (1978), 63–76; Rüdiger an der Heiden et al., *Um Glauben und Reich: Kurfürst Maximilian I,* 2:part 2, exh. cat., Residenz, Munich, 1980; Thomas DaCosta Kaufmann, *L'Ecole de Prague: La Peinture à la Cour de Rodolphe II,* Paris, 1985, nos. 1–14.

Adam Elsheimer

Frankfurt am Main 1578–1610 Rome

44 *The Flight into Egypt*

1609
oil on copper
31 x 41 (12¼ x 16⅛)
signed on the back, *Adam Elsheimer fecit Romae 1609*
inv. no. 216

On the night after the three wise men had found the newborn Jesus in Bethlehem, Joseph had a dream in which the Lord commanded him to "Arise, and take the child and his mother, and flee into Egypt, and remain there until I tell thee. For Herod will seek the child to destroy him." So, Joseph "arose, and took the child and his mother by night, and withdrew into Egypt" (Matthew 2:13–14).

This short narrative describing the Christ Child's escape from certain death at the hands of Herod the tyrant is one of the most beloved episodes from Christ's childhood. Among the legends and depictions of this event that have since sought to capture the essence of the story, none has ever matched this extraordinary image by Adam Elsheimer.

Here, under the full moon of a glorious winter night sky, the Holy Family begins its trek to this vast unknown land. Mary, who rides on the donkey with Jesus in her arms, looks back apprehensively as Joseph, walking beside them, entertains the child by offering him a stalk of grain. This small group, illuminated only by the light of a torch held in Joseph's left hand, passes before a densely forested landscape, whose trees are silhouetted against the sky and reflected in the lake at the

right. The only other humans out at this time of night are shepherds who tend a roaring fire near some rock cliffs at the edge of the forest, oblivious to the dramatic event that is unfolding near them.

Elsheimer executed this small scene in Rome at the very end of his short career. Although trained in Germany, he had his most creative period in Venice, where he studied with Hans Rottenhammer from 1598 to 1600, and in Rome, where he lived for the last ten years of his life. His mature style thus represented a fusion of various artistic traditions: northern naturalism, Venetian elegance and refinement, and the forceful chiaroscuro effects of Caravaggio's work that he saw in Rome. As is evident in this painting, moreover, he retained throughout his life a profound awareness of the narrative qualities of the graphic art of his German heritage, particularly of the engravings of Albrecht Dürer and Martin Schongauer.

Elsheimer's pictures had an enormous impact on his contemporaries. Peter Paul Rubens, who was also in Rome from 1600 to 1609, was a great admirer of his work and of this painting in particular (Andrews 1977, document 186). One of Elsheimer's biographers, Joachim van Sandraert, credited him with being the first artist to cap-

Cat. 44

ture the naturalistic effects of night scenes: "[above the thick forest] are depicted in the clear sky the stars and especially the Milky Way and even more miraculously the clear full moon, which rises above the clouds on the horizon and whose reflection is perfectly rendered in the water, in a way which has never before been attempted" (Andrews 1977, 56).

Elsheimer's naturalism, which according to Sandraert was based on long hours of careful observation and contemplation of nature, derives from the artist's northern heritage. Nevertheless, his intense fascination with the stars and solar system parallels scientific investigations at that time in Italy. Galileo's discoveries of the solar system, published in 1610, only a year after the execution of this painting, derived from a similar impulse to understand as accurately as possible the nature of God's creation. Yet Elsheimer's sky is not an accurate record of the position of the Milky Way or of other constellations (Andrews 1977, no. 26). His interest was both to create the appearance of reality and to use these natural forms to enhance the meaning and drama of the scene. Thus, while the combination of brilliant stars and full moon is not astronomically accurate, it does suggest that divine guidance is leading the Holy Family safely to its destination. Despite the ominous darkness of the world and the limited illumination cast by Joseph's torch, the heavenly spheres provide guidance and comfort. At the same time, Elsheimer subtly suggests, through the receding perspective of the tree line and the glimpses into the forest provided by the brilliant flare of the shepherd's fire, both the sense of passage and the unknowns that assuredly will confront the Holy Family on its flight.

The first owner of this picture was Hendrick Goudt, a Dutch count who helped support Elsheimer during the last years of his life. Goudt was also an able engraver, and the print that he made from this work in 1613, after he had returned to Utrecht from Rome, helped spread the fame of the painting throughout the Netherlands, where it influenced, among others, the work of Rembrandt van Rijn. The picture seems to have been sold by Goudt to the Elector Maximilian of Bavaria, in whose inventory it was listed in 1628.

A.K.W.

PROVENANCE
from the Düsseldorfer Galerie

LITERATURE
Adam Elsheimer, Werk, Künstlerische Herkunft und Nachfolge, exh. cat., Städelsches Kunstinstitut und Städtische Galerie, Frankfurt am Main, 1966; Keith Andrews, *Adam Elsheimer, Paintings, Drawings, Prints*, Oxford, 1977.

Georg Flegel
Moravia 1566–1638 Frankfurt am Main

45 *Banquet Piece*

c. 1600–1605
oil on copper
78 x 67 (30¾ x 26⅜)
signed at lower right, *GF* (monogram) *Georgius Flegelius pinx*
inv. no. 1622

The evolution of still-life painting by the end of the sixteenth century from an auxiliary element in a religious or allegorical picture to an independent art form is a complex and not completely understood phenomenon. In large part, however, it must relate to the widespread interest in scientific naturalism that pervaded most of northern Europe. Botanists and zoologists, intent on describing and codifying the various species of plants and animals, published a large number of scientific treatises on flora and fauna. At the same time collectors strove to bring together in their *Wunderkammern* exotic species from around the world, and artists began to record natural phenomena in precise, minutely described watercolor drawings.

Georg Flegel is one of the most fascinating of these early still-life painters. Flegel was born in Bohemia but, apparently because of his Protestant beliefs, he left his homeland and emigrated to Frankfurt, a *Handelsstadt* (free-trading city) that welcomed many refugees from religious persecution. Frankfurt had received a number of Protestant refugees from Antwerp by the later decades of the sixteenth century and had developed a strong artistic tradition in painting as well as in silver-

and goldsmithing. Among the Flemish artist immigrants in Frankfurt was a landscape and portrait painter named Lucas van Valckenborch. Valckenborch, who arrived in 1592/1593, hired Flegel to paint still-life elements in his large allegorical paintings of the seasons and perhaps also in banquet scenes. These collaborative paintings, executed until Valckenborch's death in 1597, are the earliest known works by Flegel.

At the time when Flegel and Valckenborch were collaborating in this manner, Joris Hoefnagel, the artist who most fully epitomizes the artistic pursuit of scientific naturalism, was also working in Frankfurt. Not only can Hoefnagel's presence be documented in Frankfurt from 1591 to 1594, but in 1592 his son Jacob published his designs in his book *Archetypa* in Frankfurt. Whether or not Hoefnagel actually trained Flegel to describe the intricacies of natural phenomena in his refined and almost microscopically detailed watercolor drawings of plants and animals is not known, but the presence of his personality must have strongly affected the young artist. Indeed, one of Flegel's most remarkable artistic achievements is a series of 110 watercolor depictions of flowers and fruit within the scientific naturalist tradition,

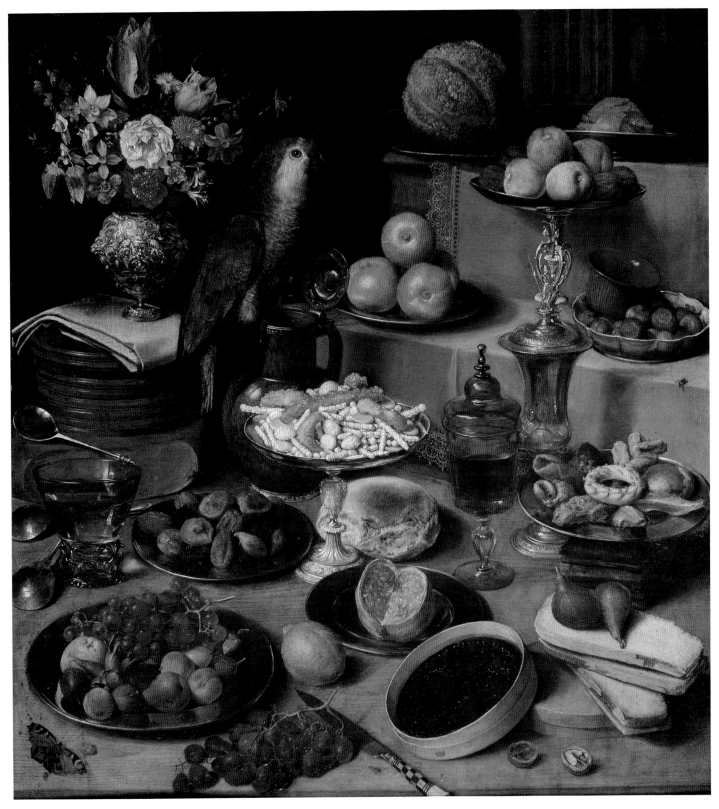

Cat. 45

now preserved in the Kupferstichkabinett und Sammlungen der Zeichnungen, Berlin.

Flegel had begun to paint independent still lifes derived from Hoefnagel by the first decade of the seventeenth century. One of his earliest works is this large and remarkably complex banquet piece, painted in a style that is at once sophisticated and mature yet is at the same time charmingly naive.

Flegel portrayed a vast array of delicacies on a tabletop and the two linen-covered shelves behind it. Grapes, figs, peaches, melons, acorns, an opened pomegranate, a plate of sweets and one of cookies are carefully displayed on a variety of serving dishes, while grapes, cheese, two walnut halves, and a lemon lie on the table itself. Both white and red wine accompany this panoply of foods. Resting on top of the stack of cheeses is an extraordinarily elaborate gold and silver vase containing a bouquet of flowers. Finally, completing this sensual feast are a multicolored butterfly in the lower left and a green parrot who perches enigmatically on an open beer stein.

Flegel has filled the entire picture plane with these objects, which is a characteristic in his works. By choosing a relatively high vantage point he is able to look down upon the various compositional elements to minimize the overlapping of their forms. Thus, one has the impression that the still life consists of a number of individual portraits carefully juxtaposed so that the full character of each object is maintained. The items themselves have been rendered with careful attention to texture to make each one, whether a transparent glass, a pewter plate, or a piece of fruit, as realistic as possible.

This tour de force is much larger and more complex than most other still lifes by Flegel, but nothing is known about a possible commission or about the painter's artistic intentions in creating the work. It is tempting to search for emblematic meanings, since a number of symbolic connotations traditionally exist for fruits and flowers. Flegel was clearly aware that flowers and fruits symbolized abundance and the seasons, since he utilized these concepts in his collaborative works with Valckenborch. The complex emblematic meanings applied to studies after nature by Hoefnagel were also known to Flegel.

In this painting, the artist wished to project a world of abundance and beauty, where natural and carefully crafted objects are displayed for the viewer's sensual enjoyment. The still life has a precious quality, like a *Wunderkammer*; in both, rare and exotic specimens were assembled to suggest the richness and variety of God's creation. Flegel, however, almost certainly interjected various warnings about accepting too easily the delights of such worldly pleasures. The seemingly incongruous appearance of the parrot may relate to a sixteenth-century emblem by Johannes Sambucus (Homann 1971, 62–63). The emblem stresses that man should not allow necessity and hunger to dictate his actions in the same reflexive manner that a parrot responds to sounds of the human voice. A second warning may be contained in the knife with the black-and-white handle, prominently displayed in the foreground. In the Bible the knife refers to the need for temperance (Segal 1983, 51). Its recurrent appearance in a large number of fruit still lifes from the early years of the seventeenth century may be attributed to such a symbolic meaning.

A.K.W.

PROVENANCE
acquired in 1768 from the Dufresne Collection, Munich

LITERATURE
Wolfgang J. Müller, *Der Maler Georg Flegel und die Anfänge des Stillebens*, Frankfurt am Main, 1956; Holger Homann, *Studien zur Emblematik des 16. Jahrhunderts*, Utrecht, 1971; Ingvar Bergström, "Georg Flegel als Meister des Blumenstücks," *Westfalen* 55 (1977), 135–146; Sam Segal, *A Fruitful Past*, Amsterdam, 1983; Fritz Koreny, *Albrecht Dürer und die Tier- und Pflanzenstudien der Renaissance*, Munich, 1985.

Johann Liss

Oldenburg c. 1597–1631 Venice

46 *The Death of Cleopatra*

c. 1625
oil on canvas
97.5 x 85.5 (38⅜ x 33⅝)
inv. no. 13434

In the world of art history, peripatetic masters who develop no strong roots and leave little visible impact on their contemporaries are often overlooked simply because their work does not conform to identifiable stylistic and thematic patterns. Johann Liss is such a master. An inventive artist whose fluid touch and brilliant coloristic patterns ultimately inspired Tiepolo, Giambattista Piazzetta, and other eighteenth-century Venetian artists, Liss remains an enigmatic figure whose place in early seventeenth-century artistic traditions is still being assessed.

In this masterpiece painted in Rome around 1625, Liss depicts Cleopatra clutching her breast after receiving the viper's deadly bite. While her servant leans forward with an anguished expression, the young Moor who holds the basket of flowers in which Cleopatra had secretly placed the viper recoils in terror. The swirling patterns of the vivid blue robe and white blouse encompassing Cleopatra reinforce the intensity of the reactions, yet amid it all Cleopatra seems remarkably restrained and contemplative. As though waiting for the poison to take its toll, she leans back against her servant, her shoulder and neck bared, sensuous, and vulnerable.

During his years in Rome between about 1622 and 1627, Liss painted at least three major works that portray a traumatic moment in the life of an ancient heroine: *The Death of Cleopatra*, *The Repentant Magdalen* (Gemäldegalerie, Dresden), and *Judith and Holofernes* (National Gallery, London). While the lives of these heroines differed markedly, in each instance the moment of crisis came as a result of human lust for sensual pleasures. Cleopatra was an Egyptian queen who, through treachery and guile, sought to fulfill her ambition to rule the Roman Empire. In contrast to Mary Magdalen and Judith, she would seem to represent a negative rather than positive example; nevertheless, Liss represents her no less heroically than he does the others. He apparently saw her suicide, which she carried out after her lover Mark Antony had been defeated by Octavian, the first Roman emperor, as an honorable action rather than as a just reward for a life filled with treason, arrogance, and lustful pleasures. The alternative to death would have been humiliation, for Octavian would have brought her back to Rome as a captive to exhibit her to the populace. Interestingly, some years later Johann Carl Loth (1632–1698), a German artist influenced by Liss, painted a comparable image of Cleopatra as a pendant to his *Death of Lucretia* (Staatliche Kunsthalle, Karlsruhe), another heroine who chose death over humiliation.

The forcefulness of Liss' composition

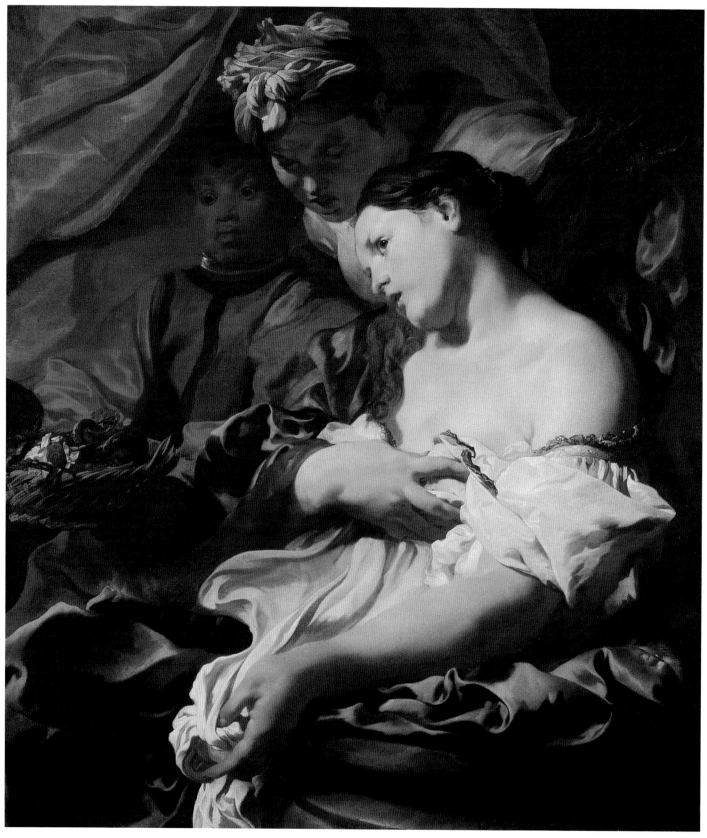

Cat. 46

derives from his successful assimilation of the artistic styles he had encountered during his travels. Although born in Germany, Liss emigrated to the Netherlands in 1615 and studied in Haarlem, Amsterdam, and Antwerp until about 1619. He then left for Venice, where he worked for a short while before moving to Rome. In 1629 he returned to Venice, where he died of the plague in 1631.

The concentrated group of half-length figures resembles those of Flemish artists who had been influenced by Caravaggio, particularly Peter Paul Rubens, Jacob Jordaens, and Abraham Janssens. Northern Caravaggism, with its dynamic and intense realism, however, differs from the sensuous rhythms and softly modeled forms evident in this work. These seem to reflect the influence of Domenico Fetti (c. 1589–1624), whom Liss met on his first visit to Venice. The startled expressions of the Moor and the servant clearly reflect Liss' firsthand experience with Caravaggio's own work, in particular his *Boy Bitten by a Lizard* (1596, National Gallery, London).

A.K.W.

PROVENANCE
entered the collection in 1964

LITERATURE
Rudiger Klessman and others, *Johann Liss*, exh. cat., Cleveland Museum of Art, Augsburg-Rathaus, 1975/1976, no. A 18; Richard E. Spear, "Johann Liss Reconsidered," *The Art Bulletin* 58 (1976), 582–593.

Johann Heinrich Schönfeld
Biberach an der Riss 1609–1683 Augsburg

47 *Ecce Homo*

c. 1648–1649
oil on canvas
146 x 204 (57½ x 80¼)
inv. no. 13399

The Gospel of John (19:1–15) describes how Christ, accused and scourged, mocked and crowned with thorns, was led before the people wearing a purple robe given to him by his tormentors. Pilate appeared at his side and said, "Ecce homo, Behold the man!" The crowd replied, "Crucify him, crucify him." In Schönfeld's enormous canvas, Pilate, Christ, and a subaltern stand on a high podium above a jeering crowd. Pilate, dressed in "biblical" robes and a turban, leans forward as he presents Christ to the people. The few raised arms among members of the crowd indicate that some have already begun to vilify Christ. Unlike Pilate, the crowd is dressed in a more-or-less contemporary peasant style, and obviously the viewer is meant to identify himself with the crowd, realizing that Christ suffered for his transgressions as well.

The practice of presenting a condemned prisoner on a raised platform or second-story balcony of a public building had a continuous history dating back to Roman times in both northern and southern Europe. In Rome itself the palace of justice or Palazzo dei Senatori stood on the Capitoline Hill, and from its open podium judicial verdicts were read and convicted criminals publicly displayed. In many cities these gruesome ceremonies were performed at town halls, and in the visual arts one often finds that these

Cat. 47

structures were used as settings for scenes of Christ's presentation to the people (Carroll 1981, 588–605). This is true in such prints as Lucas van Leyden's *Ecce Homo* of 1510, Joachim Beuckelaer's *Market Scene with Ecce Homo* of 1566, and Rembrandt's *Christ Presented to the People* of 1655; even Titian's painting *Ecce Homo* of 1543 (Kunsthistorisches Museum, Vienna) shows Christ and Pilate at the top of a sixteenth-century Venetian stairway.

Schönfeld, too, has chosen a contemporary building for his scene—the remains of the Roman temple of the Dioscuri in Naples. While it was not the local seat of justice, it was a true antique building which only fifty years earlier had been converted into the church of San Paolo Maggiore. Its famous Corinthian columns were to fall in the earthquake of 1688, but when Schönfeld painted them at the end of the 1640s they provided an imposing reminder of Roman judicial authority. To the left of the canvas Schönfeld added two authentic representations from Rome's Capitoline Hill: a relief of Marcus Aurelius from the temple of Jupiter and a river god who still sits at the base of the Palazzo dei Senatori. The porch of San Paolo Maggiore also served as a stage for reenactments of

Christ's Passion (Pée 1971, 124–125, no. 49). Thus Schönfeld's painting chronicles a contemporary event in Neapolitan history as well as illustrating a well-known biblical episode.

The synthesis of a primarily northern European theme with an Italianate style is typical of Schönfeld's work. A German by birth and training, the artist spent sixteen years in Italy, the last twelve of those—between 1637 and 1649—in Naples. There he was particularly attracted by the religious art of Andrea Vaccaro and Bernardo Cavallino. He adopted their poetic mode, dark tonality, and concentrated patches of brilliant light. His work tends toward the theatrical, using extravagant architectural settings and multifigured compositions. Isolated areas of light and luminous color, which suggest the strong impact of Venetian art, can also be found in Cavallino's work. Schönfeld, in fact, so assimilated an Italian mode of presentation that the *Ecce Homo* was originally attributed to Cavallino (Cleveland 1984, 233, no. 32). The painting is now universally accepted as the last great masterpiece Schönfeld executed before his return to Germany in 1649.

It is not only the scale of the work that makes it impressive, but also the

sensitive and delicate handling of the painted surface. The dark, ominous clouds fill the sky, which is pierced by a ray of pure, brilliant light. The shaft of light falls on the magnificent columnated porch, which dwarfs all the figures including Christ. The light flickers across the composition, enlivening the surface with rich touches of gold, blue, and red. The atmosphere is charged with the mystical presence of a supernatural power. This is a religious scene played out with all the lyrical beauty of poetry and the dramatic brio of Neapolitan life.

B.L.B.

PROVENANCE
acquired in 1963

LITERATURE
Hermann Voss, *Johann Heinrich Schönfeld: Ein Schwäbischer Maler des 17. Jahrhunderts*, Biberach an der Riss, 1964; *Johann Heinrich Schönfeld, Bilder, Zeichnungen, Graphik*, exh. cat., Ulmer Museum, Ulm, 1967; Herbert Pée, *Johann Heinrich Schönfeld: Die Gemälde*, Berlin, 1971; Götz Adriani, *Deutsche Malerei im 17. Jahrhundert*, Cologne, 1977; Margaret Deutsch Carroll, "Rembrandt as Meditational Printmaker," *The Art Bulletin* 63 (1981), 585–610; *Bernardo Cavallino of Naples 1616–1656*, exh. cat., The Cleveland Museum of Art, Cleveland, 1984.

Johann Zick

Lachen 1702–1762 Würzburg

48 *The Assassination of Alexander Severus*

1754
oil on canvas
68.2 x 86.5 (26⅞ x 34)
inscribed at lower right, *Johann Zick inv. et pinx*
1754
inv. no. 10010

Alexander Severus, who ruled as Roman emperor from 222 until 235, was murdered by his mutinous soldiers at Sicula on the Rhine. Despite his tragic end, the emperor is remembered as an affable and virtuous ruler and his reign as a peerless age of stability. Alexander personally led a successful military campaign against the Persians in 233. Encouraged by his victory, he set out the following year on a new campaign against the Alamanni, a German tribe from the Rhineland. When it became clear that the European and Oriental legions that he had assembled could not work together, he tried to save the situation by buying off the Germans. This seeming act of cowardice was used as a pretext for a mutiny by the European legions. C. Julius Maximinus, a Thracian peasant who had risen through the ranks, was proclaimed emperor, and Alexander was murdered.

Johann Zick's painting may well be the only depiction of this obscure episode in Germano-Roman history. Since the Renaissance, there had been a continuing and escalating interest in national history in Germany. This interest was to peak in the nineteenth century, and it is probable that Zick's depiction of the assassination of Alexander Severus was part of the trend toward a more vigorous promotion of national-ism through the study of early Germanic history. Whether this was Zick's particular enthusiasm or that of his patrons is impossible to say, for the artist's career is as forgotten as the story of Alexander Severus.

The career of Johann Zick has been overshadowed by the more impressive talent of his son Januarius (Munich 1730–1797 Ehrenbreitstein). Yet Johann was one of the leading German painters of the eighteenth century, and his relative obscurity outside Germany is explained by the fact that he was primarily a fresco painter. Paired with such luminary architects as the brothers Asam, Balthasar Neumann, and François Cuvilliés, Zick played an important role in the creation of illusionistic interior spaces. His hyperbolic explosions of light and color shatter the confines of architectural structure, and open realms of otherwordly splendor. His ceiling decorations in the Mariahilfkirche, Munich, the Klosterkirche, Oberzell, and the Residenz at Bruchsal are an integral part of their artistic environment, helping to mask the frontier between reality and fiction. Johann Zick and his son Januarius worked in the Gartensaal at the Würzburg Residenz during the same years that Tiepolo was employed there on other decorations. Both father and son were

Cat. 48

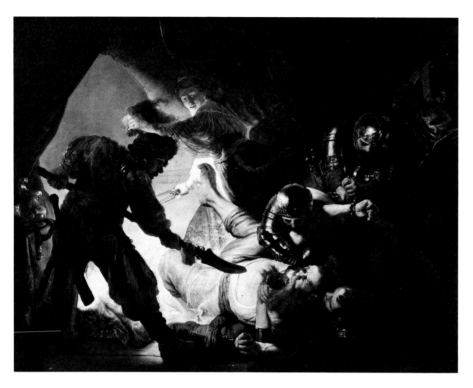

Fig. 1. Rembrandt van Rijn, *The Blinding of Samson*, Städelsches Kunstinstitut, Frankfurt

strongly influenced by the Venetian master, but they were inspired by others as well. This canvas, in particular, adapts the composition of Rembrandt's *The Blinding of Samson* (fig. 1), which during those years was part of Friedrich Karl von Schönborn's collection in Würzburg.

Zick must have turned to Rembrandt's powerfully dramatic biblical tale because it afforded him a ready model for an easel painting, a form the illusionistic decorator rarely tackled. Just as Rembrandt did, Zick set his scene within a dark interior, illuminating it from the back with a brilliant stream of sunlight. The protagonists in both paintings have been hurled to the ground and lie vulnerable and hapless at their adversaries' feet. But the raw-edged strength and gripping brutality of Rembrandt's *Blinding* have given way to an operatic elegance and balletic rhythm in Zick's picture. Zick has further compromised the emotional impact by substantially reducing the scale of the painting. His figures are willowy

and graceful and seem more likely to slash the air symbolically than actually to stab Alexander Severus. Like dancers, Maximinus' co-conspirators surround the victim, who tries to push his weary body up from the ground. A brilliant spotlight falls on his bare back as a hush falls over the company, who wait to see if he will fight back. Their gleaming daggers are poised in midair, ready to be thrust downward once again. Alexander's fate rests with Maximinus, whose delicate gesture of accusation seems more thoughtful than authoritarian and more theatrical than natural. The costumes, too, seem the stuff of theater, not war. Maximinus' flowing red mantle and plumed helmet cast an imposing silhouette against the eerie radiance of distant sunlight. The richly impastoed surface is unified by the golden brown glow of this light. Zick has led us into a dark and magical cave where murderous deeds were committed long ago.

The operatic style of *The Assassination of Alexander Severus* is close to much of

Januarius Zick's work, and the painting has sometimes mistakenly been ascribed to his hand (Von Hohenzollern 1980, 90). However, the signature clearly reads "Johann," so there can be little doubt as to the authorship. Januarius did, however, adapt the pose of one of the murderous figures for the executioner in his *Martyrdom of Saint James Major* (Ulmer Museum, Ulm). The date on the Munich picture appears to read 1754, although some have doubted the last digit (Munich 1982, 20). A dating in the early 1750s would mean that Johann painted the picture while he was working in Würzburg, which seems consistent with his adoption of Rembrandt's composition.

B.L.B.

PROVENANCE
acquired in 1935

LITERATURE
Adolf Feulner, *Die Zick*, Munich, 1920; *Staatsgalerie Schleissheim, Verzeichnis der Gemälde*, edited by J. G. P. von Hohenzollern, Munich, 1980; *Johann und Januarius Zick*, exh. cat., Neue Pinakothek, Munich, 1982.

Spanish Paintings

Doménikos Theotokópoulos, called El Greco
Candia 1541–1614 Toledo

49 *The Disrobing of Christ (El Espolio)*

c. 1602–1607
oil on canvas
165 x 99 (65 x 39)
inv. no. 8573

El Greco's eccentric yet magnificently spiritual altarpiece, which is still in situ in the sacristy of the cathedral of Toledo, depicts the disrobing of Christ or *El Espolio* (fig. 1). El Greco received this important commission in 1577, only a year after he had fled Italy for Spain. The unorthodox inconography and exaggerated pictorial style of this work owe much to the artist's quasi-nomadic background. Born on the island of Crete, El Greco received his first training in the tradition of Byzantine icon painters. By 1566 he had traveled to Venice, where he developed his skills as a painter, quickly assimilating the Venetian mode of mannerism practiced by Tintoretto and Bassano. Just four years later he had migrated to Rome. There, the impact of Michelangelo's powerful human anatomy was to have a profound and lasting effect on the style of the young artist. This, then, was the artistic baggage that El Greco brought to Spain. Strong reminiscences of his time in Italy are apparent in *The Disrobing of Christ*, which, despite a celebrated legal battle over the artist's payment, instantly established El Greco as a major force in Spanish art. The fame of this monumental altarpiece is attested to by numerous requests from private patrons for copies of it. Among the replicas produced by El Greco and his shop, the painting in Munich is

considered one of the finest (for others, see Wethey 1962, 2:51–56, 184–188).

The disrobing of Christ is an unusual subject and one rarely depicted in Christian art after the Middle Ages (Schiller 1971–1972, 2:83–85). However, it was a theme inherently suited to the decoration of a sacristy, where priests changed their vestments before and after saying mass. The story is told only in the Gospel of Matthew (27:27–31), which describes how Christ was stripped of his garments by soldiers and clothed in a scarlet robe. The apocryphal "Acts of Pilate," which have come down to us in the *Gospel of Nicodemus*, have little more to say on the subject. Neither source mentions the presence of the Three Marys, whom El Greco has prominently included at the lower left. A literary source for their inclusion is found in Saint Bonaventure's *Meditation on the Passion of Jesus Christ* (Azcárate 1955, 192–197), but El Greco may also have been familiar with paintings in Italy by Lorenzo Monaco (Galleria dell'Accademia, Florence) or those from the school of Francesco di Giorgio (Pinacoteca Nazionale, Siena; Schiller 1971–1972, 2:318) in which the women witness Christ's humiliation. Despite the validation of Saint Bonaventure and others, the cathedral authorities objected to the presence of the Three Marys because the women did

Cat. 49

Fig. 1. El Greco, *El Espolio*, Museo Catedralicio, Toledo

not appear in this context in the Scriptures. The authorities also complained that the heads of the tormentors were higher than Christ's head, although this, too, was an artistic convention centuries old.

The dispute between El Greco and the cathedral canons of Toledo regarding the inclusion of the Three Marys in this painting may reflect to some degree the decrees issued by the Council of Trent prohibiting apocryphal or subjective interpretations of religious scenes (Ceballos 1986). The dispute, however, was more than an ideological battle between an artist and his patrons. What it really boiled down to was a financial matter. On 2 July 1577 El Greco had received a down payment of four hundred *reales* for his projected work on the altarpiece. Over the next two years he would be advanced the sizable sum of fifteen hundred *reales* to help defray the cost of materials, but according to Spanish law he would have to bargain for his final payment. Under a system called *tasación,* the artist and the client each nominated an independent team of appraisers to set a value for the work. If they could not arrive at a mutually agreeable price, the final determination was made by an arbitrator who was named in the contract in advance. The *tasación* for *The Disrobing of Christ* began in June 1579 with the canons' representatives claiming that the painting was worth less than the fifteen hundred *reales* already paid, because of the religious improprieties cited above. El Greco, in turn, maintained that the painting was "so great that no value or price could be attached to it," but that he should be awarded at least ninety-nine hundred *reales*. At this point the arbitrator was called in and admitted that the picture was among the finest that he had ever seen, suggesting a compromise figure of thirty-five hundred *reales*. After much give-and-take, the clerics agreed to this sum, but only if El Greco removed the offending figures. The litigation dragged on until 8 December 1581, when El Greco accepted a payment of two thousand *reales* and

delivered the altarpiece, unchanged, to the cathedral (Kagan 1982, 84–86; Toledo 1982, 95–98). It is impossible to say whether the outcome represents a moral victory for El Greco or merely a resolve on the canons' part finally to get the altarpiece installed in their sacristy. In either case, the painting was destined to be acknowledged as one of El Greco's undisputed masterpieces.

El Greco was in the habit of making small replicas of his major paintings, to be kept as records or models for use in his workshop. Many of his more popular compositions, including *The Disrobing of Christ,* were repeated with minor variations throughout his long career. Three small panel paintings after *El Espolio* probably served that exact purpose (Wethey 1962, 2:54–56; Toledo 1982, 232–233, no. 13). The medium-size version of the composition now in Munich was most likely completed with the aid of one of these smaller panels as a guide at a fairly late date in the artist's career. Recent technical studies have shown that the painting was laid out by an assistant and subsequently reworked in most parts by El Greco (Von Sonnenburg and Preusser, 1976). Although often dated in the 1580s, the luminous coloration, thinly applied glazes juxtaposed with thick passages of impasto, and the greater attenuation of figures suggest a date between 1602 and 1607, close to the time El Greco worked in the Hospital of Charity at Illescas, a town between Toledo and Madrid. The stylistic changes evident between the original altarpiece and the Munich picture are also consistent with this later dating.

Both versions depict the moment when Christ, surrounded by an angry mob, is about to be stripped naked. A rope is tied to Christ's wrist, recalling once again Saint Bonaventure's commentary, which relates how Jesus was pulled along by a rope like a common thief when he was no longer able to bear the cross. To Christ's immediate right stands an armor-clad figure usually identified as Saint Longinus, the centurion who converted to Christianity after piercing Christ's side with a lance. Despite the undeniable similarities between the altarpiece and the Munich painting, El Greco has subtly reworked the later composition, giving it a greater sense of spiritual agitation and mystical expression. Although the number of heads surrounding Christ has been reduced, the people seem more compressed and the atmosphere more electrically charged. The verticality of the composition is emphasized by the elongated figures, who seem less tied to their predecessors in Tintoretto's and Michelangelo's work than do their original counterparts. The colors, too, have become less Italian and more authentically eccentric. The cherry red of Christ's robe has been darkened with a purplish hue, the yellows have become more acid in tonality, and all the shadows deepened with gray. The state of anxiety has been heightened. In the midst of the chaotic turmoil, which binds the figures in a vast whirlpool of psychic energy, stands Christ, alone and aloof, unperturbed by the course of events.

B.L.B.

PROVENANCE
acquired in 1909

LITERATURE
José María de Azcárate, "La iconografía de 'El Expolio' del Greco," *Archivo Español de Arte* 28 (1955), 189–197; Hugo Kehrer, *Greco in Toledo,* Stuttgart, 1960; Harold E. Wethey, *El Greco and His School,* 2 vols., Princeton, 1962; Gertrud Schiller, *Iconography of Christian Art,* trans. Janet Seligman, 2 vols., Greenwich, Conn., 1971–1972; Hubertus von Sonnenburg and Frank Preusser, "El Grecos 'Entkleidung Christi' (Espolio) in der Alten Pinakothek," *Maltechnik/Restauro* 82 (1976), 142–156; Richard L. Kagan, "El Greco and the Law," *Studies in the History of Art* 11 (1982), 79–90; *El Greco of Toledo,* exh. cat., The Toledo Museum of Art, Toledo, Ohio, 1982; Alfonso Rodríguez G. de Ceballos, "La repercusión en España del decreto del Concilio de Trento acerca de las imágenes sagradas y las censuras al Greco," *Studies in the History of Art* 13 (1986), 153–159.

Bartolomé Esteban Murillo
Seville 1618–1682 Seville

50 *Boys Eating a Melon and Grapes*

c. 1645
oil on canvas
146 x 103.5 (57½ x 40¾)
inv. no. 605

51 *Boys Playing Dice*

c. 1670/1675
oil on canvas
144.5 x 108 (56⅞ x 42½)
inv. no. 597

Murillo was one of the first artists to employ street urchins as a subject for his painting. Genre pictures of this type were to become a staple of baroque and rococo painting throughout Europe, and although Murillo did not invent the type, his picturesque depictions of children certainly helped to popularize it. His small vagabonds recall Spanish *pícaro* novels, which most often described the various adventures of young thieves-in-the-making. These novels were popular during the late sixteenth and early seventeenth century. Murillo also undoubtedly knew earlier genre paintings by the so-called Spanish *bodegón* painters, those artists specializing in naturalistic scenes of eating and drinking at taverns. The development of *bodegón* painting during the early seventeenth century owed a great deal to the tradition of realistic genre painting that had emerged at the end of the previous century in Bologna and Rome (Haraszti-Takács 1983). Murillo must have known something of the work of the Carracci family and of Caravaggio, if only at second hand, through José de Ribera (1591–1652)

and his workshop. But none of these literary or visual precedents share Murillo's spontaneous and lighthearted view of daily life. The artist in essence created his own genre.

Murillo may have done so in response to the demands of the open art market. Unlike his numerous religious paintings for the large monasteries and parish churches of Seville, his secular works were not painted on commission and were not destined for the homes of Seville's elite. By the end of the seventeenth century nearly all of his twenty-five-or-so scenes of beggar children and street urchins were found in collections outside Spain, many in Antwerp or London. It is quite possible that they were painted specifically for northern patrons or done in hope of a sale through Flemish art dealers. There has even been speculation that the idea of painting the genre scenes was suggested to Murillo by Antwerp merchants who frequented Seville and perhaps did a little art dealing on the side (Waterhouse in London 1983, 71). Of the five genre scenes now in Munich, the two shown here were probably

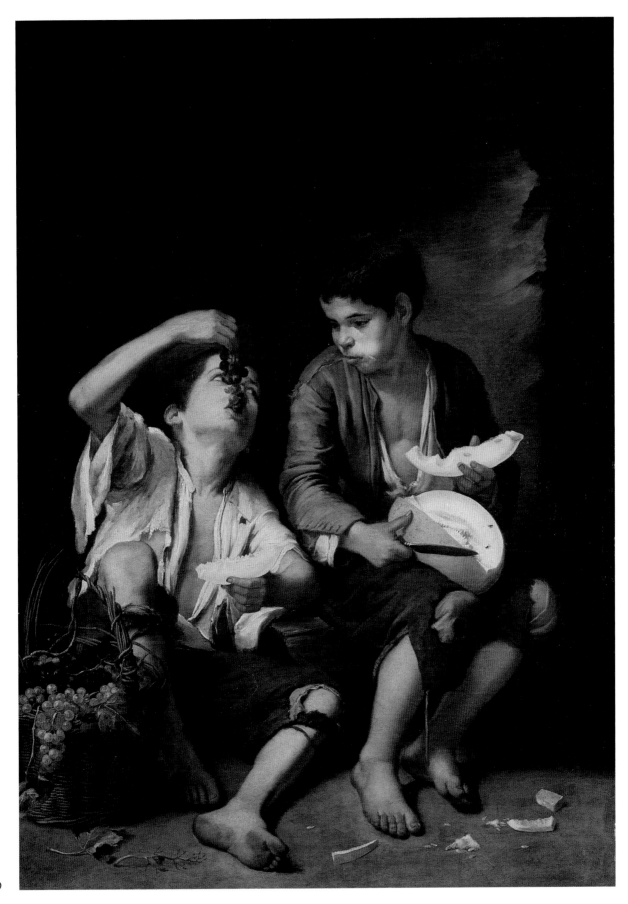

Cat. 50

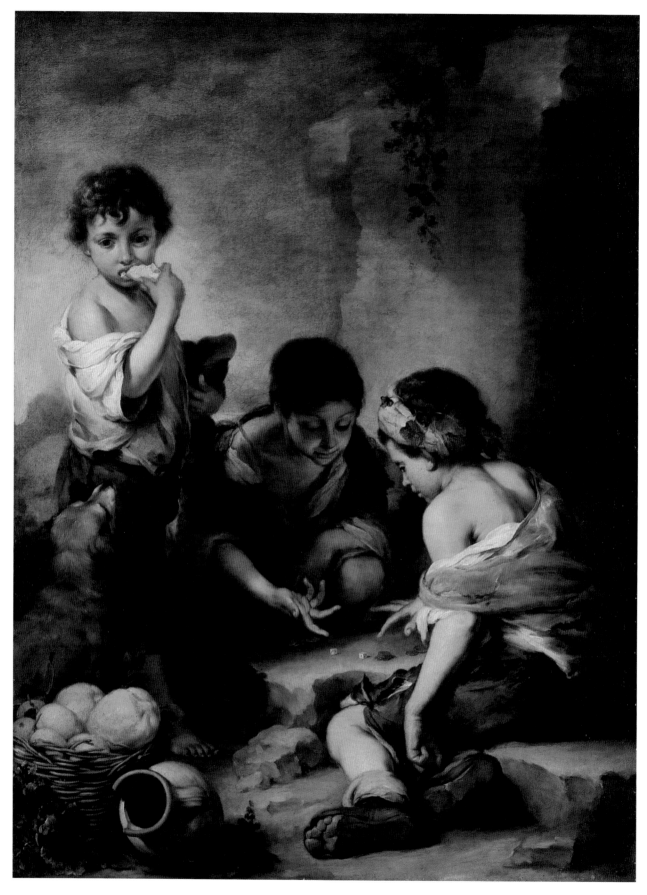

bought in Antwerp by Elector Maximilian II Emanuel, when he was regent of the Low Countries. He definitely purchased *Boys Playing Dice* in Antwerp on 17 September 1698, along with 104 other paintings from Gisbert van Ceulen (GK.I, 119). *Boys Eating a Melon and Grapes* is mentioned in a bequest inventory of 1691 as having belonged to "Joan Bapta Anthoine riddere ende postmeester" (Denucé 1932, 353–365, no. 95). From 1748 on it is listed in the inventories of the Munich Residenz.

The popularity of Murillo's genre pictures in northern Europe derives from their nostalgic look at simple childhood pleasures. Unlike earlier genre painting in either Spain or Italy, Murillo's scenes are idealized visions filled with naturalistic detail. While beggar children undoubtedly did inhabit the slums of Seville, these paintings cannot be construed as accurate portrayals of the hardships of Seville life. They evoke images of carefree youngsters at play who are well-fed, content, and only a little dirty. Murillo's psychological removal of the youngsters from the cares of their world is partially achieved through the absence of a recognizable setting. Through the pale, hazy sunlight in *Boys Eating a Melon and Grapes* the remains of a gray wall can be seen, but whether this is the wall of an interior court or street corner is impossible to say. The ivy-covered ruin in *Boys Playing Dice* is just as difficult to place; it could be in an abandoned part of the city or on a country road. Wherever they are, these locations are neither sinister nor hostile; they are just as idyllic and free from pessimism as the children who inhabit them.

Against these abstract and neutral backgrounds the children are shown with a marvelous wealth of naturalistic detail and witty anecdotal observation. The beggar boys greedily cram their mouths with fruit, their cheeks bulging like squirrels storing nuts for the winter. The ground in front of them is strewn with the paltry remains of their feast: seeds, grape stalks picked clean, and melon slices gnawed to the rind. In *Boys Playing Dice* a wide-eyed ragamuffin stares dreamily into space, absent-mindedly eating a crust of bread, while an attentive dog waits patiently for a crumb to fall. His two companions gamble with zeal, the excited gestures of their elongated fingers in contrast to the air of stillness that pervades the rest of the picture. Murillo sets his scenes with the flair of a practiced storyteller. No less impressive is the painterly bravura of the incidental still-life elements. Pottery, knives, baskets of lemons and quinces, or multicolored grapes are rendered with remarkable palpability.

Despite their shared sentimentality and picturesque subject matter, plus almost identical dimensions, the Munich pictures were not painted as pendants. In fact, *Boys Eating a Melon and Grapes* was executed at least twenty-five years before *Boys Playing Dice*. The thematic consistency of Murillo's secular work never negated his technical growth as an artist. *Boys Eating a Melon and Grapes* is one of the artist's earliest genre scenes, and elements of its handling are still reminiscent of the tenebrist manner of painting, which relied on strong contrasts of light and shade for dramatic effect. The picture's warm red-brown tonality is relieved only by the light luminous touches of the golden fruit. There is a vivacity to the paint surface which, especially in the fruit and flesh, is thickly applied and animated. By contrast, there is a greater sense of delicacy in *Boys Playing Dice*. The surface is less textured, the contours softer, and the figures less solidly modeled. The style is more vaporous, emphasizing subtle gradations of light and shade. The color scheme has been neutralized and even the few accents of red and yellow have been bled of their brilliance (Von Sonnenburg 1980).

Murillo's unquestioned ability as a painter just saved his pictures of street urchins from descending to the level of cheap sentimentalism. There is an appealing, timeless quality to their sun-drenched world. Nevertheless, the nineteenth-century critic John Ruskin

objected to Murillo's lack of social commitment:

> But look at those two ragged and vicious vagrants that Murillo has gathered out of the street. You smile at first, because they are eating so naturally, and their roguery is so complete. But is there anything else than roguery there, or was it well for the painter to give his time to the painting of those repulsive and wicked children? Do you feel moved with any charity towards children as you look at them? Are we the least more likely to take any interest in ragged schools, or to help the next pauper child that comes in our way, because the painter has shown us a cunning beggar feeding greedily? Mark the choice of the act. He might have shown hunger in other ways, and given interest to even this act of eating, by making the face wasted, or the eye wistful. But he did not care to do this. He delighted merely in the disgusting manner of eating, the food filling the cheek; the boy is not hungry, else he would not turn round to talk and grin as he eats (Ruskin 1904, 228–229).

Murillo, however, never intended his genre scenes as Dickensian essays on the moral obligations of society toward the underprivileged. His view of these young souls was more optimistic. Murillo depicted them at the happiest moment of their lives, when joy could be derived from a piece of fruit or a simple game of dice.

B.L.B.

PROVENANCE
Boys Eating a Melon and Grapes was probably acquired in 1698 by Elector Maximilian II Emanuel when he was regent of the Low Countries. *Boys Playing Dice* was acquired in Antwerp on 17 September 1698 from Gisbert van Ceulen by Elector Maximilian II Emanuel when he was regent of the Low Countries.

LITERATURE
John Ruskin, *The Works of John Ruskin*, 10, *The Stones of Venice*, London, 1904; Jean Denucé, *The Antwerp Art-Galleries Inventories of the Art-Collections in Antwerp in the 16th and 17th Centuries*, The Hague, 1932; Hubertus von Sonnenburg, "Zur Maltechnik Murillos I," *Maltechnik/Restauro* 86 (1980), 159–179; Diego Angulo Íñiguez, *Murillo*, 3 vols., Madrid, 1981; *Bartolomé Esteban Murillo 1617–1682*, exh. cat., Museo del Prado, Madrid, and Royal Academy of Arts, London, 1983; Marianna Haraszti-Takács, *Spanish Genre Painting in the Seventeenth Century*, Budapest, 1983.

Jusepe de Ribera, called Lo Spagnoletto

Játiva 1591–1652 Naples

52 *Saint Bartholomew*

c. 1633–1635
oil on canvas
76 x 64 (29⅞ x 25⅛)
inv. no. 7604

The greatest number of Ribera's paintings (and an even larger number of works by his pupils and imitators) consist of half-length figures of old men. It is not always easy to identify these elderly gentlemen, but the inclusion of a knife in the Munich canvas indicates that this is the Apostle Bartholomew, who was flayed alive. The painting may have belonged to a series of all twelve apostles; such groups of pictures were known in Spain as *Apostolados*. During the Middle Ages and the Renaissance, the Apostles had usually been depicted as barely differentiated types in long predellas or with Christ as part of a Last Supper. El Greco apparently introduced the idea of highly individualized characterizations for each Apostle, and Ribera perfected it by creating a variety of memorable personages.

One of Ribera's greatest gifts was his ability to endow his many images of Christian saints and martyrs with the compellingly lifelike qualities of portraiture; he may have used senescent models to arrive at his naturalistic portrayal of old age. Beyond the physical signs of aging, however, he was able to create a unique personality for each figure, establishing both a visual and psychological presence. Nowhere is this more apparent than in his vital image of Saint Bartholomew. We can easily

t. 52

Fig. 1. Jusepe de Ribera, *Saint Bartholomew*, Museo del Prado, Madrid

understand why the contemporary Spanish critic Francisco Pacheco praised Ribera in 1649 for his ability to make religious figures palpably real (Pacheco 1956, 2:13).

Ribera has concentrated on the sad yet noble face of Saint Bartholomew and on his powerful hands. The smooth, sweeping folds of the voluminous drapery stand in stark contrast to the richly textured impasto of the flesh. Ribera worked up these lighter passages from a dark ground with a wet-on-wet technique, in which he would pull a stiff-bristled brush across the surface to produce the deep wrinkles. These areas were then refined by the addition of small touches of soft color to give the flesh a greater luster and the beard, mustache, and hair more tactility. The dramatic isolation of the figure against the dark background and its compelling naturalism recall the strong influence of Caravaggio and Italian art, but the picture's deep spirituality is entirely Spanish.

Ribera's art, in fact, represents a unique mixture of Italian and Spanish traits. Although born in the province of Valencia, Ribera lived and worked most of his life in Naples, where he was nicknamed "lo spagnoletto," the little Spaniard. Naples at that time belonged to Spain, and while its artistic roots were undoubtedly Italian, artists such as Ribera provided a fundamental link with the traditions and heritage of the ruling culture. Nevertheless, like many of his Neapolitan contemporaries, Ribera fell under the magical spell of Caravaggio's art. He adopted Caravaggio's sharp chiaroscuro, dramatic mode of presentation, and emphasis on realistic appearance. Under the protection of the Spanish viceroys, who were, incidentally, among his greatest patrons, Ribera gained a prominent position in the Naples artistic community. He also continually sent works back to Spain and consequently had considerable impact on the development of a Caravaggesque style in his native land.

Ribera employed a large number of assistants and had many imitators. As one eighteenth-century commentator pointed out, it is difficult to tell the master from his talented pupils (De Dominici 1742, 3:22–24). This is especially true of the paintings belonging to *Apostolados*, which were produced in large numbers. Those coming directly from Ribera's shop were usually completed by assistants. No single *Apostolado* by Ribera survives with all twelve paintings intact. Only three figures (*Saint James Major, Saint Simon,* and *Saint Bartholomew*) from the *Apostolado* in the Museo del Prado, Madrid, are considered to be by Ribera's hand. The Munich *Saint Bartholomew* is a version of the Prado painting (fig. 1), and most experts consider it to be a workshop piece (Mayer 1908, 75; Kehrer 1926, 153; Felton 1971, 383). There has, however, been a persuasive argument for its authenticity (Soehner in GK.I, 163). The virtuoso handling of surface, especially in the face, suggests that Ribera probably intervened in the final stages of the work.

B.L.B.

PROVENANCE
acquired in 1861 by King Maximilian II of Bavaria

LITERATURE
Francisco Pacheco, *Arte de la pintura, su antiguedad, y grandezas* (Seville, 1649), edited by F. J. Sánchez Cantón, 2 vols., Madrid,1956; Bernardo de Dominici, *Vite de' pittori, scultori ed architetti napoletani*, 3 vols., Naples, 1742; August L. Mayer, *Jusepe de Ribera (Lo Spagnoletto)*, Leipzig, 1908; Hugo Kehrer, *Spanische Kunst von Greco bis Goya*, Munich, 1926; Craig McFadyen Felton, "*Jusepe de Ribera: a Catalogue Raisonné*," Ph.D. dissertation, University of Pittsburgh, 1971; *Jusepe de Ribera: Lo Spagnoletto 1591–1652*, exh. cat., Kimbell Art Museum, Fort Worth, 1982; *Painting in Naples 1606–1705: From Caravaggio to Giordano*, exh. cat., Royal Academy of Arts, London, 1982.

Diego Rodríguez de Silva y Velázquez
Seville 1599–1660 Madrid

53 *Portrait of a Young Spanish Gentleman*

c. 1629
oil on canvas
89 x 69 (35 x 27⅛)
inv. no. 518

This vivid and intense portrait of a young cavalier has been considered—on no specific grounds—a self-portrait. The picture, however, was undoubtedly painted by Velázquez, probably just before he made his first trip to Italy in 1629. At that time the artist had already served as a court painter to Philip IV for several years. Velázquez had received his appointment in August 1623 on the strength of his skill as a portraitist, and throughout his career he would repeatedly paint the members of the royal family and their entourage. His formal but often dry portraits established the "official" image of power, and were meant to glorify the sitter almost to the point of deification. These pictures are by necessity impersonal, aloof, and cold; the regal trappings of authority are magnified at the expense of psychological penetration. But when Velázquez painted portraits of friends or lower-ranking members of the court, he was free of such propagandizing restrictions. The result in *Portrait of a Young Spanish Gentleman* is a highly personalized study of remarkable intelligence and complexity.

The three-quarter profile pose Velázquez employed here is less static than that used in his state portraits. The ear-

Cat. 53

nest young cavalier stands with his right hand on his hip and the other hand on his sword hilt. This complex pose recalls the Venetian models of Titian or Tintoretto, but unlike the Italian masters who differentiated their figures from the background, Velázquez has harmonized his in a somber orchestration of gray, brown, and black. The tonality is chilling, yet the presence of the young Spaniard is vibrantly real. Velázquez has not idealized him. He peers at us with a mixture of aristocratic disdain and rare humanity. As in all his very best works, Velázquez has endowed his sitter with deep emotional life that is far more compelling than mere physical likeness.

The painting is generally thought to have been left unfinished, and Velázquez may well never have completed it to his own satisfaction. The sensitive face is fully modeled, but the hands and *golilla*, a type of collar adopted at court after the sumptuary laws passed in January 1623, are only roughly sketched. The background appears to be no more than a series of random strokes made as a brush was wiped clean. However, similar "chance" strokes are also apparent in paintings considered to be finished, such as *Bust of a Man* (Wellington Museum, London) or *Lady with a Fan* (Wallace Collection, London). In his *Portrait of Juan Martínez Montañés* (Museo del Prado, Madrid), Velázquez seems to have left the underdrawing deliberately visible in an otherwise completed painting (Von

Sonnenburg 1982, 20–29). All of these pictures are close in both appearance and spirit to the small-scale studies that Velázquez made from life as the first step in a formal portrait. Such studies were rapidly executed, informal in character, and never brought to a high degree of finish. Of the half-dozen unfinished portraits that are not preparatory studies, two are known to represent friends of Velázquez (Brown 1986, 52). Possibly the painting in Munich also depicts a close acquaintance. The air of intimacy manifested in this and other unfinished portraits suggests that Velázquez executed them for his own pleasure, as he experimented with new poses and techniques. Under these circumstances there would have been no pressure for him ever to complete the pictures, which he consequently left in an unfinished state.

B.L.B.

PROVENANCE
acquired in 1694 in Madrid by Heinrich von Wiser on behalf of Elector Palatine Johann Wilhelm for the Düsseldorfer Galerie

LITERATURE
Elizabeth Du Gué Trapier, *Velázquez*, New York, 1948; José Gudiol, *Velázquez 1599–1660*, trans. Kenneth Lyons, London, 1974; José López-Rey, *Velázquez: The Artist as a Maker*, Paris, 1979; Gridley McKim-Smith, "On Velázquez' Working Method," *The Art Bulletin* 61 (1979), 589–603; Hubertus von Sonnenburg, "Zur Maltechnik Murillos, II," *Maltechnik/Restauro* 88 (1982), 15–34; Jonathan Brown, *Velázquez: Painter and Courtier*, New Haven and London, 1986.

Francisco de Zurbarán
Fuente de Cantos 1598–1664 Madrid

54 *The Ecstasy of Saint Francis*

c. 1660
oil on canvas
65 x 53 (25½ x 20⅞)
inv. no. 504

Along with Velázquez and Murillo, Francisco de Zurbarán is widely regarded as one of the three major masters of Spain's golden age of painting. Unlike the work of his more famous contemporaries, Zurbarán's oeuvre consisted almost entirely of religious subjects for the monasteries and convents of Seville. At the height of his career in the 1630s and 1640s, his creative spirit seemed perfectly suited to express the conservative tastes of the ecclesiastical community. Zurbarán was able to combine a straightforward and somber realism with the rapt intensity of post-Tridentine mysticism. During his last years Zurbarán moved to Madrid, where his commissions were not nearly so numerous. Here his style slowly became more personal, his austere asceticism replaced by a deep and tender compassion.

Saint Francis of Assisi was a favorite subject of Zurbarán's. In 1209 Francis had founded an order of mendicant monks devoted to poverty in the service of Christ. After the Council of Trent he was frequently portrayed, as in the Munich painting, as a penitent ecstatic meditating upon death with the aid of a skull. The various reform branches of the Franciscan order, such as the Capuchins, the Discalced Friars Minor or Recollects ("of strict observances"), and the Alcantarians ("of strictest observance"), each preferred

Saint Francis to be represented in their particular habits. Zurbarán's bearded saint wearing a pointed hood and a habit made from patches of coarse wool indicates that this painting was probably done for a community of Discalced Friars (Baticle 1987, 271).

The Munich painting is one of Zurbarán's last works, and in it we sense his new and intensified emotionalism. The dramatic contrast of light and shade, which characterized his work of twenty years earlier, has given way to a soft, even illumination. Under this diffuse and unifying light the somber and subdued shades of gray and brown meld seamlessly together. The paint has been applied with remarkable freedom, especially in the sky, where the saint's right hand is visible in a pentimento image lying under the surface layer of paint. The pentimento indicates that Zurbarán apparently changed his mind and brought the hand closer to the body, thereby strengthening the contour of the body and emphasizing the contrast between the saint's face and the skull.

There is a spiritual purity in this simple and direct contrast. The skull, which symbolizes the fraternal bond between the saint and death, is used as a touchstone to induce a state of mystic rapture. Saint Francis is not simply meditating upon death. He has transcended into the realm of divine power

Cat. 54

and is shown in ecstatic exaltation. The personal devotion that has transported him is made into a universal experience through the intense and intimate nature of Zurbarán's image. As a nineteenth-century critic noted, "no painter has portrayed the Spanish monk, both in his quiet and in his passionate devotion, and also in his fearful fanaticism, with such truth and power as Zurbarán" (Waagen 1867,2:67).

B.L.B.

PROVENANCE
from the Mannheimer Galerie

LITERATURE
Gustav Waagen, *Treasures of Art in Great Britain*, 4 vols., London, 1854–1857; Hugo Kehrer, *Spanische Kunst von Greco bis Goya*, Munich, 1926; Jonathan Brown, *Francisco de Zurbarán*, New York, 1974; Julián Gáilego and José Gudiol, *Zurbarán 1598–1664*, New York, 1977; *Von Greco bis Goya: Vier Jahrhunderte Spanische Malerei*, exh. cat., Haus der Kunst, Munich, 1982; Jeannine Baticle, *Zurbarán*, exh. cat., The Metropolitan Museum of Art, New York, 1987.

French Paintings

François Boucher

Paris 1703–1770 Paris

55 *The Blonde Odalisque*

1752
oil on canvas
59 x 73 (23¼ x 28¾)
signed at bottom left, *F Boucher 1752*
inv. no. 1166

In Boucher's coquettish image of innocence and charm, a nubile young girl reclines on a couch filled with soft, plump cushions. Her creamy flesh is as delicate as the petals of the pink rose casually discarded by her side. Without a touch of self-consciousness, her body is exposed in a manner that suggests readiness for sensual pleasure. She is lost in her own dreamy languor, idly toying with a blue ribbon. Despite her lascivious position, there is nothing lewd about this pretty creature. Her naïveté is beguiling.

Her open and natural behavior is in reality the artifice of Boucher. The soft curve of her thighs, the delicate arch of her back, and the gentle play of her hands are echoed by the line of the couch and by the decorative inlay of the paneling. Everything flows in a fluid rhythm that sweeps through figure and setting alike. The young girl is as carelessly tossed on the couch as are the pillows, or the billowing drapery that materializes out of nowhere and cascades to the floor. Yet, at the same time, Boucher has set his model apart from her surroundings. The wallpaper, brocade couch, and velvet curtain are all a subdued shade of tawny gold. Surrounded by this golden frame and placed against the disheveled pink and white sheets is the young girl's flawless skin. Every line, every limb, every nuance is deliberately contrived into a delicate harmony of form and color.

There is, admittedly, something irresistible about Boucher's fetchingly erotic young girl. The traditions that have grown up around this picture are equally irresistible, in that they involve the legendary lover Casanova and a mistress of King Louis XV, Louise O'Murphy. Who, we might well ask, would know more about this type of picture than Casanova? And in certain superficial ways the picture does sound like a painting described by Casanova concerning two Flemish sisters, "la Morfi" and her thirteen-year-old sibling "la petite Morfi," whom the author recalls meeting in 1751. Apparently the well-known womanizer convinced the little virgin to show him how she slept on a straw sack without her clothes. Casanova was so captivated by her beauty that he paid a German painter six *louis* to depict her in the nude. "She was lying on her stomach, propping herself up with her arms and breast on a pillow, and holding her head as if she was lying on her back. The clever artist had depicted her legs and thighs in such a way that the eyes could not desire to see more. I had someone inscribe below: *O'Morphi*. Not a Homeric word, but one that is nonetheless Greek. It signifies Beauty" (Casanova 1960, 3:197–201; New York

Cat. 55

Fig. 1. François Boucher, *The Dark-Haired Odalisque*, Musée du Louvre, Paris

the series. The settings do suggest the opium-scented harems of the East. The raven-haired beauties wear plumed headdresses, recline on piles of cushions, and breathe the intoxicating air of incense-burning *cassolettes*. In Munich's *Blonde Odalisque*, painted almost ten years after the Reims and Paris pictures, Boucher has transformed his seraglio into a Parisian boudoir. The incense burner remains, but the feathers are gone and the mattresses have been replaced by a low sofa. This domesticated version proved just as popular as Boucher's "Turkish delight." The artist himself repeated it in paintings, drawings, and pastels, while imitators created prints, miniatures, and decorative objects bearing the model's likeness (Ananoff 1976, 2:83, no. 379, 2:99–101, no. 411; New York 1986, 258–263, no. 61).

It is quite possible that Casanova's German painter emulated Boucher's well-known pose when he depicted "la petite Morfi." And it does not strain credibility to suggest that a painting similar to the one in Munich was once shown to Louis XV. The king, after all, was a superficial sensualist who could be momentarily aroused from his boredom by a frivolous image. Others shared the monarch's predilection, among them Mme de Pompadour's brother the Marquis de Marigny. Marigny had a "private cabinet" in which he kept only "nudities," including a painting by Boucher of a young woman lying on her stomach. The Marquis asked the painter Charles Natoire to enrich his collection with a model who wore "no—or at least, barely any—drapery" (New York 1986, 261–262). Other gentlemen preferred to have the faces of their own mistresses replace that of Boucher's model. No matter what the private circumstances surrounding the individual commissions might have been, the numerous versions of this composition suggest that it was among the eighteenth century's most popular. Since then, Boucher's invitation to pleasure has lost none of its enticement. His young girl is the quintessential French

1986, 258–260). Casanova's picture, which in reality must have been only a miniature, was given to Louis XV's *valet de chambre*, who was in charge of procuring young girls for the sovereign's pleasure. Apparently delighted with what he saw, the king had "la petite Morfi" installed in the Parc-aux-Cerfs, where he customarily stabled his more transient fillies.

Over the years Casanova's salacious tale has been conflated with an episode straight from the police blotters of eighteenth-century Paris. In 1753 the king's concubine was reported to be a fourteen-year-old girl who had previously served as a model for Boucher (Frankl 1961, 140; New York 1986, 260). This girl, Louise O'Murphy, was one of four daughters of an Irish cobbler living in Paris, and although she undoubtedly amused the king for a short time, she had never been employed as an artist's model. Alas, we

have no reason to believe that Louise O'Murphy was Casanova's "la petite Morfi," or that Boucher's enchanting picture is a portrait of Louis XV's teenage mistress.

Who is she, then, and why did Boucher paint her? In truth her seductive pose was one of Boucher's favorites. He employed it in paintings and drawings throughout his career, especially for swimming nymphs and naiads (Frankl 1961). However, it was not until 1743, when he painted his first *Dark-Haired Odalisque* (Musée des Beaux-Arts, Reims), that Boucher exploited the eroticism of the pose by making it the focal point of a painting (Ananoff 1976, 1:379–380, no. 264; New York 1986, 216–220, no. 48). The picture in Reims, the version in Paris (fig. 1), and a host of replicas, copies, and graphic reproductions are all quasi-oriental in flavor, which has prompted the sobriquet "odalisque" for

confection, presented on her pink and white cushions like a bonbon ready to be plucked from its box.

<div align="right">B.L.B.</div>

PROVENANCE
entered the Zweibrücker Collection by 1795

LITERATURE
Jacques Casanova, *Histoire de ma vie*, 12 vols., Paris, 1960–1962; Paul Frankl, "Boucher's Girl on the Couch," *Essays in Honor of Erwin Panofsky*, 2 vols., New York, 1961, 1:138–152; Alexandre Ananoff, *François Boucher*, 2 vols., Paris, 1976; *Boucher 1703–1770*, exh. cat., The Metropolitan Museum of Art, New York, 1986; *François Boucher: His Circle and Influence*, exh. cat., Stair Sainty Matthiesen, New York, 1987.

Philippe de Champaigne
Brussels 1602–1674 Paris

56 *Virgin and Child*

c. 1630
oil on canvas
75 x 60 (29½ x 23⅝)
inv. no. L 1811

Although, throughout the entire seventeenth century, French artists customarily turned to Italy for inspiration, some artists, such as Philippe de Champaigne, also looked northward to Flanders. For Philippe this was perhaps to be expected, since he was born and trained in Brussels. In 1621 he moved to Paris where, by mid-century, he had emerged as the most successful and important painter of the day. He was appointed court painter to the queen mother, Maria de' Medici, and enjoyed the extensive patronage of Cardinal Richelieu and a variety of religious orders. Philippe was one of the founding members of the Académie Royale de Peinture et de Sculpture in 1648. Through his lectures to the academy we learn a good deal about his theory of art. Philippe maintained that the excellence of painting depended less on the rules of art than on great genius (Martin 1977, 291). His own work proves that he was something of a technical genius, more interested in veracity than rhetoric. To this end his Flemish background served him well, giving him the necessary skills to translate his penetrating perception into paint.

Philippe de Champaigne's *Virgin and Child* is a subtle masterpiece of natural observation and simple charm. An obviously pretty young Virgin smiles in

Fig. 1. Raphael, *Small Cowper Madonna*, National Gallery of Art, Washington, Widener Collection

silent contemplation as her robust and cherubic child stares quizzically at the viewer. They are enveloped by massive, almost sculpturesque drapery, which pulls the figures together and at the same time gives the effect that they are revolving around one another. The pair is isolated against a neutral background that accentuates the bright and luminous blue, white, and red of their robes. With a truly Flemish touch Philippe has rendered the flesh and drapery with exacting care. The result is a picture of astonishing vivacity.

The motif of a half-length Virgin and Child has always been among the most popular Christian subjects, and Philippe had many precedents to choose from. In particular the position of the Christ Child, with his back turned partially toward the viewer and his hands resting on his mother's breasts, recalls the work of Raphael, who used a variant of this pose a number of times, most notably in the *Madonna del Granduca* (Palazzo Pitti, Florence), the *Tempi Madonna* (Alte Pinakothek, Munich, see p. 30, fig. 11), and the *Small Cowper Madonna* (fig. 1). Although Philippe never traveled to Italy, he was conversant

Cat. 56

Fig. 2. Peter Paul Rubens, *Virgin and Child Surrounded by Flowers*, Musée du Louvre, Paris

collection in Brussels (Dorival 1976, 2:57, no. 91, 385, no. 2042). The composition was engraved in reverse by Jean Morin. The print carries the inscription "Dilectus meus inter ubera mea commorabitur," and an attribution to Philippe, but no date (Dorival 1972, 38, no. 99). Philippe frequently repeated similar compositions at different times in his career. Because from the very beginning he was able to paint with an astonishing technical bravura, it is extraordinarily difficult to date his work precisely. However, this composition, together with other variations on the theme in which the Christ Child eats a grape or sleeps on his mother's breast, is generally believed to date from Philippe's early career.

B.L.B.

PROVENANCE
private collection, on loan to the Alte Pinakothek

LITERATURE
Bernard Dorival, "Recherches sur les sujets sacrés et allégoriques gravés au XVII^e et au XVIII^e siècle d'après Philippe de Champaigne," *Gazette des Beaux-Arts* 80 (July–August 1972), 6–60; Bernard Dorival, *Philippe de Champaigne 1602–1674*, 2 vols., Paris, 1976; John Rupert Martin, *Baroque*, New York, 1977; Anthony Blunt, *Art and Architecture in France 1500–1700*, 4th ed., Harmondsworth and New York, 1980; Pierre Rosenberg, *France in the Golden Age: Seventeenth-Century French Paintings in American Collections*, exh. cat., The Metropolitan Museum of Art, New York, 1982; Olan A. Rand, Jr., "Philippe de Champaigne and the *Ex-Voto* of 1662: A Historical Perspective," *The Art Bulletin* 65 (1983), 78–93; Christopher Wright, *The French Painters of the Seventeenth Century*, Boston, 1985.

with Raphael and Italian art. We know that he owned a collection of engravings and that he also made copies after Raphael as well as after Titian, the Carracci family, Domenichino, and Guido Reni (Rand 1983, 87). Furthermore, the image of a half-length Virgin and Child was one Rubens had appropriated from Raphael. In paintings such as *Virgin and Child Surrounded by Flowers* (fig. 2), Rubens modified and restructured Raphael's compositions so that their whole character was changed. In Rubens' hands the Virgin and Child take on a thoroughly baroque complexion. The forms are amplified and softened and their presence made less ideal and more palpable. This, in essence, is also what Philippe accomplishes and it may well be that for him Raphael was filtered through Rubens' interpretation.

The picture now in Munich only came to light in 1975. It is a slightly modified version of another *Virgin and Child* by the artist, which is in a private

Jean-Honoré Fragonard

Grasse 1732–1806 Paris

57 *Girl with a Dog*

c. 1770–1775
oil on canvas
89 x 70 (35 x 27½)
inv. no. HuW 35

In this painting Fragonard has given us a moment of erotic fantasy. Within the privacy of a secluded alcove, a young girl plays with a King Charles spaniel. Unaware that she is being watched, she momentarily abandons all pretext of decorous behavior. Her bed is in disarray, her nightdress more off than on, and in the general excitement her blue-ribboned cap has fallen to the pillow. Her merciless teasing of the dog has aroused a state of near ecstatic pleasure. It is a moment which we are not meant to share, but unseen we are indiscreetly allowed to be titillated.

Fragonard has long been considered the eighteenth century's most brilliant interpreter of these "surprises de l'amour," intimate scenes of erotic voyeurism in which one's presence is unsuspected. The art of boudoir painting had already been perfected by Fragonard's teacher François Boucher. Although Boucher's amorous scenes could be equally as frivolous as Fragonard's, they were not nearly as naughty. Boucher most often cloaked his more provocative subjects in a mythological guise, and when he did not, as in *The Blonde Odalisque* (see cat. 55), he was charmingly coy about offering an invitation to sensual pleasure. Fragonard, on the other hand, was rarely discreet about his indiscretion. The work of both artists was fueled by the insatiable appetites of affluent

gentlemen striving to fill their private cabinets with secret treasures, but Fragonard's pictures, even more than Boucher's, reflect the extreme relaxation of the mores of proper Parisian society.

The contemporary view was that, because of financial difficulties after his return from Italy around 1770, Fragonard had been "compelled by need to devote himself to works scarcely in keeping with his genius" (Wildenstein 1960, 12). But in truth, works such as *Girl with a Dog, All in a Blaze* and *The Stolen Shift* (both Musée du Louvre, Paris), and *The Useless Resistance* (Nationalmuseum, Stockholm), are among the artist's very best. Their lyrical license is matched by spontaneous and open brushwork. In the Munich picture, transparent glazes have been applied with rapid, energetic strokes. The richly textured drapery is played against the creamy smoothness of the young girl's flesh. No matter how frivolous the subject matter or how small the canvas, the artistry is of the highest technical distinction.

Girl with a Dog is sometimes known by the title *La Gimblette*, because of its similarities to a series of works by Fragonard in which the girl is teasing her dog with a ring-shaped biscuit or *gimblette*. When it was noticed that there was no sign of a biscuit in the Munich painting, its title in French was

Cat. 57

changed to the polite *Jeune fille faisant danser son chien sur son lit* (Young Girl Making Her Dog Dance on Her Bed). But it was quite obvious that the painting had nothing to do with dancing and, even in the eighteenth century, most considered the subject to be in doubtful taste. A note on an engraving after the picture executed by Bertony reads: "Ce sujet ne doit pas être mis à l'étalage" (this subject should not be displayed). Nevertheless, the image was more widely circulated than one might have thought, and the sculptor Clodion even made a terra-cotta statuette based on "La Gimblette" (Rosenberg 1987, 232–235). V. M. Picol engraved the picture in 1783 for a London *bonbonnière* and called it *New Thought*. What the London candymaker's new thought might have been we can only guess. But surely, Fragonard's *Girl with a Dog* remains one of art's most delectable confections.

B.L.B.

PROVENANCE
acquired in 1977 for the collection of the Bayerische Hypotheken- und Wechsel-Bank A.G., on loan to the Alte Pinakothek

LITERATURE
Arno Schönberger, Halldor Soehner, and Theodor Müller, *The Rococo Age: Art and Civilization of the 18th Century*, New York, Toronto, and London, 1960; Georges Wildenstein, *The Paintings of Fragonard*, New York, 1960; *Masters of the Loaded Brush: Oil Sketches from Rubens to Tiepolo*, exh. cat., Knoedler and Company, New York, 1967; *Aspects de Fragonard: Peintures-Dessins-Estampes*, exh. cat., Galerie Cailleux, Paris, 1987; Jean-Pierre Cuzin, *Jean-Honoré Fragonard vie et oeuvre*, Paris, 1987; Pierre Rosenberg, *Fragonard*, exh. cat., Galeries Nationales d'Exposition du Grand Palais, Paris, 1987.

Eustache Le Sueur
Paris 1616–1655 Paris

58 *Christ in the House of Mary and Martha*

c. 1650
oil on canvas
162 x 130 (63¾ x 51⅛)
inv. no. WAF 492

The story of Christ's visit to the house of Mary and Martha is told in the Gospel of Luke (10:38–42). Because the names of the two women given in Luke are the same as those of the two sisters of Lazarus (John, 11:1), it was assumed, when this picture was painted, that the same sisters figure in both stories. This would mean that Mary is Mary Magdalen, the repentant prostitute. In Le Sueur's painting Mary kneels at Christ's feet and listens attentively to his words while others are busy preparing the meal. Martha, resenting her sister's inactivity, approaches Christ and complains that her sister is shirking her share of the work. Christ's reply is the essence of the story: "Mary has chosen the best part, and it will not be taken away from her." The theme was a popular reminder of Christian virtue and often depicted during the Renaissance and baroque periods (see cat. 12).

Christ in the House of Mary and Martha exemplifies Le Sueur's "grand style" at its most austere. The artist has represented the scene with the minimum of dramatic confrontation, little emotional impact, and an astringent use of decorative detail. The extreme severity of the architectural setting provides a bleak backdrop for the frozen action of this carefully contrived com-

Cat. 5

position. The paint surface is untextured, with the emphasis on the precision of the draftsmanship and not on the application of the paint. The colors, too, are chilled and hard; crystalline blues and rare mauves are set against the neutral hues of clammy stone. The figures, many of whom are seen in strict profile, are inordinately elongated and stylized. This elegance and refinement of form is typical of Le Sueur's work in the 1650s, when he seems to have been most affected by the school of Fontainebleau. However, the figures' rhythmic grouping and rhetorical poses, as well as the dignity and spaciousness of the composition, ultimately derive from the lofty model of Raphael's *School of Athens* in the Stanza della Segnatura of the Vatican.

Le Sueur, however, never made the obligatory trip to Rome. What he knew of Raphael came secondhand through prints and a few works available in private Parisian collections. During Poussin's brief return from Rome in 1640 the two men met, and the encounter was to leave a lasting mark on Le Sueur's style. Poussin reintroduced him to the masters of the High Renaissance, and Le Sueur quickly assimilated Poussin's new classicism in both his composition and modeling. In the end Le Sueur, not Poussin, became the true spiritual heir of the Renaissance masters. This was recognized in the nineteenth century by artists such as Ingres, who wrote, "Eustache Le Sueur: gentle child of Raphael's works, who, without leaving Paris, understood that which was beautiful and brought forth marvels of grace and sublime simplicity" (Delaborde 1870, 163).

The Munich picture was originally painted for one of the nave chapels in Saint-Germain l'Auxerrois in Paris. In the eighteenth century the chancellor, Comte de Pontchartrain, took Le Sueur's painting for his own private collection and had it replaced by a copy. It is not surprising to learn that King Ludwig I of Bavaria, who had a special affection for Raphael, liked this picture. In 1845 he bought it from the collection of Cardinal Fesch in Rome. Ludwig was not alone in his admiration of the work; copies of the picture exist in Marseilles, Tours, Aix-en-Provence, Milan, Paris, and Vienna (Mérot 1987, 296–297). There are numerous drawings which have been identified as preparatory studies for the Munich painting, but recently all of them except a sheet in the Städelsches Kunstinstitut in Frankfurt (Inv. 1001) have been rejected (Mérot 1987, 296–298). The Frankfurt drawing exemplifies Le Sueur's working method, in which he would lay out a perspectival grid and plot the architectural elements before arranging the figures. In the painting he has modified the position of Martha and that of Christ, creating a calmer and less emotional encounter.

B.L.B.

PROVENANCE
acquired in 1845 by King Ludwig I of Bavaria, on loan to the Alte Pinakothek

LITERATURE
Viscomte Henri Delaborde, *Ingres, sa vie, ses travaux, sa doctrine*, Paris, 1870; Jacques Thuillier and Albert Châtelet, *French Painting from Le Nain to Fragonard*, Geneva, 1964; Marguerite Sapin, "Contribution à l'étude de quelques oeuvres d'Eustache Le Sueur," *La Revue du Louvre et des Musées de France* 28 (1978), 242–254; Pierre Rosenberg, *France in the Golden Age: Seventeenth-Century French Paintings in American Collections*, exh. cat., The Metropolitan Museum of Art, New York, 1982; Christopher Wright, *The French Painters of the Seventeenth Century*, Boston, 1985; Alain Mérot, *Eustache Le Sueur 1616–1655*, Paris, 1987.

Nicolas Poussin

near Les Andelys 1594–1665 Rome

59 *The Lamentation over the Dead Christ*

c. 1628–1629
oil on canvas
103 x 146 (40½ x 57½)
inv. no. 625

Despite his French nationality, Nicolas Poussin was, in terms of residence and practice, an Italian artist. By 1623 he had traveled to Venice and two years later he settled more or less permanently in Rome. While his stay in Venice obviously made a lasting impression on his palette, the strongest influences on his style came from his exposure in Rome to the masters of the High Renaissance, contemporary painters such as Domenichino, and the art of classical antiquity. Poussin developed an uncompromising style of extreme intellectual and moral severity, which held little appeal for most patrons in France or Italy who wanted full-blown baroque works. His clientele came almost exclusively from a small circle of antiquarians who were friends of Cardinal Francesco Barberini and his secretary, Cassiano del Pozzo. Regardless of this Italianate background, Poussin is the key to the whole later evolution of the classical style in France. French artists either followed his lead or rebelled against him with a vehemence that in itself was a tribute to his genius.

The chronology of Poussin's painting from his first decade in Rome is extremely uncertain and has given rise to considerable scholarly contention (Mahon 1960; summary in Blunt 1967, 1:61, no. 19). It was a period of great experimentation for the artist, who seems to have treated different subjects

in different modes, changing his manner with each new commission. Because this picture is one of the relatively few religious scenes Poussin painted during his early years in Rome, it is all the more difficult to date precisely. However, its emotional intensity and complex composition seem to indicate a date around 1628 or 1629, during the period when Poussin was at work on *The Martyrdom of Saint Erasmus*, his monumental altarpiece for Saint Peter's (Pinacoteca Vaticana, Vatican City). The Vatican picture proved that Poussin had mastered the drama and rhetorical language of Italian baroque painting. The act of martyrdom is distilled into a frozen moment of melancholy, tragedy, and death.

Timeless grief also characterizes the much smaller Munich painting. Here, Poussin has depicted the final minutes before Christ's body is anointed and wrapped for burial. His pallid corpse rests on the laps of Mary his mother and Mary Magdalen. The Virgin swoons in anguish as the Magdalen, who is shown in strict profile, reaches toward her with a plaintive gesture. Behind them, Joseph of Arimathaea prepares the sarcophagus. Young John the Evangelist sits mourning on the edge of the tomb, lost in his own private world of sorrow. Two weeping angels appear at Christ's feet, recalling the *pleureurs* (mourners) of French sepul-

Cat. 59

Fig. 1. Nicolas Poussin, *Venus with the Dead Adonis*, Musée des Beaux-Arts, Caen

chral art. All of these figures are woven into a tightly knit structure that echoes the rocky ledge and tombs behind them. Like a classical bas-relief, they are set in a single plane with the action built into the crystalline harmony of a grand pyramid. Poussin's calculated gestures and movements were meant to give the picture the high-pitched intensity of pure emotional catharsis. This emotional effect was reinforced by the cool restraint of a carefully modulated pastel palette. The apricot light of the setting sun streaks across the pale gray sky, its pearly hues reflected in the silver basin and ewer, the beige of rocks and tombs, and even in the deathly pallor of Christ's greenish flesh. As in Poussin's so-called "blonde" paintings, the light remains clear and unclouded by dramatic contrasts of chiaroscuro. The vivid color is localized in a few pieces of drapery. Poussin has given us a very precise, surprisingly unemotional idea of grief.

One of the most curious features of this painting is the resemblance it bears to Poussin's *Venus with the Dead Adonis* (fig. 1). The figure of Christ, in reverse, is nearly identical with the dead Adonis, and both figures were probably derived from a Meleager sarcophagus now in the Musei Capitolini, Rome. The cherubic angels are similar in pose and type to the putti, and the Magdalen is a more grief-striken version of Venus. The similarities should not be taken as a lack of invention on Poussin's part, but as a conscious attempt to equate Christian and pagan themes of resurrection. Venus pours nectar into Adonis' wound, from which springs a scarlet anemone symbolizing the death of nature in winter and its rebirth in spring. The cult of Adonis and its implications were discussed at length in Lucian's dialogue *On the Syrian Goddess*, which was widely read in the seventeenth century (Blunt 1967, 1:114–116; Badt 1969, 1:475–476). Like many of his contemporaries, Poussin was fascinated by what we would now call "comparative religion." Poussin's blend of Christian and antique references is typical of the revival of interest in early Christianity, which was fostered by men such as his great patron, Cardinal Barberini. Further, Poussin reused these recumbent poses for heroes and heroines who were not necessarily dead. In *Venus Surprised by Satyrs* (Musée du Louvre, Paris) and a series of other bacchanals, the goddess lies back in luxurious and drunken abandon while satyrs lift a sheet to examine her sleeping form. It is evident, though less easy to explain, that Poussin employed similar compositions to depict the sorrows as well as the delights of life. Alpatov believes that Poussin intended his heroes, whether Christian or pagan, to transcend their own stories and become archetypal symbols of human existence (Alpatov 1967). However, it is much more likely that Poussin's interest was in the formal beauty of the classical motif, which could be used in interchangeable ways for different themes.

<div align="right">B.L.B.</div>

PROVENANCE
first recorded in 1748 in Munich in the collection of the electors of Bavaria

LITERATURE
Denis Mahon, "Poussin's Early Development: an Alternative Hypothesis," *The Burlington Magazine* 102 (1960), 288–304; Walter Friedlaender, *Nicolas Poussin: A New Approach*, New York, 1966; M. Alpatov, "Poussin's 'Tancred and Erminia' in the Hermitage: an Interpretation," in *Studies in Renaissance and Baroque Art Presented to Anthony Blunt on His 60th Birthday*, London and New York, 1967, 130–135; Anthony Blunt, *Nicolas Poussin*, 2 vols., Washington, 1967; Kurt Badt, *Die Kunst des Nicolas Poussin*, 2 vols., Cologne, 1969; Doris Wild, *Nicolas Poussin*, 2 vols., Zurich, 1980; Christopher Wright, *Poussin Paintings: a Catalogue Raisonné*, London, 1985.

Valentin de Boulogne
Coulommiers 1594–1632 Rome

60 *Erminia and the Shepherds*

c. 1630
oil on canvas
135 x 186 (53⅛ x 73⅛)
inv. no. 937

This scene is taken from Torquato Tasso's epic poem *La Gerusalemme Liberata*, which was first published in 1581. Tasso's tale of the first Crusade was among the most popular sources for secular painting throughout the seventeenth century (see cats. 4, 5). This was due less to the main story, which strikes a lofty moral tenor, than to the romantic interludes within the poem. One such interlude is Erminia's encounter with the shepherds (canto 8). Erminia, the daughter of a Saracen king who had been defeated by the Franks, fell in love with Tancred, the conqueror. Tancred and his army continued their campaign toward Jerusalem, and Erminia, believing Tancred to have been wounded, set off in search of him disguised in the white robes and armor of the female warrior Clorinda. Erminia was discovered, however, and forced to flee, reaching safety on the banks of the river Jordan only late at night. There, the next morning, she found an old shepherd weaving reed baskets to the rustic piping of his three young sons. The shepherd extolled the joy of his secluded and peaceful existence, and for a time Erminia found safety in their pastoral refuge.

This particular episode had been the subject of an *Impresa per dipingere l'historia d'Erminia*, an essay written in 1602 by the famed art theorist Monsignor Giovanni Battista Agucchi (Whitfield 1973). The interest of the story for Agucchi lay in the evocation of serenity in the midst of chaos. The shepherds' rustic dwelling becomes the classical *locus amoenus*, a refuge from the world and, in Erminia's case, from the war raging nearby. Agucchi commissioned a painting (now lost) of this subject from Ludovico Carracci, but found Ludovico's work unsatisfactory. Nevertheless, Agucchi's precise instructions more or less determined the iconographical model most painters, including Valentin, would later follow.

For Valentin de Boulogne to have painted a scene from Tasso is something of an anomaly. *Erminia and the Shepherds* is the only picture in his entire oeuvre taken from this poem or from any other. The French-born painter, who came to Rome sometime before 1614, specialized in powerful religious pictures and Caravaggesque genre scenes of tavern life and musical groups. His personal image was also closely bound to the drinkers, gypsy women, smugglers, and musicians who inhabit his canvases. Even the circumstances surrounding his untimely death have contributed to the notion that Valentin was a bohemian artist and habitué of low-class establishments. According to a contemporary account, after a bout of serious drinking Valen-

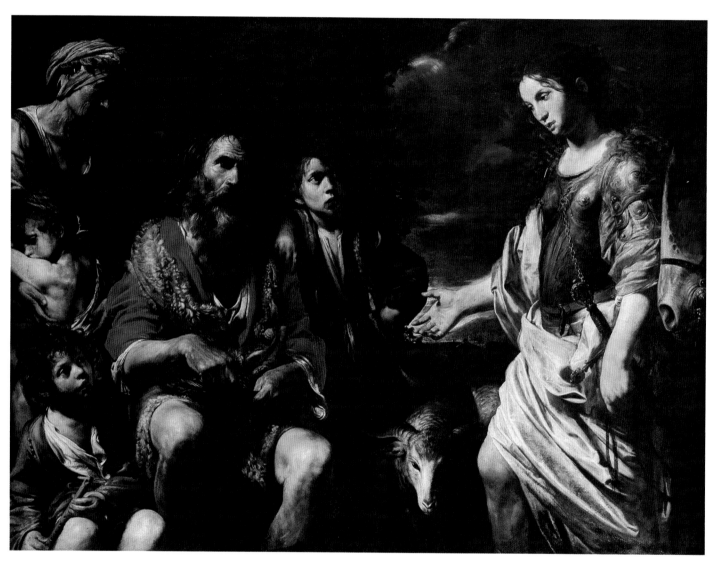

Cat. 60

tin fell into a fountain of cold water and died from a severe chill (Baglione 1935, 338). Although this story may be apocryphal, Valentin was the only French painter in Rome to be completely dominated by Caravaggio's subject matter, compelling sense of drama, and naturalistic mode of expression. He was patronized by the same circle as Poussin, yet there is little in Valentin's output that one can associate with the elegant classicism of his fellow countryman's art. Even the pastoral tranquility of his *Erminia and the Shepherds* is characterized by a gritty realism.

The scene is staged in a rustic setting, but Valentin has minimized the landscape almost to the point of negation. He focuses on the tightly knit group of figures, squeezing them within the picture frame and filling the gap between Erminia and the shepherd's family with a ram advancing head-on toward the viewer. Valentin also employed this type of restricted movement in genre paintings such as *A Meeting in a Cabaret* (Musée du Louvre, Paris), and religious works such as *The Last Supper* (Palazzo Corsini, Rome), and *Judith and Holofernes* (Musée National, Valletta, Malta). It is a trick he learned from Caravaggio, but one that also recalls the compression and rhythmic movement of antique bas-reliefs.

Valentin was a sensitive colorist, which is sometimes overlooked because of the somber, almost black tonality predominating in most of his work. He employed dark-gray shadows, however, to harmonize the deep blues and reds of his palette. In this painting the focused, penetrating light leaves a somewhat sinister shadow across an otherwise peaceful setting. The mood of apprehension is matched by Erminia's tentative gesture of greeting and the children's recoiling posture of fear. The scene is filled with tension, which Valentin exploits by sharply illuminating the actors' facial expressions. Within this dark and visceral world, ordinary details take on an extraordinary appearance. Erminia's armor, the shepherd's mantle, and the ram's coat are more than wondrous bits of naturalistic observation; they give the painting a complex pictorial richness.

Valentin's first documented painting is from 1627, only five years before his death. The Munich canvas with its immobile figures, ample drapery, and richly textured surface comes from the final years of the artist's short career. There is a replica of the picture by another hand in the collection of the Earl of Spencer (Hanfstaengl 1964).

B.L.B.

PROVENANCE
entered the Electoral Gallery by 1761

LITERATURE
Giovanni Baglione, *Le vite de' pittori scultori et architetti* (Rome, 1642), edited by V. Mariani, Rome, 1935; Eberhard Hanfstaengl, "Le Valentin: Erminia bei den Hirten," *Pantheon* 22 (1964), 137–142; Clovis Whitfield, "A Programme for 'Erminia and the Shepherds' by G. B. Agucchi," *Storia dell'arte* 19 (1973), 217–229; *Valentin et les Caravagesques français*, exh. cat., Galeries Nationales d'Exposition du Grand Palais, Paris, 1974; Jean-Pierre Cuzin, "Problèmes du caravagisme: Pour Valentin," *Revue de l'Art* 28 (1975), 53–61; Pierre Rosenberg, *France in the Golden Age:Seventeenth-Century French Paintings in American Collections*, exh. cat., The Metropolitan Museum of Art, New York, 1982.

Claude-Joseph Vernet
Avignon 1714–1789 Paris

61 *Rocky Coast in a Storm*

1770
oil on canvas
113 x 162 (44½ x 63¾)
signed at right, on the rock, *J. Vernet. f 1770*
inv. no. 444

62 *Seaport in the Evening Light*

1770
oil on canvas
113 x 162 (44½ x 63¾)
signed at right, on the rock, *J. Vernet. f 1770*
inv. no. 449

Claude-Joseph Vernet was the foremost French landscape and marine painter of the eighteenth century. He was an industrious artist who exhibited regularly at the Paris Salon from 1746 to 1789. Like Claude Lorraine before him, Vernet formed his style during a long sojourn in Italy. Between 1734 and 1753 he lived and worked in Rome, turning out Italianate landscapes populated by fashionable English sightseers. Not surprisingly, these same tourists were Vernet's chief clientele. His Italian coastal scenes, both real and imagined, led to a royal commission from Louis XV in 1753 for views of the twenty-four most important harbors in France. By the time Vernet settled in Paris in 1762, he was one of the most famous and successful painters of the day, receiving commissions from every corner of Europe.

This pair of canvases and a third painting were commissioned on 16 October 1769 by Karl Theodor, the elector palatine, for the elector's gallery at Mannheim. Vernet recorded in his

Livre de vérité that the subjects were to be left to his own fantasy; one storm and one seascape or something else of that nature. The pair was exhibited at the Salon of 1771, and on 15 February of that year Vernet received seventy-two hundred *livres* for it. The third painting was apparently never completed (Lagrange 1864, 349, no. 246; 350, no. 250; 366, no. 153).

Vernet's pairs of coastal scenes contrasting stormy weather and calm seas as well as different times of day were not only his most popular works, but artistically his most original. The pair exhibited here is typical of this genre. In *Rocky Coast in a Storm* a badly battered vessel has been smashed against the shore. The gray and ominous sky is streaked with rain and pierced by lightning. In the foreground rescue workers struggle to pull the survivors from the icy water. By comparison, *Seaport in the Evening Light* is a study of blissful tranquility. As the golden shadows of the setting sun dance across the smooth waters, fishermen haul in their final

Cat. 61

Cat. 62

catch and laundresses quietly complete their chores. The relationship between the two paintings is based on the tangible differentiation of atmospheric qualities and their relation to the human condition. The contrast between the simple, mundane tasks of daily life and the struggle for mere survival is underscored by the change in weather, mood, and illumination. On the one hand Vernet created an idyllic world of gentle, quiet beauty, and on the other an expressive drama about the uncontrollable forces of nature.

Vernet did not paint "series" of works in the sense that Claude Monet later painted series of cathedrals or haystacks. He never succumbed to the temptation of showing the same setting at different times or under different conditions. Rather, he presented complementary scenes composed in similar ways. In each of these works the foreground sweeps around toward a prominent cliff on the right, crowned in *Seaport in the Evening Light* by a circular temple, and in *Rocky Coast in a Storm* by a mighty fortress. There is a powerful diagonal thrust across the expansive sky created by ships, trees, rocks, and even torrents of rain, but the human action remains in the foreground. Despite being diverse in character, the foregrounds of both paintings have a decorative and picturesque quality, while the backgrounds take on the realistic appearance of carefully observed nature study.

Although in mood Vernet's art foreshadowed the romantic movement of the next century, the painter was an assiduous student of nature. His work combined an accuracy of detail with a feeling for atmosphere and a keen interest in the effects of light and air. No matter how fanciful or inventive the narrative might be, the settings depended on Vernet's practice of making oil sketches from nature. For Vernet, truth to nature meant truth to natural effect. Vernet's landscape and marine paintings were meant to evoke the emotions aroused by the sight of water, sunsets, temples, hills, trees, and ships. If the composition of the picture was imaginary it did not matter, as long as it unlocked the proper response in the viewer. Today this may be difficult for us to imagine, but Vernet's contemporaries could be moved to tears by his images of despairing and anguished souls clinging to the rocky shores of a storm-lashed landscape.

The pair of works was engraved by Abel Schlicht.

B.L.B.

PROVENANCE
entered the Mannheimer Galerie in 1771

LITERATURE
Léon Lagrange, *Joseph Vernet et la peinture au XVIII*, siécle, 2d ed., Paris, 1864; Florence Ingersoll-Smouse, *Joseph Vernet peintre de marine 1714–1789*, 2 vols., Paris, 1926; Pierre Arlaud, *Catalogue raisonné des estampes gravées d'après Joseph Vernet*, Avignon, 1976; Phillip Conisbee, *Claude-Joseph Vernet 1714–1789*, exh. cat., Kenwood, London, 1976; Michael Kitson, "Vernet at Kenwood," *The Burlington Magazine* 118 (1976), 540–544.

Index of Artists in the Exhibition